IMAGES
of Rail

ROARING CAMP
RAILROADS

IMAGES
of Rail

ROARING CAMP
RAILROADS

Beniam Kifle and Nathan Goodman

ARCADIA
PUBLISHING

Published by Arcadia Publishing
Charleston, South Carolina

Library of Congress Control Number: 2013937267

For all general information, please contact Arcadia Publishing:
Telephone 843-853-2070
Fax 843-853-0044
E-mail sales@arcadiapublishing.com
For customer service and orders:
Toll-Free 1-888-313-2665

Visit us on the Internet at www.arcadiapublishing.com

Mr. Kifle would like to dedicate this book to
his younger brother Yonathan.

Mr. Goodman would like to dedicate it to his parents, who
introduced him to the railroad at the age of two.

CONTENTS

ACKNOWLEDGMENTS

This book would not have been possible without the help of the many past and present Roaring Camp employees and community members who have come out of the woodwork with images, stories, dates, facts, and ideas. We are especially grateful to Georgiana and Melani Clark for allowing us access to the Clark Estate's vast collection of photographs, newspaper clippings, and scrapbooks.

Thanks go to Jim Vail, who was instrumental in placing names to faces in the old photographs he so graciously provided, along with his wealth of knowledge about details and dates. Gene "Junior" O'Lague, Jeff Badger, Kent Jeffries, Bill Burket, and Brian Liddicoat were also most generous with their collections of images and railroad stories.

Last but not least, thank you, to John Park, Sandy Lydon, and Tom Shreve for the history lessons, and to TSG Multimedia and the Santa Cruz Museum of Art and History for their contributions of images. Unless otherwise noted, all photographs are courtesy of the Clark Estate.

INTRODUCTION

Long before California was a state, a party of trappers from Tennessee and Kentucky made their way west over the Santa Fe Trail, arriving in Mexican territory in 1834. One of the members of this party was named Isaac Graham. Not being a Mexican citizen, he was prohibited from owning land. However, another member of his party, Joseph Majors, became a naturalized Mexican citizen and was then able to procure the land then known as Rancho Zayante. By 1841, Majors, Graham, and others had set up the first powered sawmill in California, along the banks of Zayante Creek. The sawmill was soon joined by a gristmill and a whiskey distillery.

This camp of British and American men in decidedly Mexican territory became an attractive spot for many travelers coming west in the 1830s and 1840s. As the population of Graham's colony swelled, the sawmill and machinery roared and the liquor flowed. It soon became known as "Drunkards Camp" or "A Wild and Roaring Camp," depending on who was talking about it. As the output of Graham's sawmill increased beyond the capacity of his camp to use the lumber, he constructed a highway from his mill through the mountains into Santa Cruz. The highway was to be used for shipping his lumber, and still exists, as today's Graham Hill Road. Until the railroad arrived in the middle of 1875, Graham's road was the only reliable route into Santa Cruz.

In 1850, California was admitted into the Union. Isaac Graham died on November 3, 1863. By 1867, arrangements were being made for his lands to be turned over to local logging interests. Wealthy San Francisco attorney Joseph Welch thwarted that plan by purchasing the land himself. Welch ended up with approximately 300 acres of old-growth redwood trees and meadows, including a grove of truly massive trees along the San Lorenzo River. What became known as the Big Trees Ranch was one of the first properties ever purchased with the aim of preservation. While the rest of the Santa Cruz Mountains were being clear-cut, Welch was hard at work setting up a tourist resort in his grove of big trees. By 1880, a narrow gauge railroad deposited travelers, eager for picnicking and escaping the heat of California's Central Valley, on the doorstep of his resort.

Today, this tradition continues thanks to the vision of Norman Clark and his family, who arrived in the area in the mid-1950s with the dream of preserving this slice of California's history. Upon seeing the Big Trees Ranch, Clark found it to be a perfect location, and he was able to secure the 180 acres still owned by Joseph Welch's descendents in a 99-year lease. In honor of the 50th anniversary of Clark's dream becoming a reality, this book is a look back over those first 50 years and what it took to build America's Most Backward Railroad.

One

THE RAILROAD ARRIVES

In 1875, the Santa Cruz & Felton Railway (SC&F) was hastily constructed over the course of nine months, originally conceived as an extension of a lumber flume that terminated in what is now downtown Felton. Cut lumber from mills in the headwaters of the San Lorenzo River was floated down the 40-inch-wide triangular flume, and upon its arrival in Felton, it was sorted and loaded onto the 36-inch-gauge flatcars of the SC&F. After eight miles of sharp curves through the San Lorenzo River Canyon, the SC&F arrived at the wharf in Santa Cruz. Here, the lumber was loaded on oceangoing ships and sent to market.

After only five years of existence, the SC&F was purchased by another 36-inch-gauge railroad looking to gain access to Santa Cruz. The South Pacific Coast Railroad (SPCRR), which had started construction only a year after the SC&F, was being built south from Dumbarton Point and Newark through San Jose and Los Gatos. In 1879, the SPCRR had reached Felton after boring two separate, mile-long tunnels and two shorter tunnels, and building countless bridges to get through the Santa Cruz Mountains. Rather than constructing a new line down the east wall of the San Lorenzo River Canyon, the SPCRR absorbed the SC&F. By May 1880, the line "over the hill" was open for business. Heavy freights full of lumber, lime, produce, and gunpowder battled the grades out of the mountains, and long passenger trains full of travelers and tourists rolled in.

The SPCRR was short-lived as well, and in 1886, it was sold to the Southern Pacific Railroad. The sale did not much affect the day-to-day operations until around 1900. In December 1902, the first section of standard gauge track was laid, and on May 29, 1909, the first standard gauge Southern Pacific train ran between San Francisco and Santa Cruz. For the next 30 years, the Southern Pacific did big business in the Santa Cruz Mountains. By the end of 1940, however, the line "over the hill" between Los Gatos and Olympia had been torn up, and all trains were routed through Watsonville. The portion of the railroad between Santa Cruz and Olympia—just north of Felton—continued to see heavy freight traffic from a sand quarry and occasional passenger trains until the 1980s, when the line was sold once again, this time to Norman Clark.

F. Norman Clark, the founder of
Roaring Camp, was originally from
Southern California. He fell in love
with the scenic beauty of the old-growth
redwood forest in the Big Trees Ranch
in Felton, and envisioned opening an
1880s-themed railroad town in the area.

The aerial view below shows the Big
Trees Ranch and the Felton yard of the
Southern Pacific Railroad in 1959.

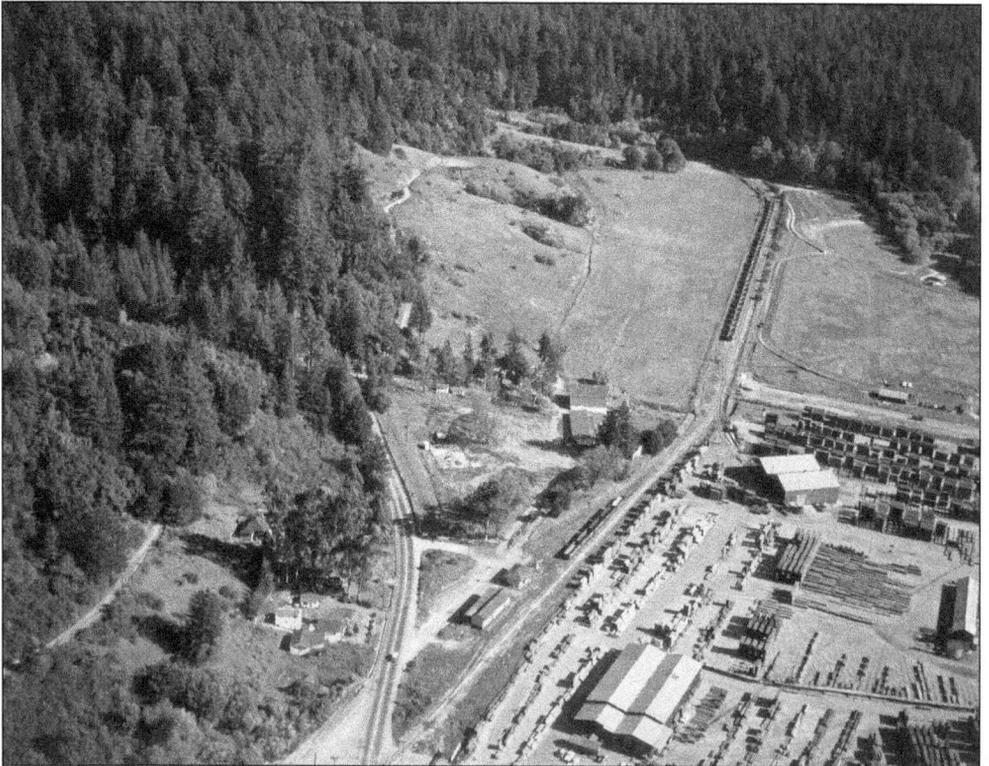

The Big Trees station of the South Pacific Coast Railroad, seen here, was visited by Pres. Theodore Roosevelt in May 1903. In honor of the momentous event, one of the giant sequoias was named after him, and it still stands today.

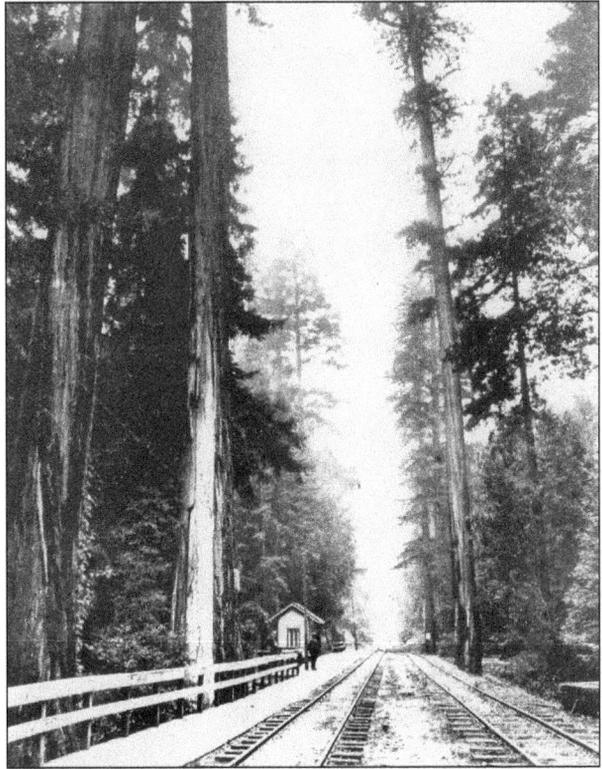

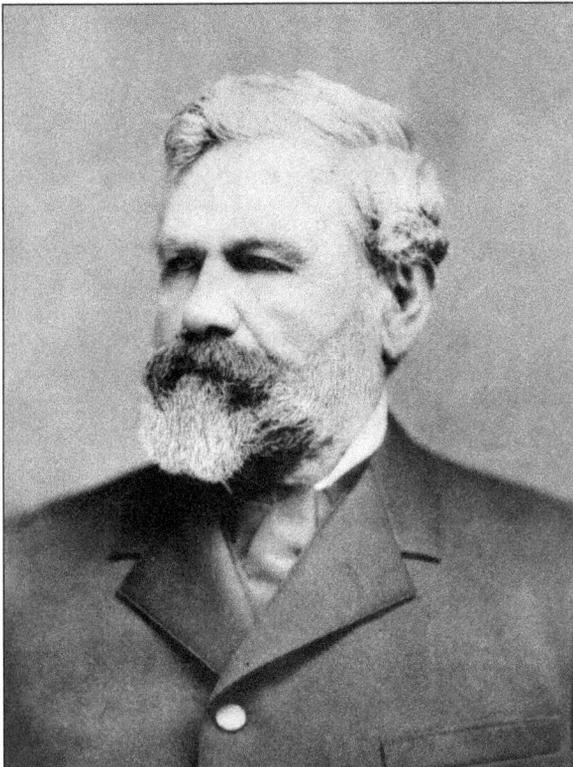

Industrialist Henry Cowell owned and operated the lime works, quarries, ranch, and large tracts of surrounding timberland in the Santa Cruz Mountains. The ranch remained in his family until the death of S.H. "Harry" Cowell, the youngest of Henry's five children and the last surviving member of the family, in 1955. Cowell's vast estate went to the S.H. Cowell Foundation, which is still in existence today. (Courtesy of the Santa Cruz Museum of Art and History.)

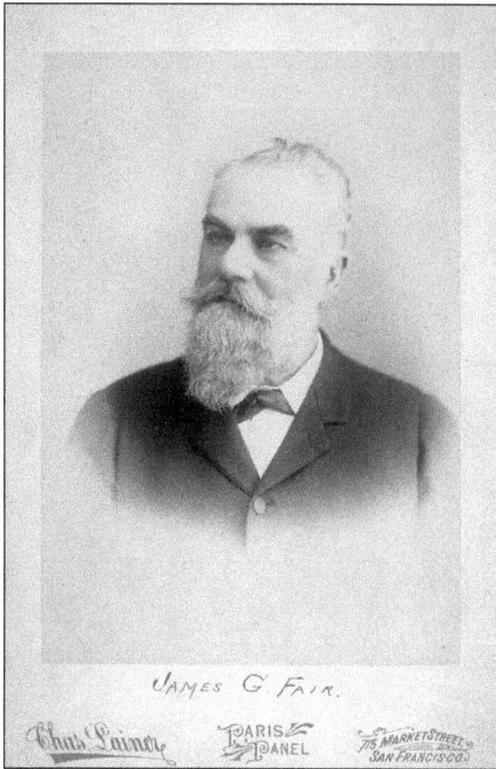

James G. Fair was the owner of the South Pacific Coast Railroad (SPCRR), which originated in Newark and eventually stretched from Oakland to Santa Cruz, with ferry connections to San Francisco in Alameda. The SPCRR reached Felton in 1879 after boring several long tunnels through the Santa Cruz Mountains. (Courtesy of Brian Liddicoat.)

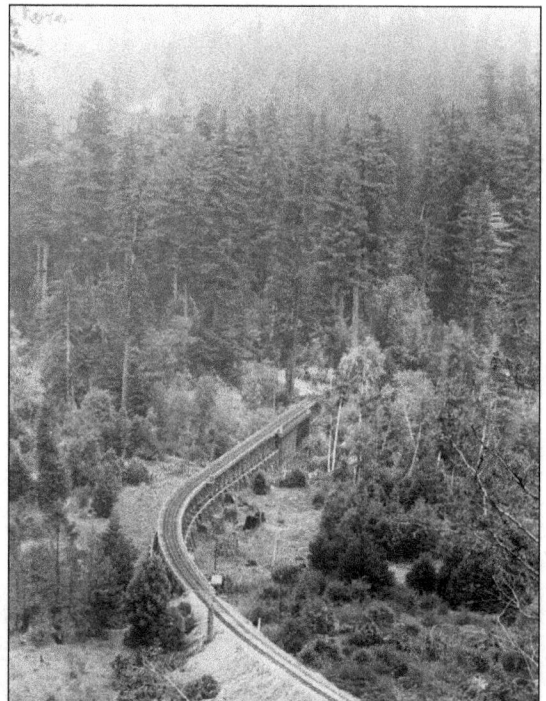

The South Pacific Coast Railroad bridge over the San Lorenzo River is seen here just south of Joseph Welch's Big Trees Grove. Today, the long trestle portion of the bridge towards the bottom of the photograph has been replaced by fill, and the wooden truss over the river has been replaced by a steel truss built in 1909 as part of the Southern Pacific Railroad's standard-gauging of the line.

A South Pacific Coast (SPCRR) train heading north is seen on the approach trestle to the bridge over the San Lorenzo River. The SPCRR was sold to the Southern Pacific Railroad in 1886.

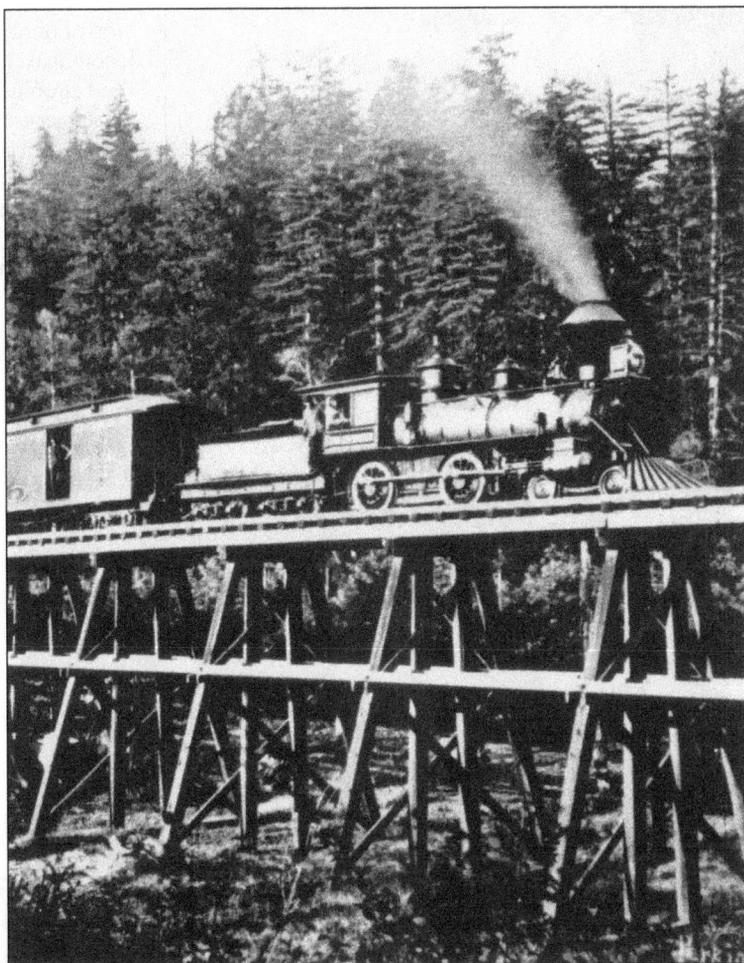

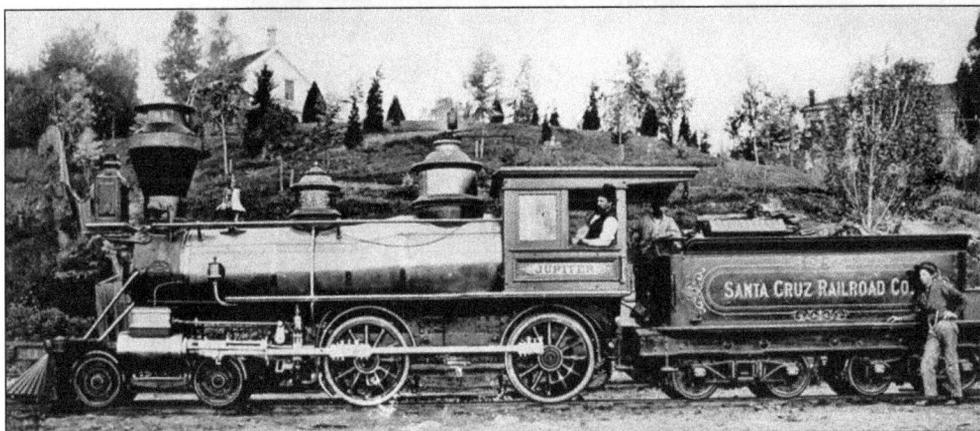

Built by Baldwin Locomotive Works in Philadelphia in 1876, the *Jupiter* was the Santa Cruz Railroad's third locomotive. Made for 36-inch narrow gauge track, it became obsolete in 1883 when the short line switched to standard gauge. It was sold to a railroad in Guatemala, where it hauled bananas for more than 60 years. In 1975, it was donated to the Smithsonian for "1876: A Centennial Exhibition," and it is still on view at the National Museum of American History.

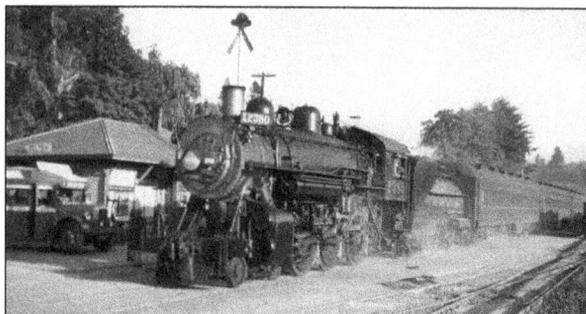

Northbound Southern Pacific locomotive No. 2380 arrives at the Felton depot in 1938 with a passenger train bound over the hill for San Jose and beyond. The bus to the left of the station was the Southern Pacific's replacement for the branch to Boulder Creek, which had been recently abandoned. (Courtesy of Jim Vail.)

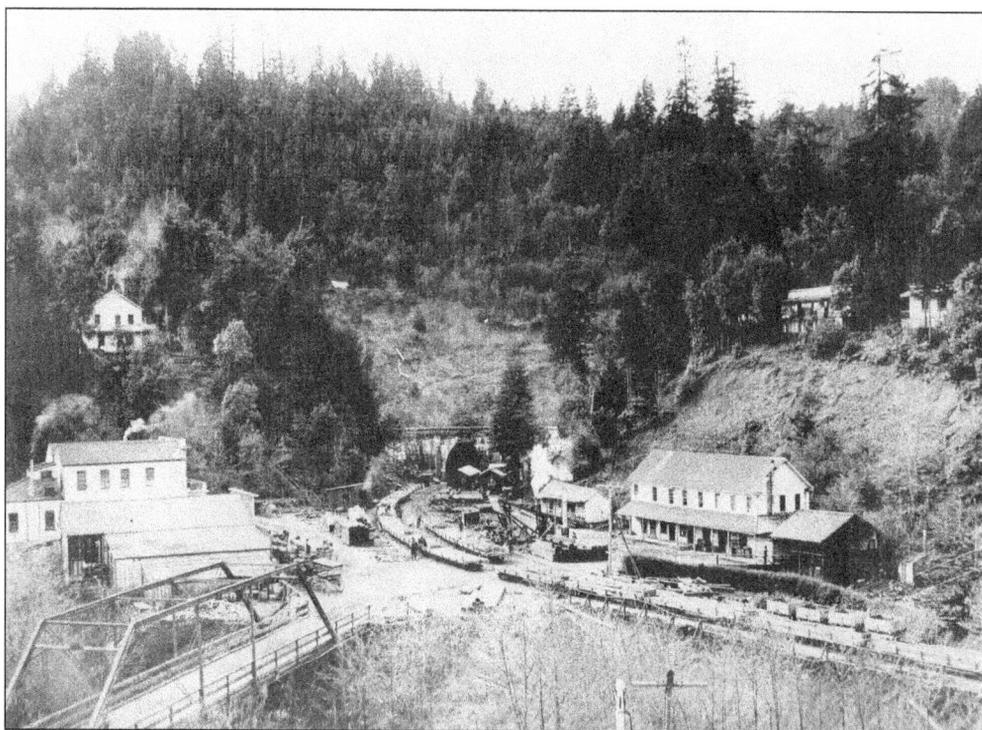

The mountain railroad town of Wrights is seen here in the South Pacific Coast Railroad (SPCRR) days. The tunnel portal was the beginning of one of the two tunnels on the SPCRR that were more than a mile in length, which were necessary to get the line through to Santa Cruz. Today, only the remains of the tunnel portal and some foundations are left.

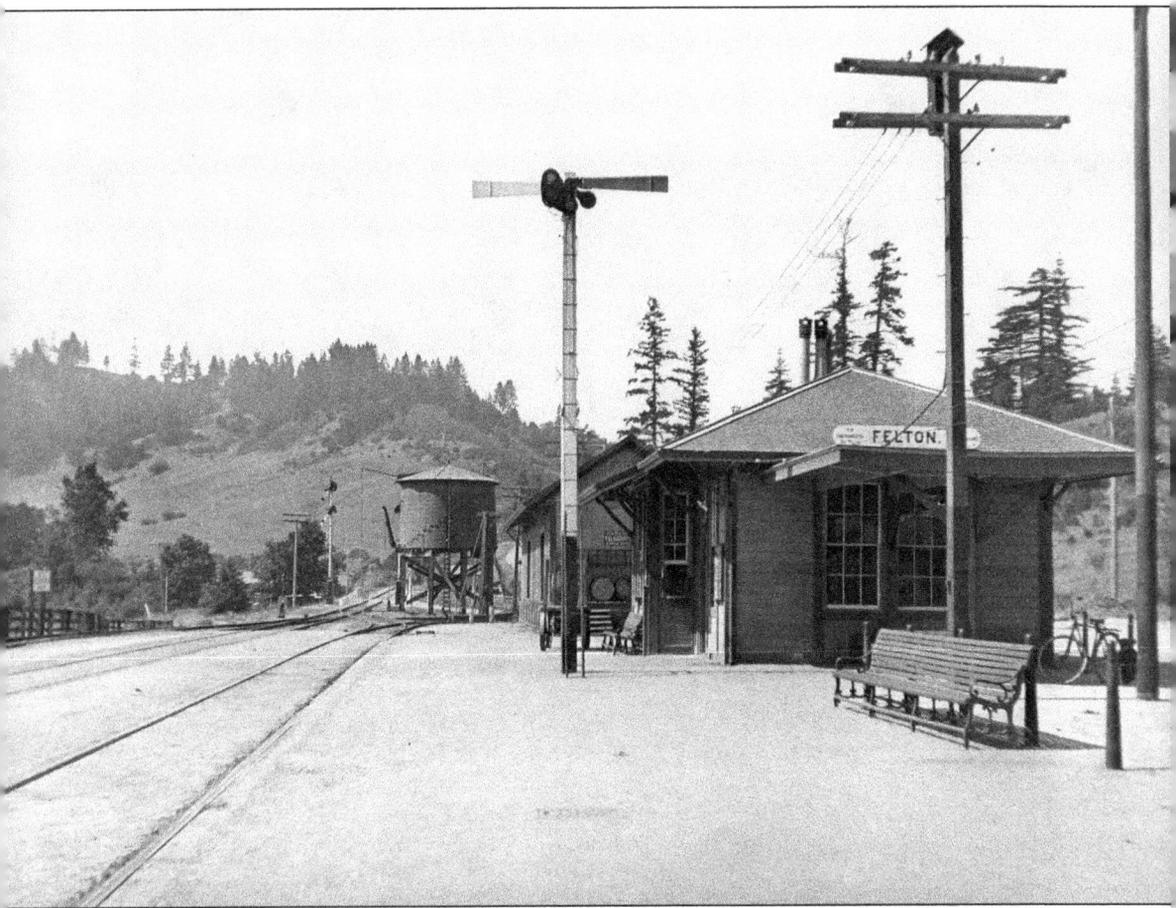

The view in this photograph looks north at the Felton yard and depot on a quiet day. The freight shed in the background was constructed out of lumber salvaged from the old lumber flume, which had its terminus in what is now downtown Felton. The siding is board-and-batten made of 2-by-24-inch old-growth redwood. The turntable is just beyond the freight shed. (Courtesy of Jim Vail.)

The Big Trees Ranch is seen here as Norman Clark saw it upon his arrival. The Southern Pacific Felton rail

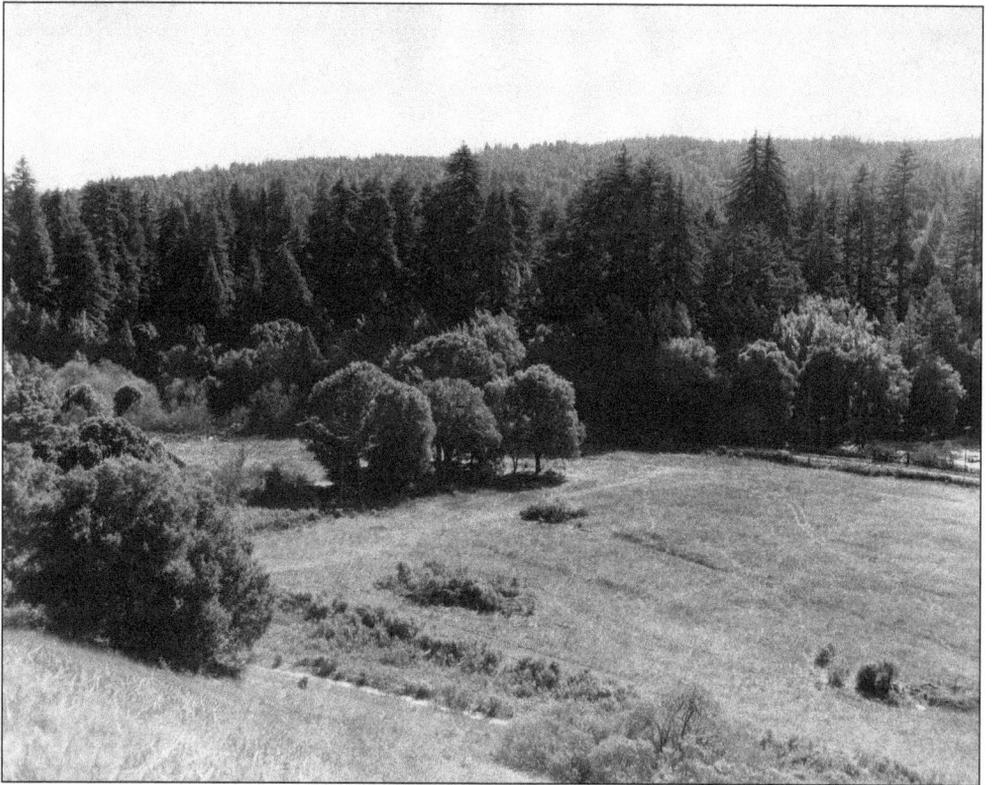

This view looks west at the Big Trees Ranch. The Roaring Camp depot and townsite is now located in the area in the center of this photograph.

yard is on the left. This photograph was taken from the Santa Cruz Lumber Company yard.

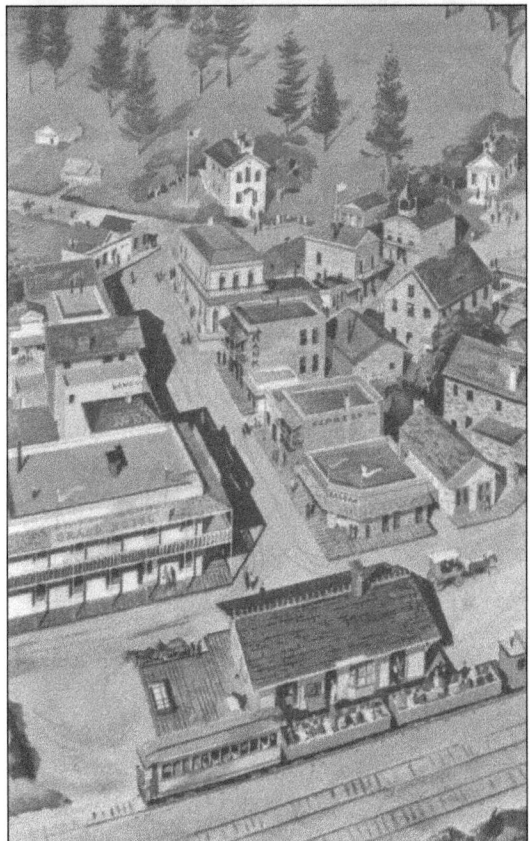

This is an early drawing of the town Norman Clark wanted to build. It was to resemble the period from 1848 to 1888 and would have included a hotel at the top of Bear Mountain, accessible by stagecoach and narrow gauge railroad.

Roaring Camp's first locomotive is seen here as it was found by Norman Clark in 1962 in Dixiana, Virginia. The *Dixiana* was built in 1912 by the Lima Locomotive Works for the Alaculsy Lumber Company, and it worked for several railroads over its lifetime. It has had a longer career at Roaring Camp than for any previous owner. (Courtesy of Gene O'Lague.)

Two

BEGINNINGS

When Norman Clark saw the Big Trees Ranch for the first time, in the late 1950s, it was 180 acres of rolling meadows transitioning into steep redwood-covered hills, bordered on one side by the new Henry Cowell State Park, on another side by Graham Hill Road, and on the third side by the Southern Pacific Railroad line that ran from Santa Cruz to the Lonestar Industries sand plant near Olympia. The property had a house dating back to the Civil War era, horse stables, a barn, and lots of potential.

Clark's vision was to re-create a piece of history that was quickly being destroyed all across the West. Having researched the history of the South Pacific Coast Railroad (SPCRR), Clark envisioned reopening the line and running steam-powered passenger trains to San Jose. In addition to this, he had a dovetailed vision to pay homage to the area's logging heritage. Logging towns were by their nature temporary, and Clark's idea was to build one from the ground up with such attention to detail that visitors would be transported back in time. His original plans included a hotel, a blacksmith's shop, a candy store, and more than 150 buildings in all.

Unfortunately, the Southern Pacific Railroad was not willing to sell the line to Santa Cruz at the time, and Clark's focus turned to his town and its narrow gauge railroad. Using rails that had sailed around Cape Horn in 1881, the 36-inch-gauge track was laid, starting at the SPCRR Felton depot and freight shed, near where Graham Hill Road crosses the Southern Pacific tracks. The narrow gauge tracks headed south, paralleling the Southern Pacific line. Clark discovered what would soon become his first locomotive sitting under a coal tipple at Coal Processing Corporation's railroad in Dixiana, Virginia, and brought it out West. It was a Shay-type geared engine built in 1912 by the Lima Locomotive Works. After its restoration, which was conducted outdoors in front of the freight shed, the No. 1, *Dixiana*, saw alternating duty in passenger service and in a construction train helping to build the railroad. Construction was also started on four wood-frame, open-air passenger cars, using trucks, hardware, and running gear salvaged from the old Southern Pacific narrow gauge, the Denver & Rio Grande Railroad, Westside Lumber Company, and other 36-inch-gauge railroads.

Clark's railroad soon drew the tongue-in-cheek nickname "America's Most Backward Railroad," as it was being constructed using the aesthetics, technology, and equipment of nearly 100 years before.

Norman Clark and employees of the Coal Processing Corporation in Dixiana, Virginia, prepare to load the No. 1 onto a standard gauge flatcar. The machine on the truck trailer to the left is a large air compressor, which was used to pressurize the No. 1's boiler. When all was set, the throttle was opened and the locomotive loaded itself right onto the flatcar. (Courtesy of Gene O'Lague.)

This is another view of the construction of the earthen loading ramp and track that was necessary to load the No. 1 onto the flatcar that would take it to California. Norman Clark is in the center in the black bowler hat. (Courtesy of Gene O'Lague.)

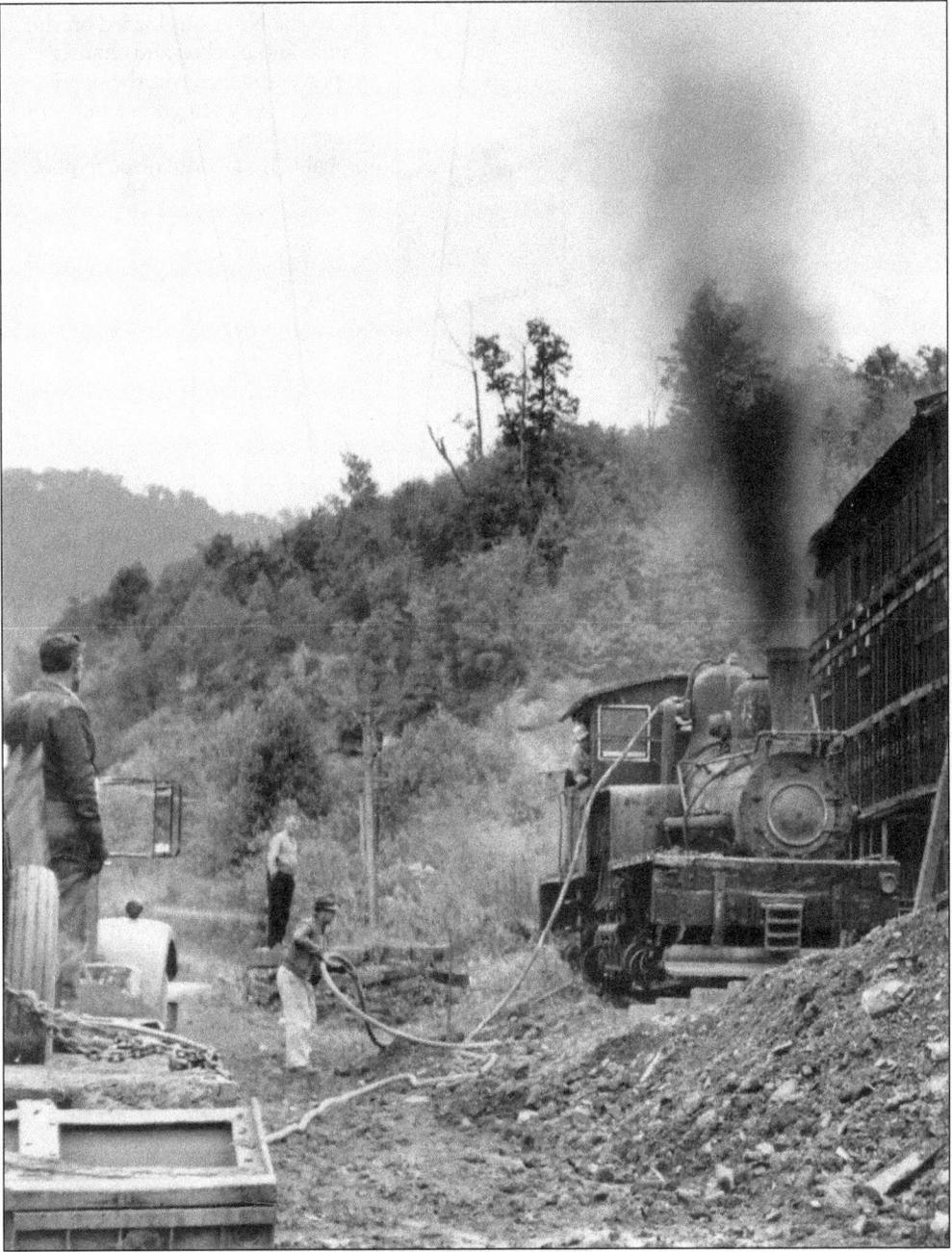

After a thorough oiling, and with the boiler pressurized thanks to a trailer-sized air compressor, a crack of the throttle brought the engine to life. Notice the plume of loose carbon and soot blown out of the stack as the engine rolls right up the ramp and onto the flatcar under air pressure. (Courtesy of Gene O'Lague.)

Once the No. 1 was loaded on the flatcar and blocked and chained to prevent movement, the previous owner's young son takes a moment to say goodbye to what was probably his favorite place to play.

During an afternoon storm in Virginia, Norman Clark and the previous owner stand next to the No. 1 shortly before it is to depart for California with a hand-painted billboard on the side of its tender tank. Clark made sure that any opportunity for publicity was well taken.

This is the last known image of the No. 1 as it was spotted for interchange in Virginia, ready to begin the journey to its new lease on life in California. The Interstate Railroad's Alco RS-3 No. 31 is about to switch out the No. 1's flatcar into a train headed west. (Courtesy of Gene O'Lague.)

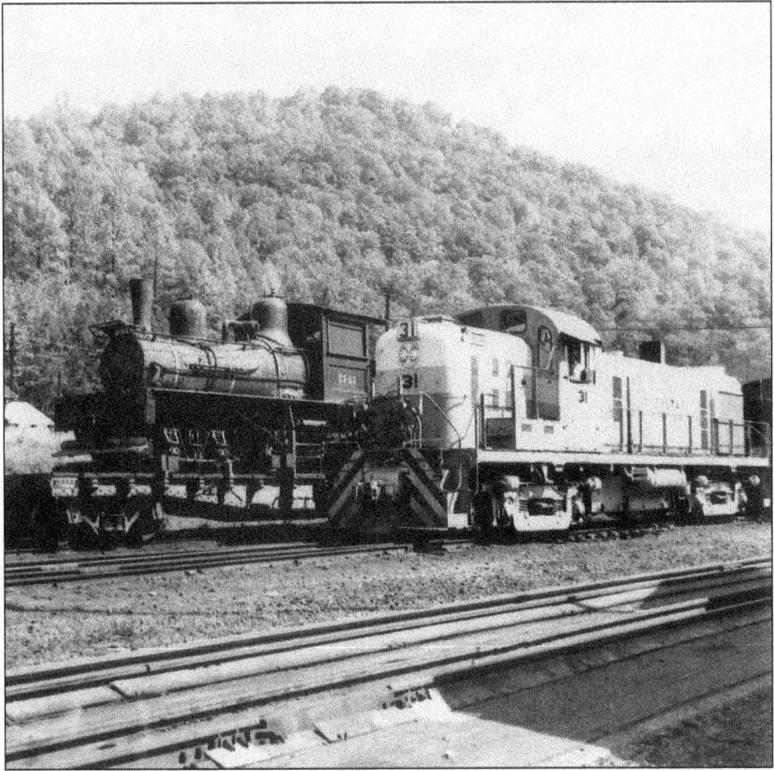

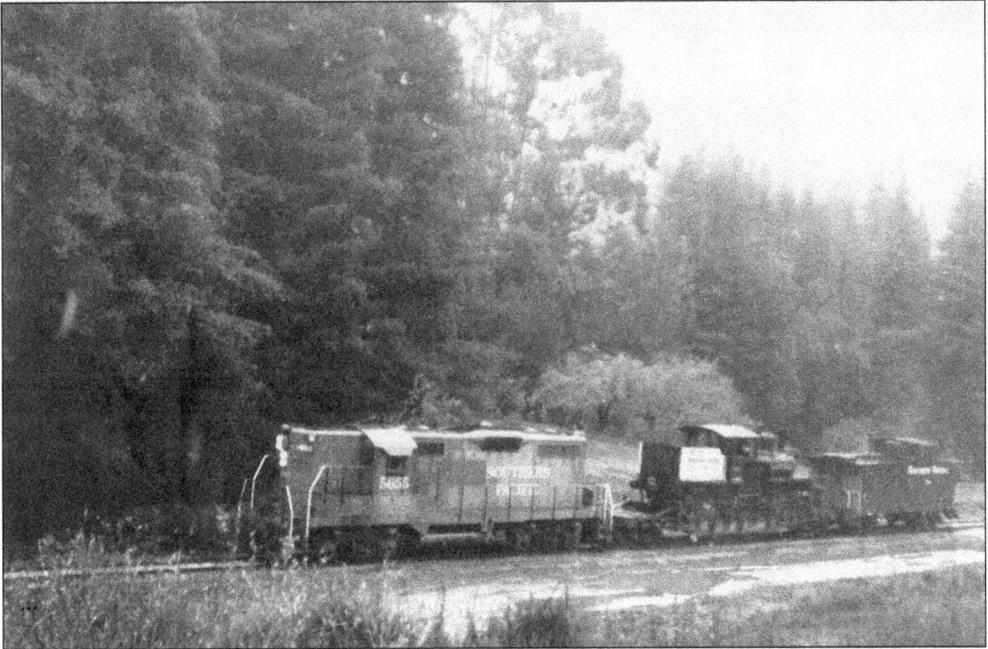

On October 12, 1962, Southern Pacific GP-9 No. 5655, with engineer Gene "Junior" O'Lague at the throttle, brings the No. 1 north through Rincon on a special move to deliver the locomotive to Roaring Camp. The No. 1 arrived there exactly 50 years to the day after it rolled off the shop floor at Lima Locomotive Works.

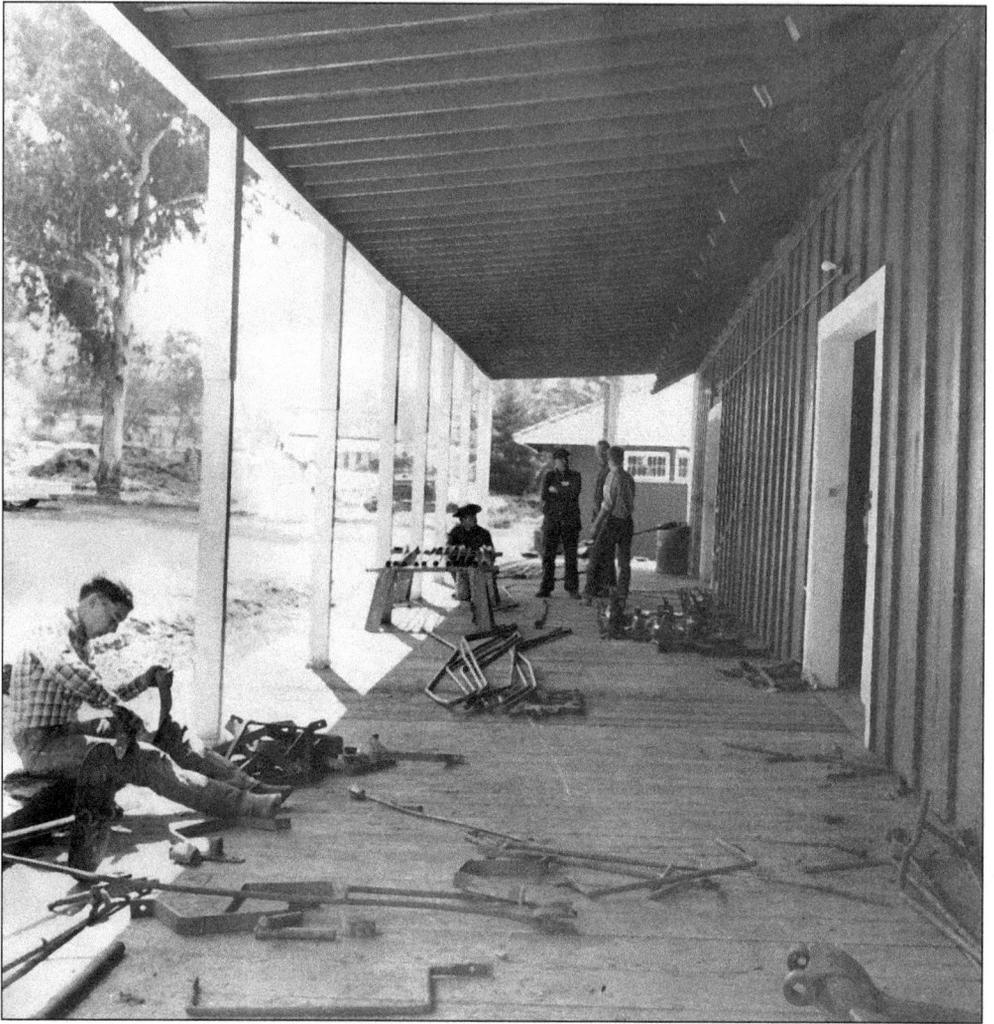

Some of Roaring Camp's first employees sort through brake rigging and other car parts in front of the SPCRR-era freight shed at Felton. These parts were used in the construction of the first passenger cars of the Roaring Camp & Big Trees Narrow Gauge Railroad. (RC&BT).

Norman Clark is seen here salvaging parts from the scrapping of Southern Pacific's narrow gauge freight cars in 1962. Many of the grab irons, couplers, and steps seen missing from this stock car are still in service today, attached to RC&BT passenger cars. (Courtesy of Jeff Badger.)

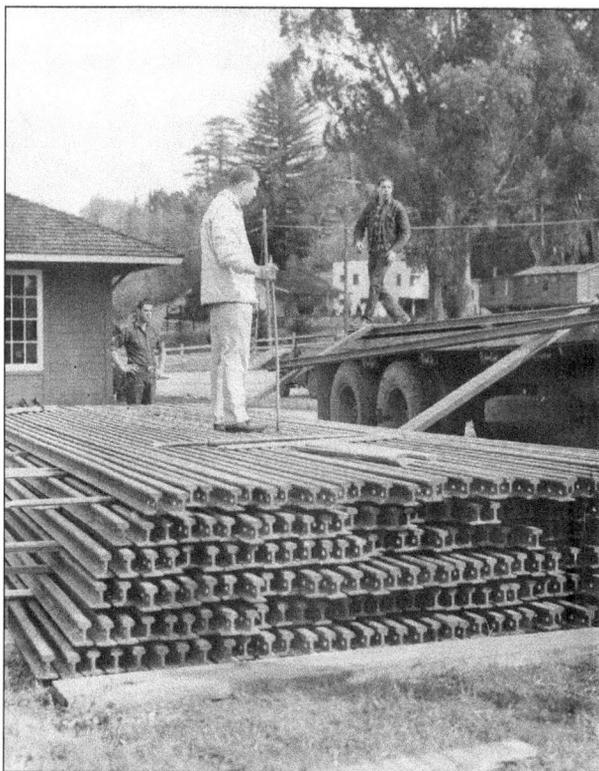

Norman Clark stands on the pile of the first full delivery of 65-pound rail near the old Felton depot. This delivery extended the railroad around the top of the meadow on the Big Trees Ranch and into the forest near Henry Cowell State Park. (Courtesy of Jeff Badger.)

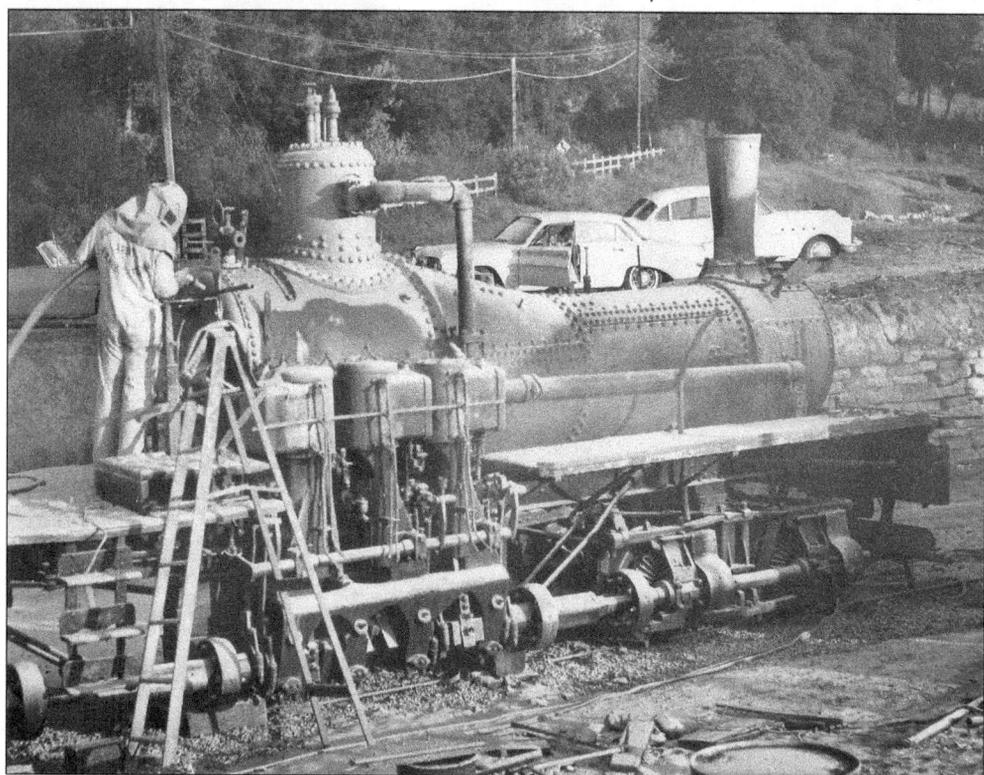

The restoration of the No. 1 is well underway in this photograph, with the cab and boiler jacketing removed and a sandblaster at work. The restoration was carried out in front of the freight shed at Felton. The cars in the background are parked approximately where Roaring Camp's main entrance is today, and beyond them is Graham Hill Road, constructed by Isaac Graham in the 1840s.

Charlie Hoyle is in the fireman's seat of the *Dixie*. Hoyle was Roaring Camp's first "master mechanic" in his spare time, but his day job was hostler of Southern Pacific locomotives at the San Jose and Oakland roundhouses. He was also involved in the restoration of Southern Pacific No. 2467. (Courtesy of Gene O'Lague.)

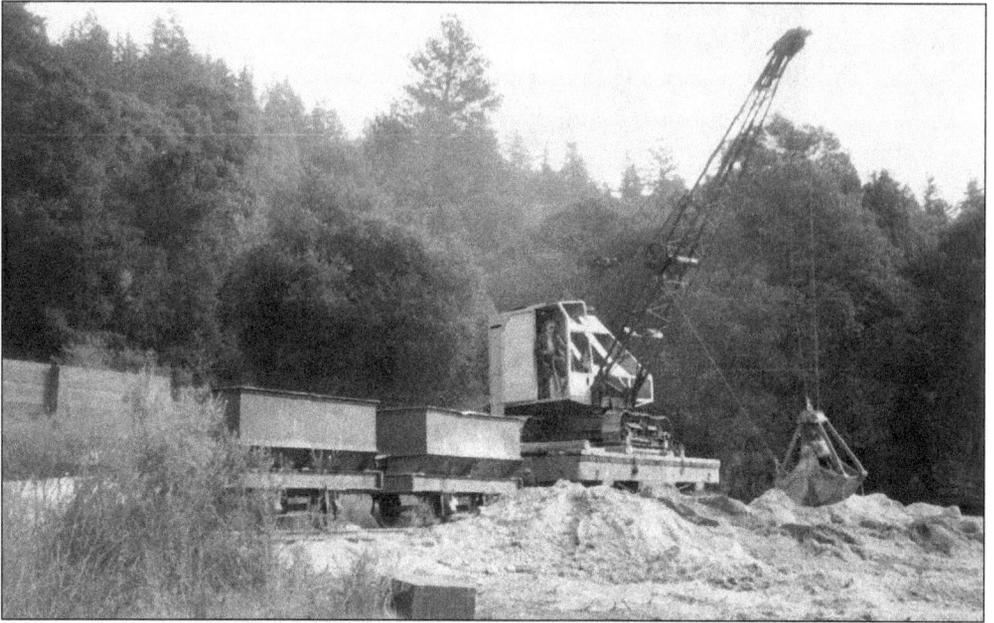

In March 1965, the railroad construction crew was in full swing. The company's old Northwestern crane is seen here sitting on a flatcar obtained from the Westside Lumber Company. It is loading two center-dump cars with ballast to be taken up to the end of the track. The center-dump cars also came from the Westside Lumber Company, and are still in use today at Roaring Camp. (Courtesy of Gene O'Lague.)

The crew from Roaring Camp and the Westside Lumber Company prepares to load a recently purchased Westside caboose in the yard in Tuolumne, California. These cabooses were built at the Westside and saw several years of service at Roaring Camp before the company built its own caboose. (Courtesy of Gene O'Lague.)

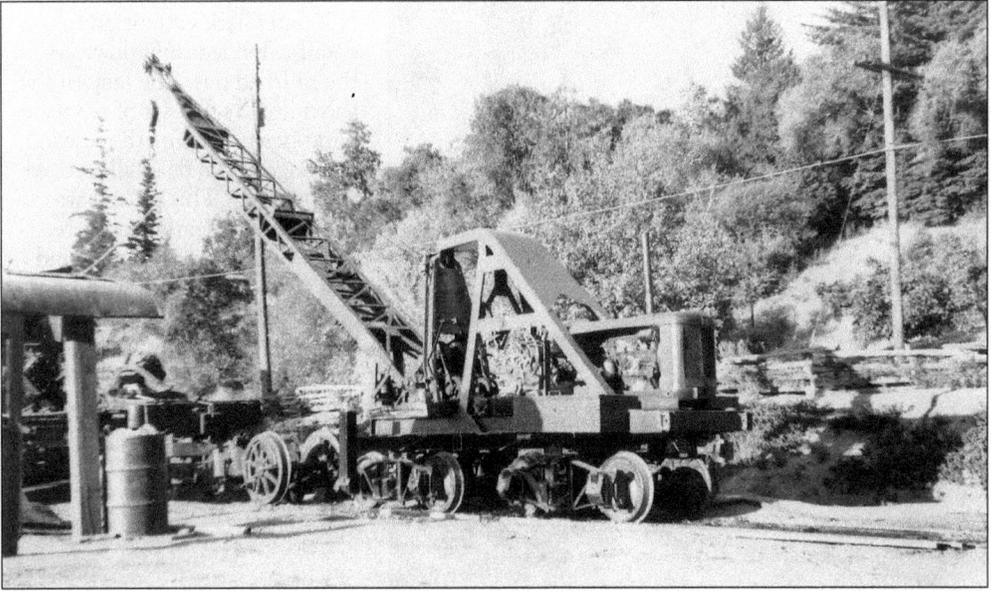

This mechanical oddity seen at the Felton depot was a huge help in the construction of bridges and the restoration of the locomotives. It was converted to move over the railroad at Roaring Camp and was wrecked in an accident while unloading railroad ties from a standard gauge gondola car in the late 1960s. (Courtesy of Gene O'Lague.)

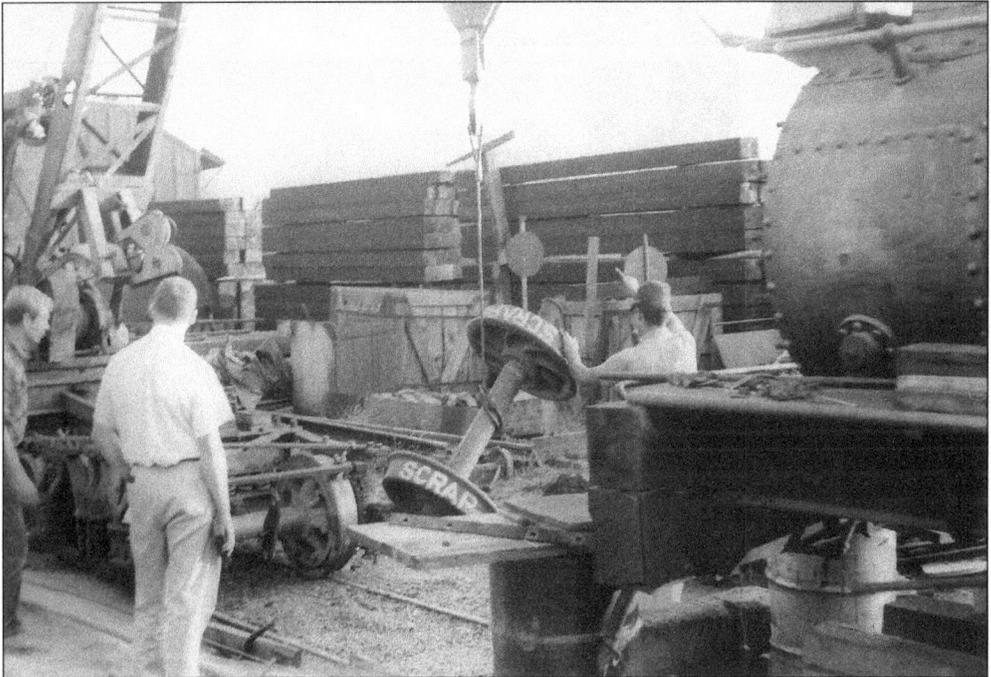

Norman Clark, in the foreground with his back to the camera, looks on as the crane lifts a scrap axle out of the way during work on the No. 1, which is on the right. Directly in front of Clark is one of the No. 1's trucks, which had been pulled out for servicing. Notice the tall stacks of standard gauge railroad ties in the background, likely staged by the Southern Pacific for maintenance work on the line to Santa Cruz. (Courtesy of Gene O'Lague.)

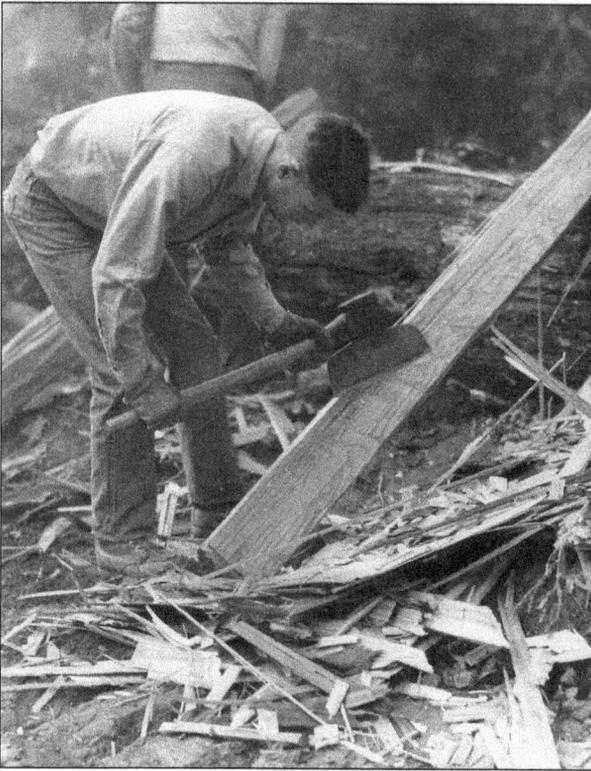

Norman Clark's attention to detail extended right down to the railroad ties. The majority of the railroad's first set of ties were hand-hewn old-growth redwood scavenged from deadfall trees on the property. This process was laborious, as clearly seen here. The ties were set in the ground and spiked to the rail with no tie plates, just as they would have been on a logging line in the 1880s. Today, the railroad has moved on to standard creosoted ties and tie plates, for obvious reasons. (Courtesy of Jeff Badger.)

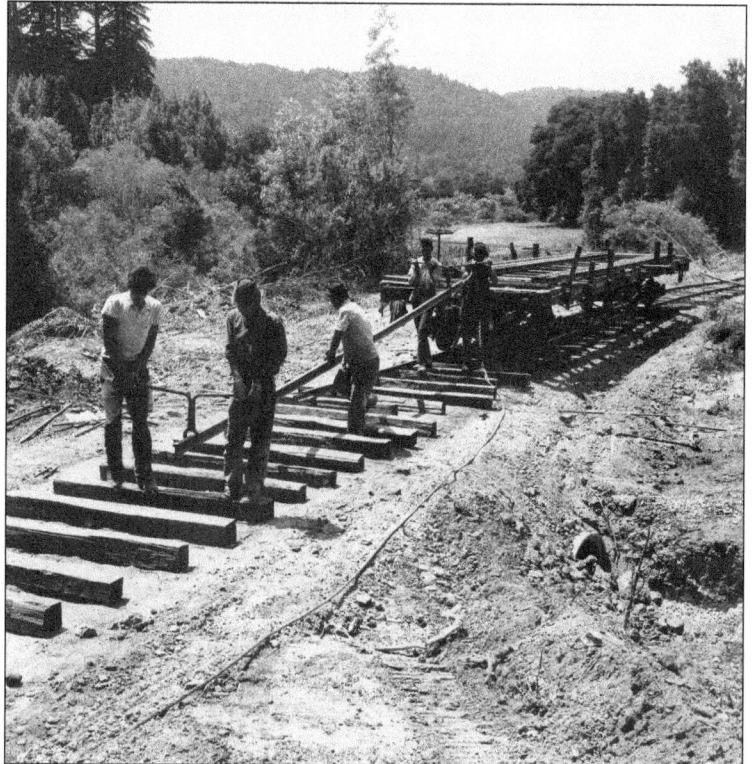

This track gang lays rail across the top of the meadow at the Big Trees Ranch in 1962. As each rail length was pulled off the Westside Lumber Company flatcar and spiked down, a tractor out of view on the left pulled the flatcar forward, and the process was repeated. (Courtesy of Jeff Badger.)

Track construction continued through the Big Trees area with the help of a delivery of rail from Felton courtesy of the No. 1. Notice the hand-split, untreated ties. Roaring Camp's longtime civil engineer Bradley J. Honholt was careful to lay out the grade to miss the trees. (Courtesy of Gene O'Lague.)

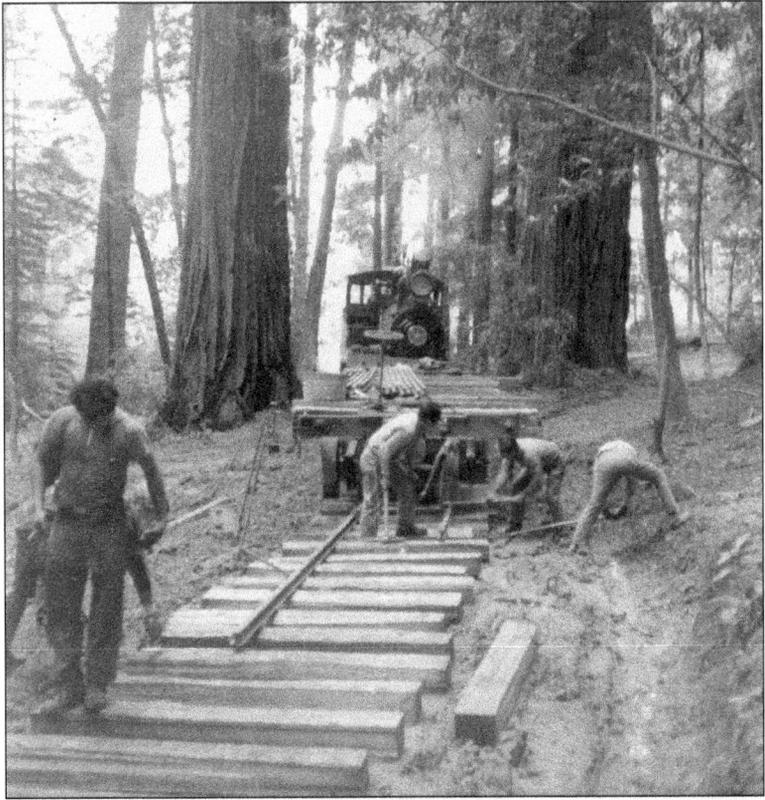

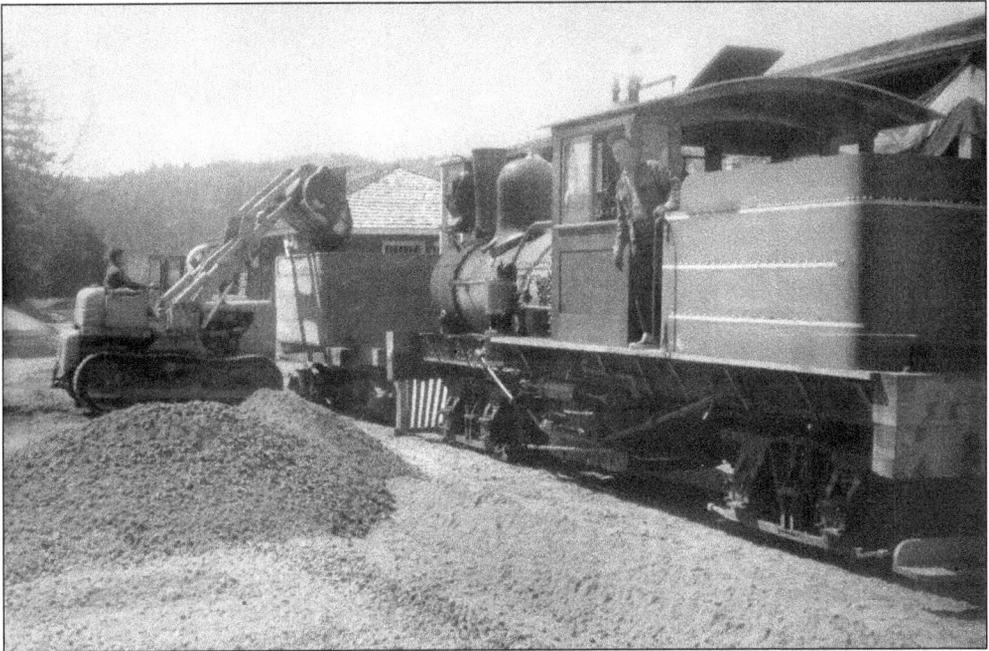

As part of the No. 1's restoration, it received a new tender tank. In classic form, the old tender tank was turned into a homemade ballast car, seen here being loaded with rock by the railroad's Allis-Chalmers tractor at Felton in 1963. (Courtesy of Gene O'Lague.)

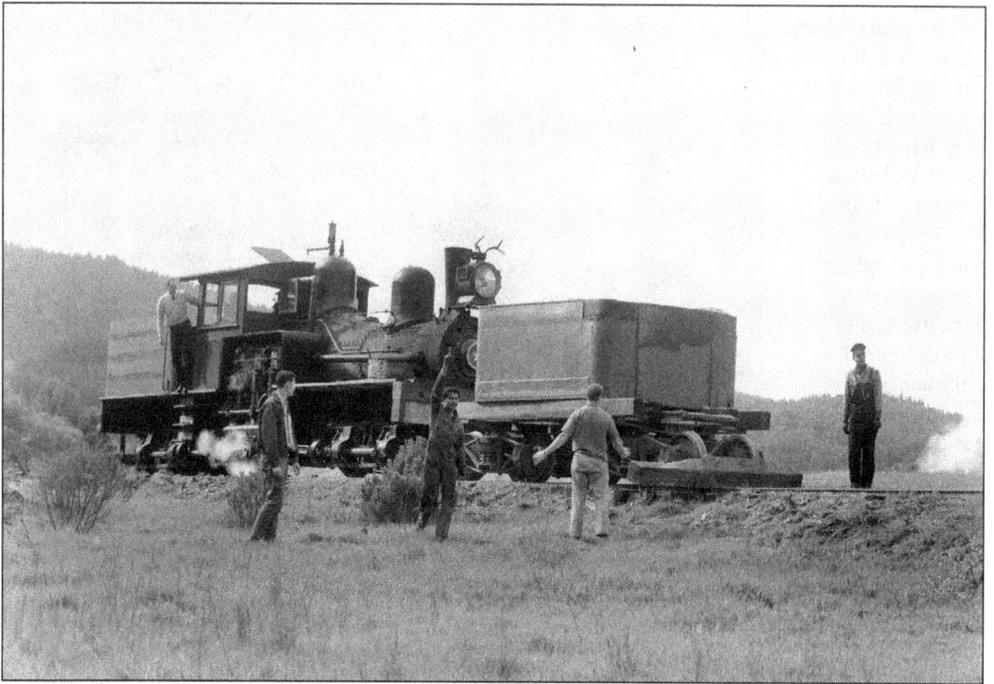

The No. 1 and the homemade ballast car are seen again here, dumping rock along the right-of-way near where the Roaring Camp schoolhouse sits today. Norman Clark runs the locomotive while the track gang looks on. The tie placed in front of the ballast car's wheels was a handy way to spread the gravel. (Courtesy of Gene O'Lague.)

Neil Vodden is seen here at the throttle of the *Dixiana*. Vodden was a railroader for more than 40 years. He retired from the Southern Pacific in 1986 and was involved with the restoration and operation of Southern Pacific locomotive No. 2472 at the Golden Gate Railroad Museum. (Courtesy of Gene O'Lague.)

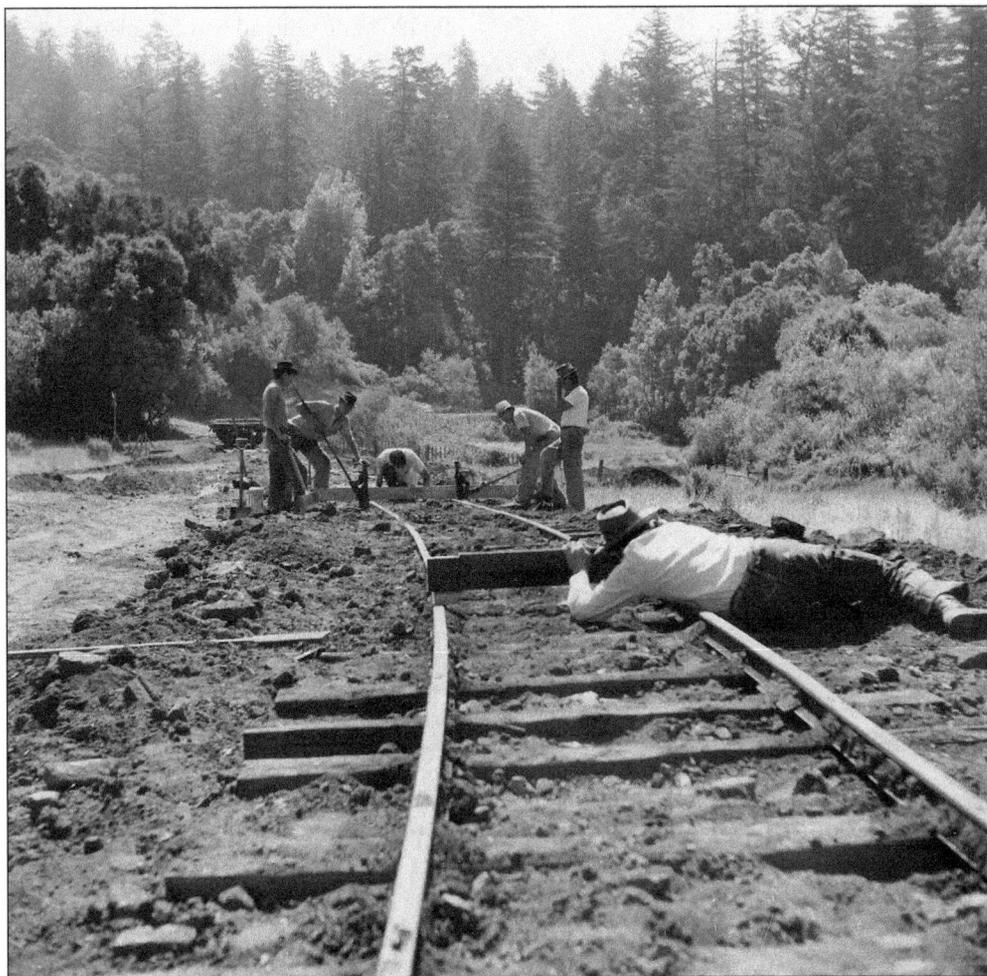

The track gang is seen here hard at work in 1962, tamping and leveling the line across the top of the meadow. The Big Trees grove and the Southern Pacific line to Santa Cruz are beyond them to the south. (Courtesy of Gene O'Lague.)

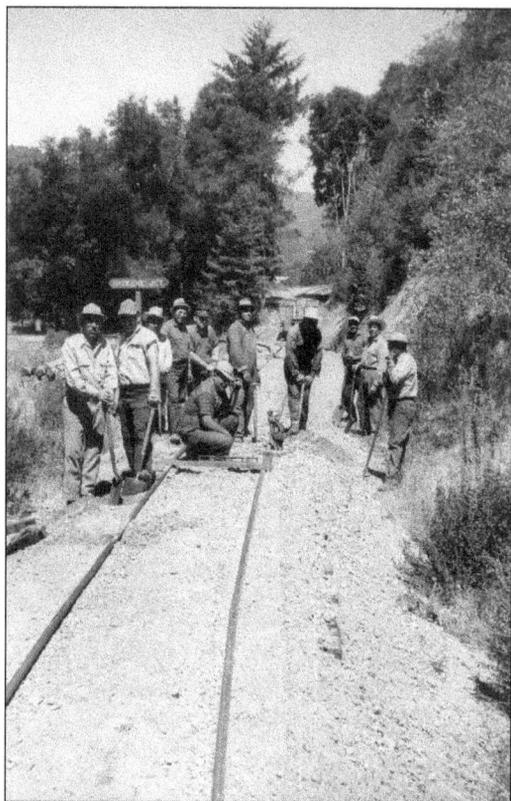

By 1964, the railroad had completed its balloon loop through the meadow and installed the switch at McSkunk Junction. Here, the crew makes the finishing touches on the switch before opening it up for trains.

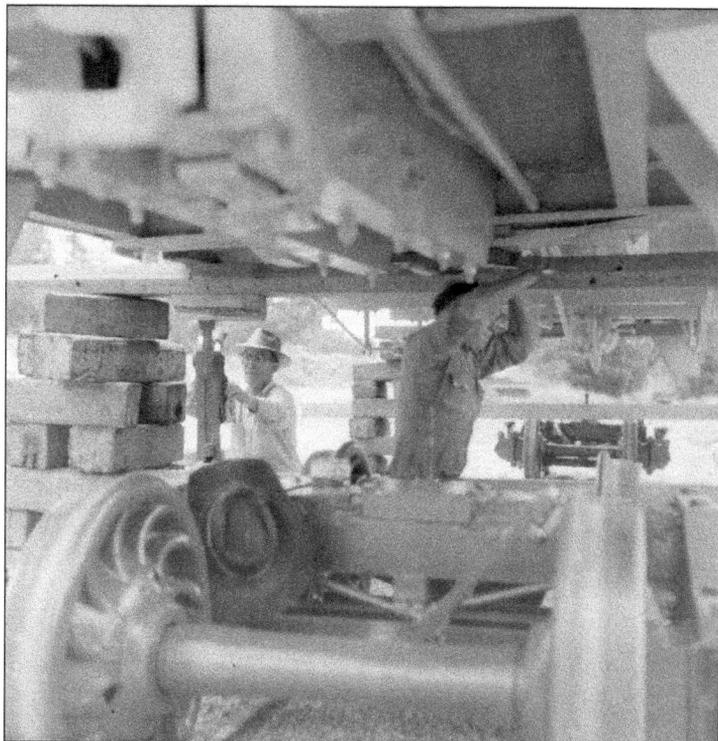

In March 1964, mechanics work on one of the four first-generation wood-framed passenger cars, Nos. 101–104. These cars did not hold up well to the rigors of the railroad and were eventually rebuilt with steel frames. In addition, all cars after No. 104 were constructed new with steel frames. (Courtesy of Gene O'Lague.)

34

Three

America's Most
Backward Railroad

On April 6, 1963, when the Roaring Camp & Big Trees Narrow Gauge Railroad had laid its first half mile of track, the first scheduled revenue train departed the old South Pacific Coast Felton depot with 44 passengers aboard. It was a short trip to the end of the track, through the meadows of the Big Trees Ranch to the future townsite and back. Norman Clark himself ran the locomotive, his great-uncle was the fireman, and his brother was the conductor.

As time passed and more rail was laid, the tracks curved away from the Southern Pacific and looped around the top of the meadow, eventually plunging into the redwood forest in the Big Trees area near where Joseph Welch had constructed his resort many years before. To effectively juggle construction trains and passenger trains, a wye was added where the tracks curved away from the Southern Pacific line, with one leg of the wye continuing parallel to the Southern Pacific line.

Soon, ground was broken on the Roaring Camp depot, directly adjacent to the main parking lot for the Henry Cowell State Park and the Southern Pacific tracks. In its original incarnation, the Roaring Camp depot was a single-room building with the classic bay window and broad eaves reminiscent of depots seen along the South Pacific Coast Railroad route through the mountains. As the railroad has grown, the depot has been expanded twice, to include an office on one side and a waiting platform on the other with a hip gable roof.

Now with two depots, the railroad continued grading through the redwoods, a job aided by the purchase of a second locomotive. Norman Clark acquired the No. 2, also known as *Tuolumne*, from the Westside Lumber Company in Tuolumne, California. The No. 2, a Heisler locomotive built in 1899, was another example of a type of geared engine used frequently on logging lines. The Westside had used this engine as a standard gauge switch engine around the mill site, but had included its original 36-inch-gauge trucks with the sale. The No. 2 was the last steam engine in service at the Westside Lumber Company. Upon its arrival at Roaring Camp, all that was necessary was to jack it up and change out the trucks before it could be run on the line. With the No. 1 in passenger service, the No. 2 was pressed into construction service. Soon, rail had been laid through Big Trees and construction had begun on the first of three wooden trestles that would carry the line to Bear Mountain.

Seen here is the beginning of one of the second-generation open passenger cars, Nos. 104–111, which were built with a steel channel frame and wood floors and body. This design held up much better on the extremely steep grades and tight curves the railroad is known for.

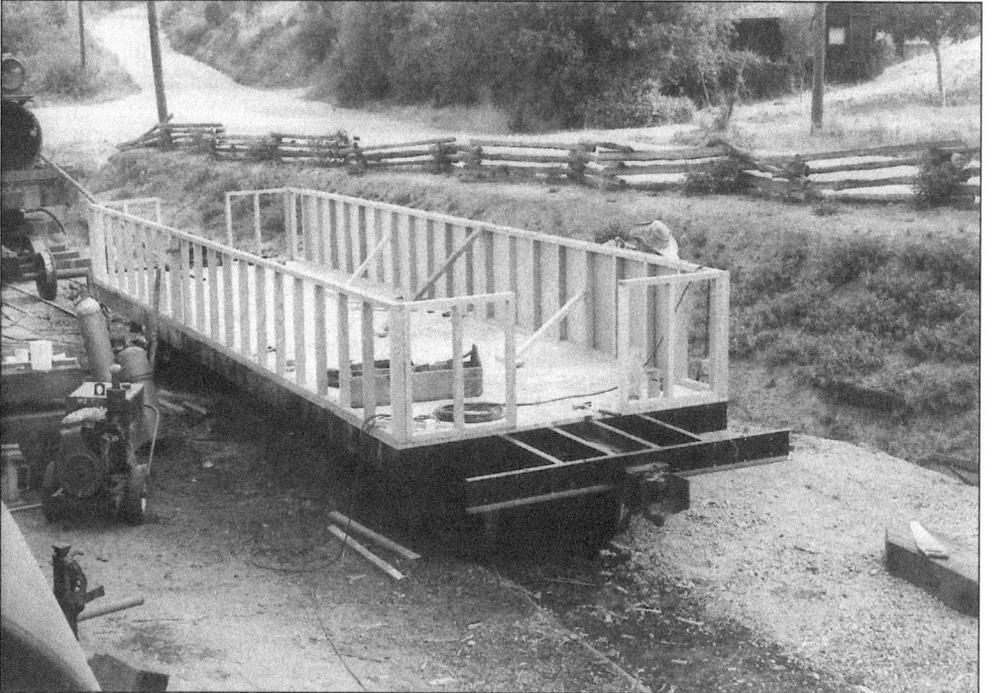

Here, the carpenters have been hard at work near the end of track, and the floor and wall framing is complete on one of the steel-framed cars. In the extreme left background, the No. 1 is seen undergoing restoration work.

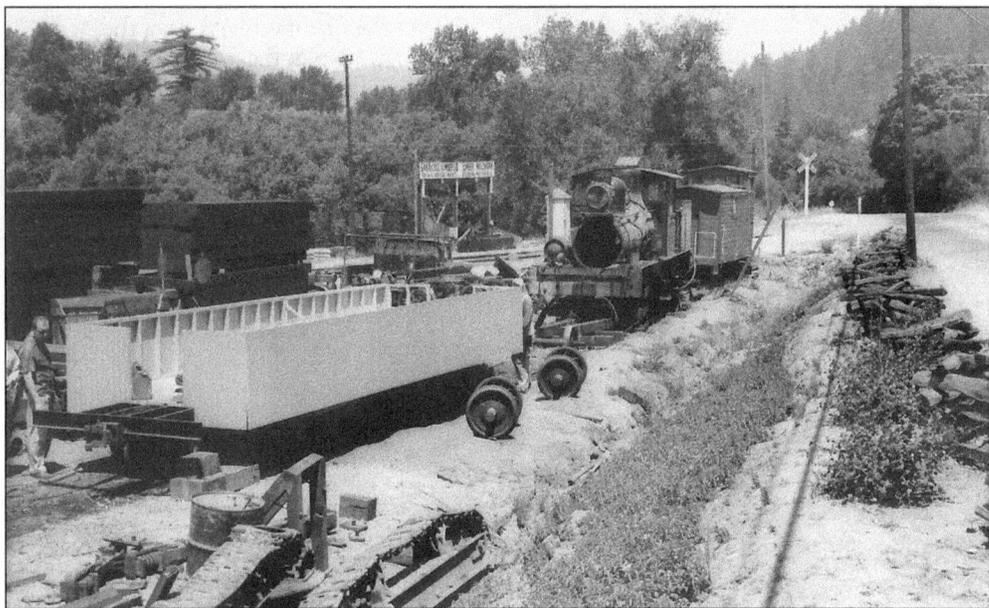

Here, just a few days after the photograph on the previous page, more progress has been made on car construction, with the wooden tongue-and-groove siding installed. This photograph also shows a great view of the maintenance area near the end of track at the Felton depot. Behind the No. 1 is a Westside Lumber Company caboose and the Southern Pacific's grade crossing of Graham Hill Road.

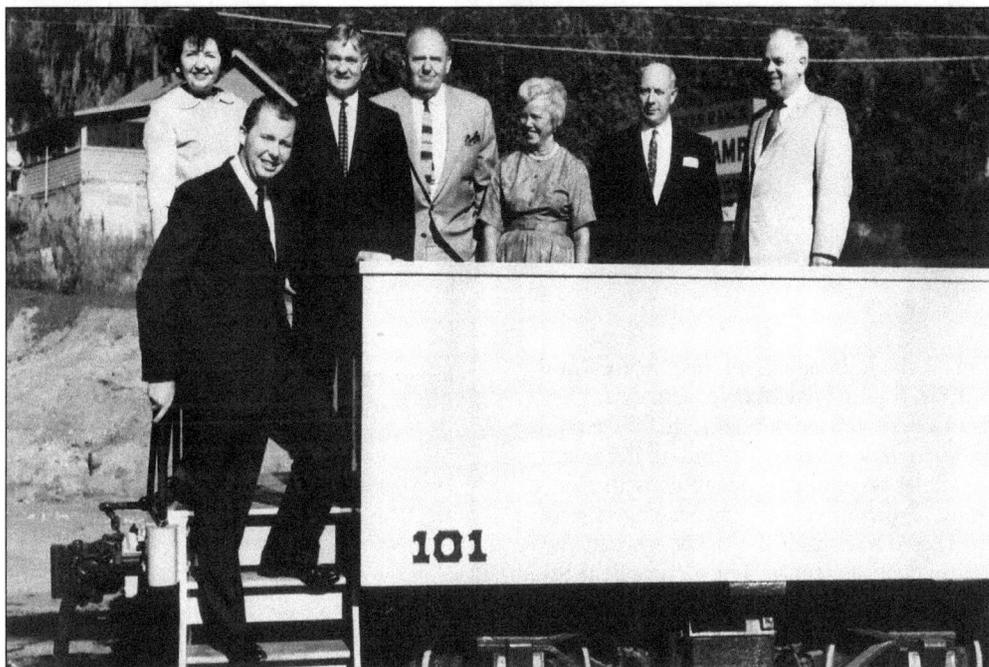

Norman Clark (left, standing on the stairs) and several of the railroad's first shareholders pose for the camera on a beautiful Felton day. Car No. 101 was the first car constructed and is brand-new in this photograph. The car bodies were all constructed by a friend of Clark's, Harry A. Pulaski of Irwindale, California.

One of the first revenue runs of the Roaring Camp & Big Trees Narrow Gauge Railroad is seen here. The cars were handled ahead of the engine in those days, with the locomotive shoving the cars out of the Felton depot and up to the end of track. Trains would pause there, to allow passengers to inspect the construction and see how far along the work crews were, before returning to Felton.

This is the railroad's first schedule, for April 6, 1963, the first day of revenue trains. Trains departed every hour from 9:00 a.m. to 5:00 p.m. on weekends, and on irregular schedules on weekdays due to construction trains. Prospective weekday passengers were instructed to consult the ticket agent at the Felton depot for times. The Grizzly Bear Route herald in the bottom left corner was the line's original. The story goes that Clark had the artist redraw the bear many, many times. Eventually, in exasperation, the artist tried to make the bear a likeness of Clark himself. Without knowing this, Clark loved it, and it has since been known as Norman the Bear.

Karl Koenig keeps a steady hand on the throttle and a watchful eye out of the window of the No. 2. Karl was a member of the Pacific Locomotive Association and the general manager of Roaring Camp before moving to North Carolina to run a tourist railroad there. (Courtesy of Gene O'Lague.)

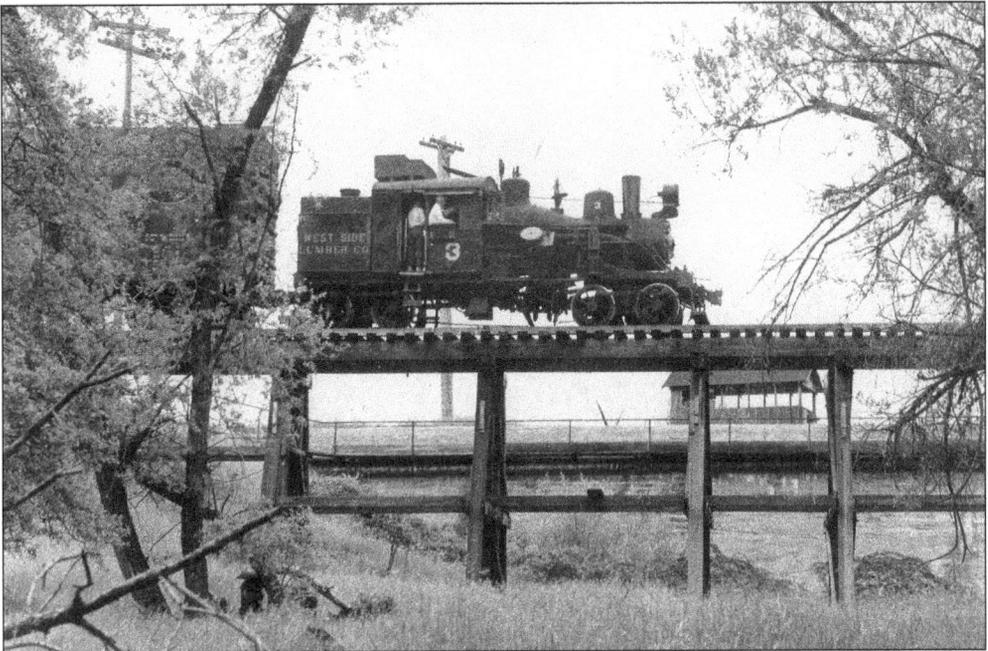

Standard gauge Heisler Locomotive No. 3 is seen here at the Westside Lumber Company in September 1961. This engine was built in 1899 by the Stearns Manufacturing Company as 36-inch gauge. Eventually, it was standard-gauged and used as the mill switcher at Tuolumne. It eventually became Roaring Camp's No. 2 after being re-gauged again back to 36 inches in 1963. (Courtesy of Gene O'Lague.)

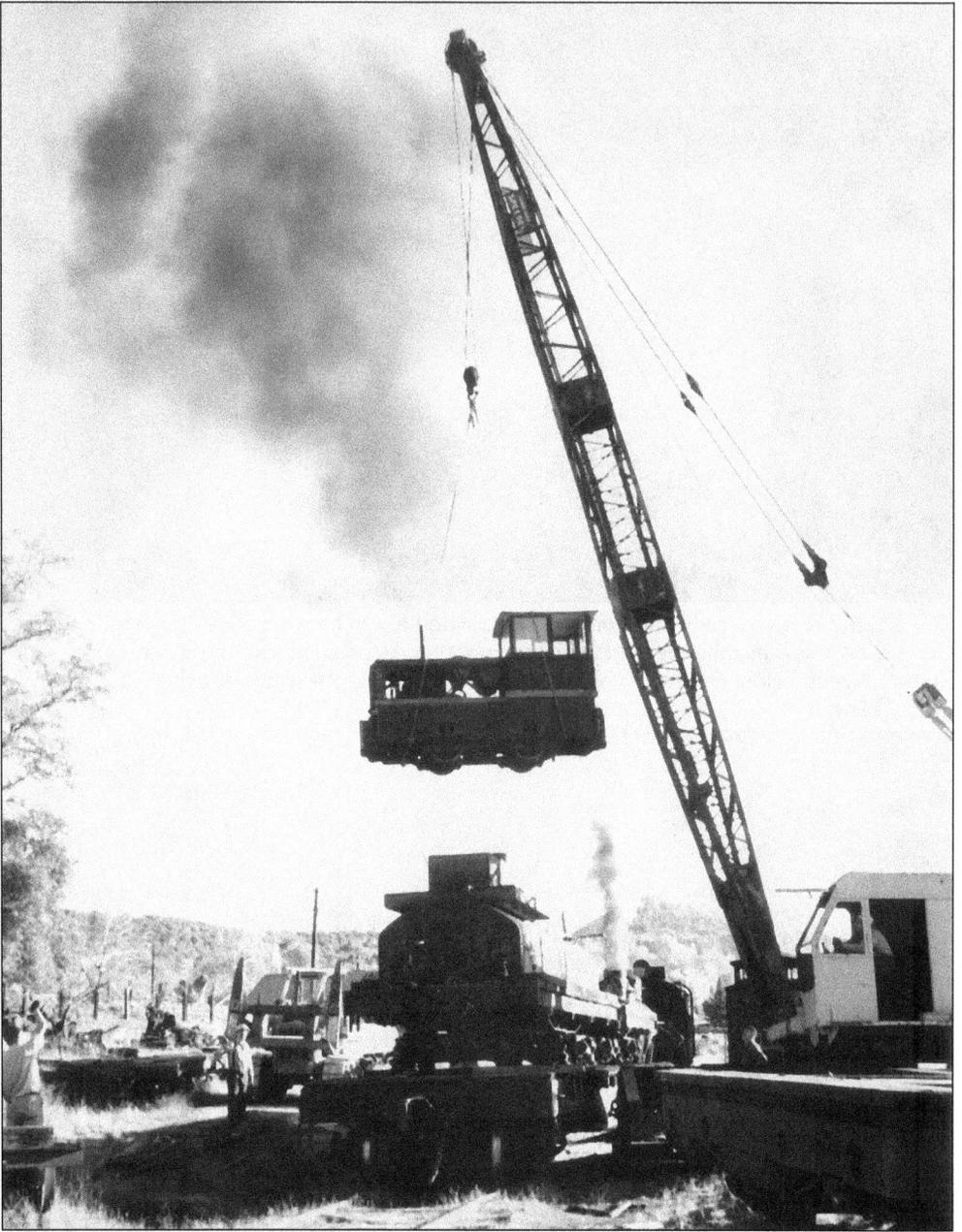

Here, in 1963, the Westside Lumber Company's crane loads a standard gauge flatcar with narrow gauge equipment bound for Roaring Camp. In the foreground is one of Westside's coffin tanks, and dangling from the crane is a 1919 Milwaukee gas engine, which was destined to become Roaring Camp's first internal combustion locomotive. The Westside's Heisler No. 3 is in the background, waiting to switch out the flatcar once it is loaded. By December 1963, the Heisler was at Roaring Camp as well. (Courtesy of Jeff Badger.)

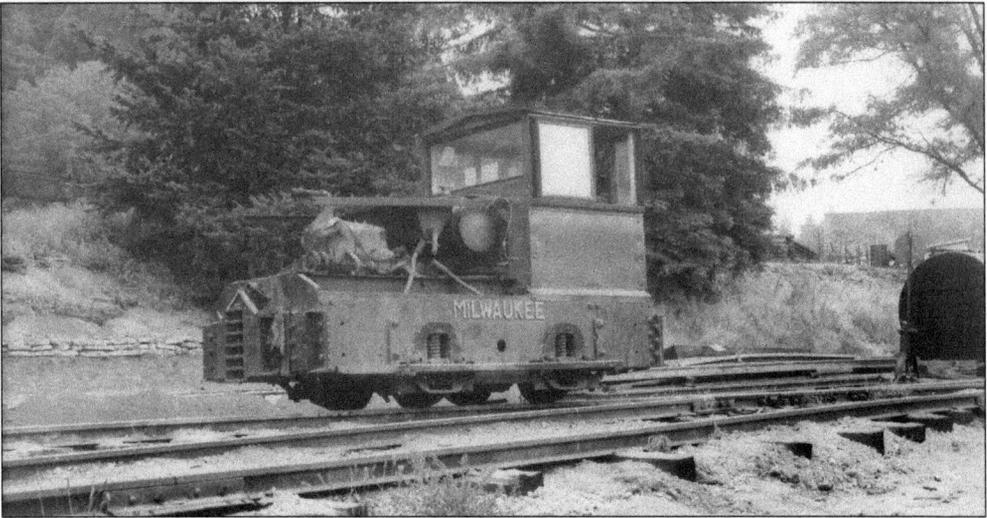

The *Milwaukee*, also known as No. 10, or "critter," arrived at Roaring Camp in 1963, when this photograph was taken by Gene O'Lague. It has since been repowered with a two-cylinder diesel engine, the cab has been removed, and bench seats have been installed along both sides of the frame. It is used occasionally on particularly slow days in the winter, and has a capacity of about 10 passengers. (Courtesy of Gene O'Lague.)

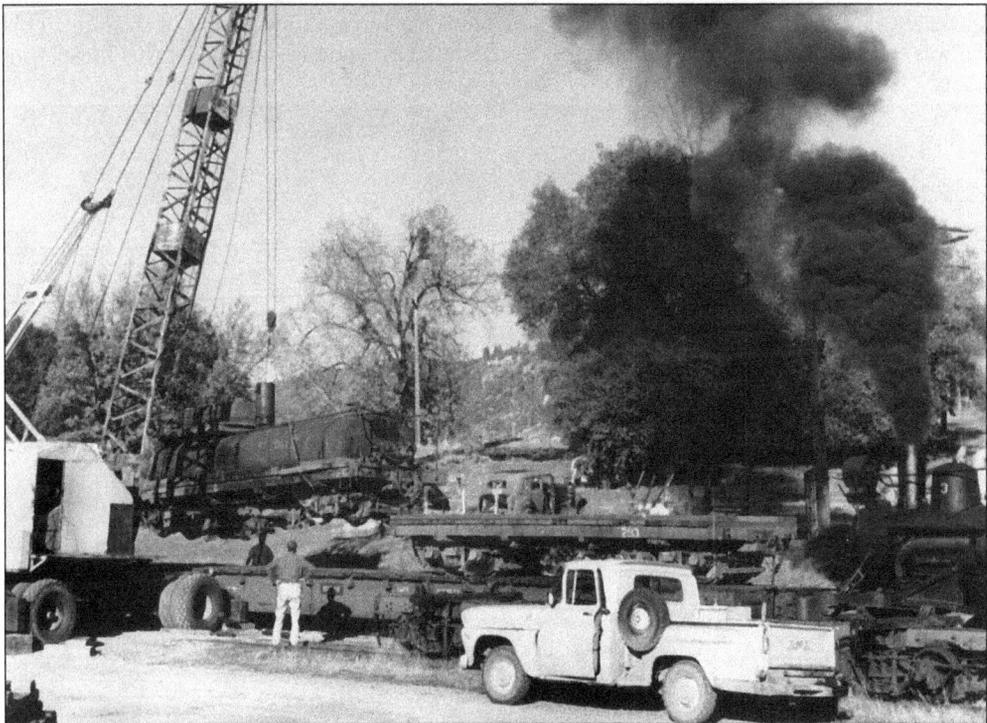

This dramatic shot from the Westside Lumber Company yard in Tuolumne shows the coffin tank and a Westside flatcar about to be chained down and sent off to the Sierra Railroad, interchanged with the Southern Pacific, and then brought to Felton. The photographer was Gene O'Lague, who was running the Southern Pacific locomotive that brought this flatcar and its load up from Santa Cruz. (Courtesy of Gene O'Lague.)

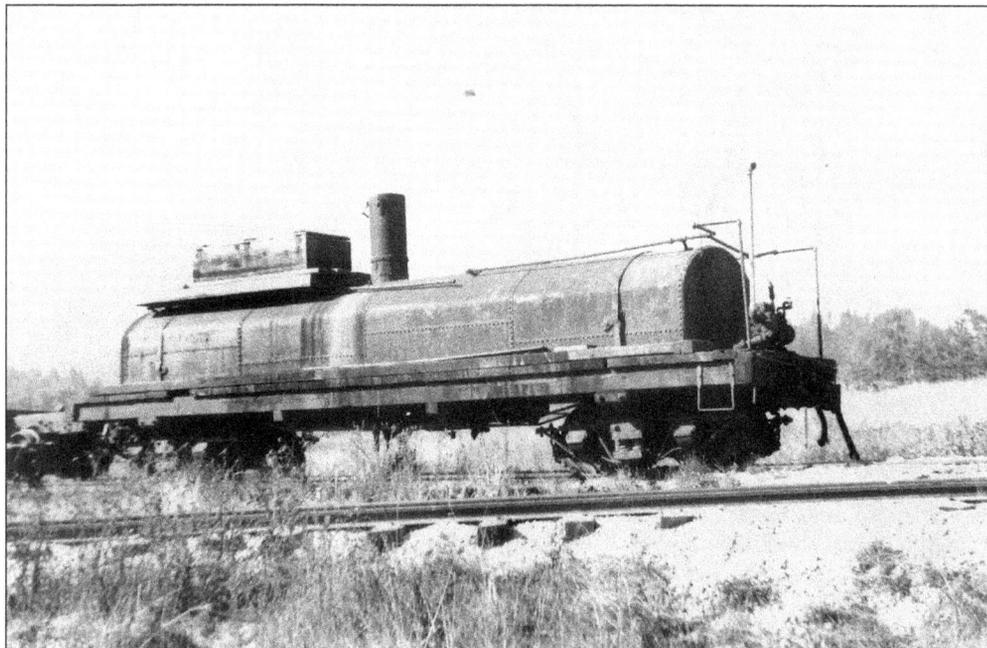

This close-up of the Westside Lumber Company coffin tank after its arrival at Roaring Camp shows the duplex steam pump on one end, which was used to pump water out of the tank. This car was eventually traded to the Sumpter Valley Railroad in exchange for a boiler that fit Roaring Camp's Climax locomotive. (Courtesy of Gene O'Lague.)

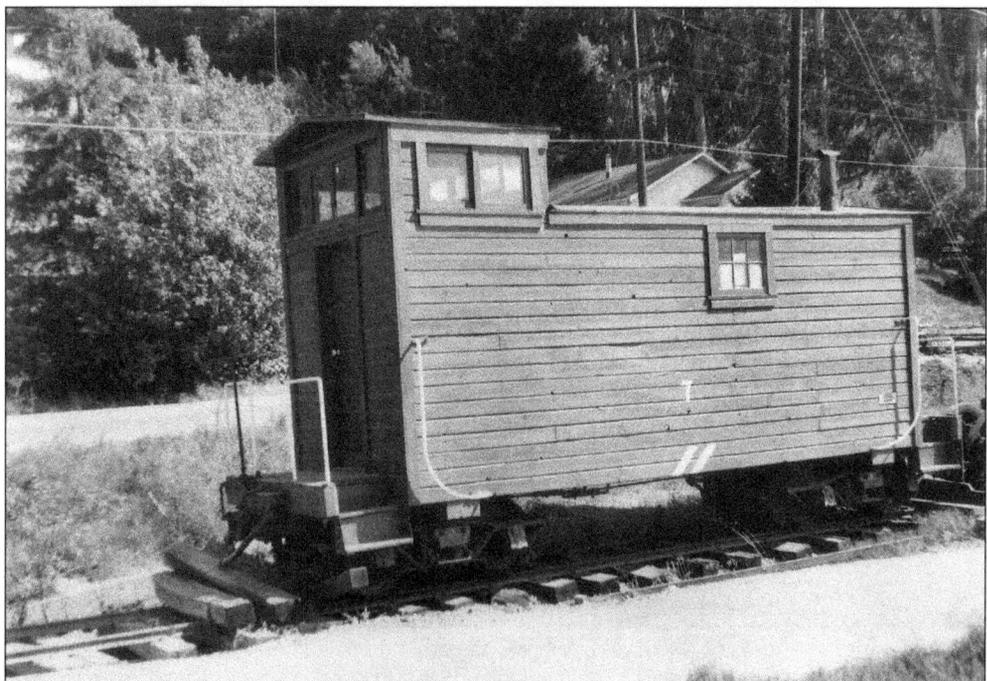

Seen here is Roaring Camp's Westside caboose No. 7. These bare-bones cabooses were home built by Westside to bring up the rear of their long trains of sugar pine logs. (Courtesy of Gene O'Lague.)

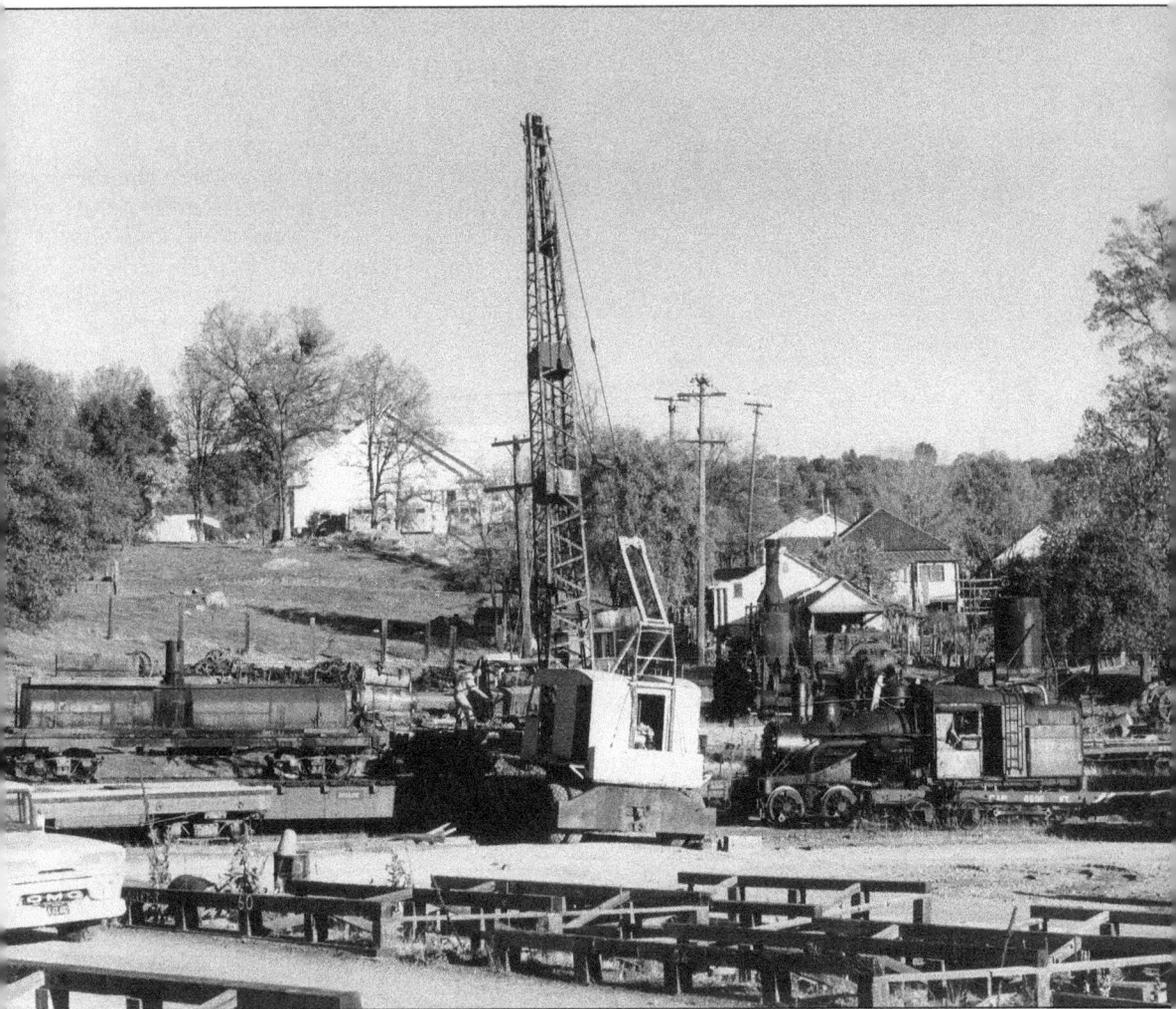

In this view of the Westside Lumber Company yard, the coffin tank and the narrow gauge flatcar are both loaded on a standard gauge flatcar. The *Milwaukee* gas engine is being positioned on top of the narrow gauge flatcar, just moments before the Heisler No. 3 will switch out the car into a train headed to Felton. Notice the remains of the two steam donkeys behind the Heisler. (Courtesy of Gene O'Lague.)

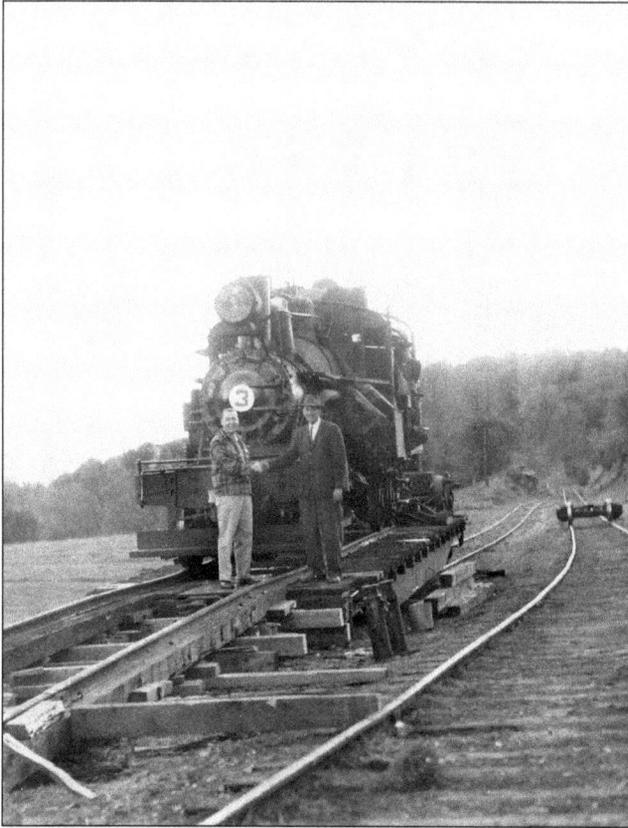

In 1963, after opening Roaring Camp to the general public, Norman Clark visited Tuolumne again to assist with the loading of his latest acquisition, Westside Lumber Company's standard gauge Heisler locomotive No. 3. Behind the locomotive on the flatcar is a set of 36-inch-gauge trucks that came with the sale. (Courtesy of Gene O'Lague.)

This rare shot shows Roaring Camp's own standard gauge tank car, which was used for a few years to deliver fuel oil to the railroad. Seen behind it on three-rail track are the recently arrived, still standard gauge Heisler No. 3, as well as a couple of Westside flatcars at the end of the track. (Courtesy of Gene O'Lague.)

While many of Roaring Camp's passenger cars were constructed on the property, this caboose was built by Harry A. Pulaski at his shops in Irwindale and trucked to Felton. The cupola was removed for transportation, due to height restrictions. Here, the crew gets the brand-new caboose ready to lower onto its trucks. (Courtesy of Gene O'Lague.)

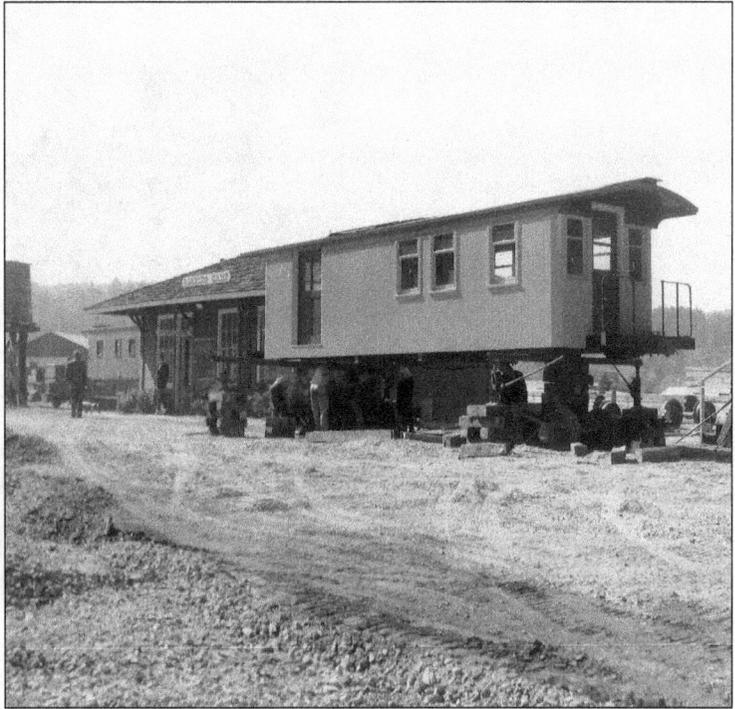

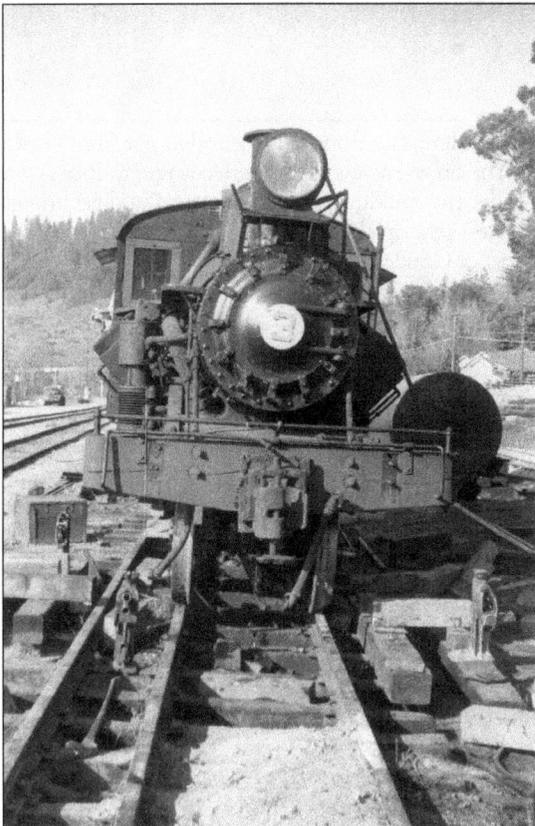

This photograph was taken by Gene "Junior" O'Lague after he worked all night converting Westside Lumber Company's Heisler No. 3 back to 36-inch gauge. On the left is the Southern Pacific Felton yard, and on the right is the narrow gauge. There was a stub switch on the narrow gauge near the Felton depot that brought 36-inch-gauge rail out into a standard gauge spur that came from the south end of the Southern Pacific yard. This way, the Heisler could be unloaded onto the standard gauge spur, jacked up and converted, and then rolled back toward the depot and onto the narrow gauge line. (Courtesy of Gene O'Lague.)

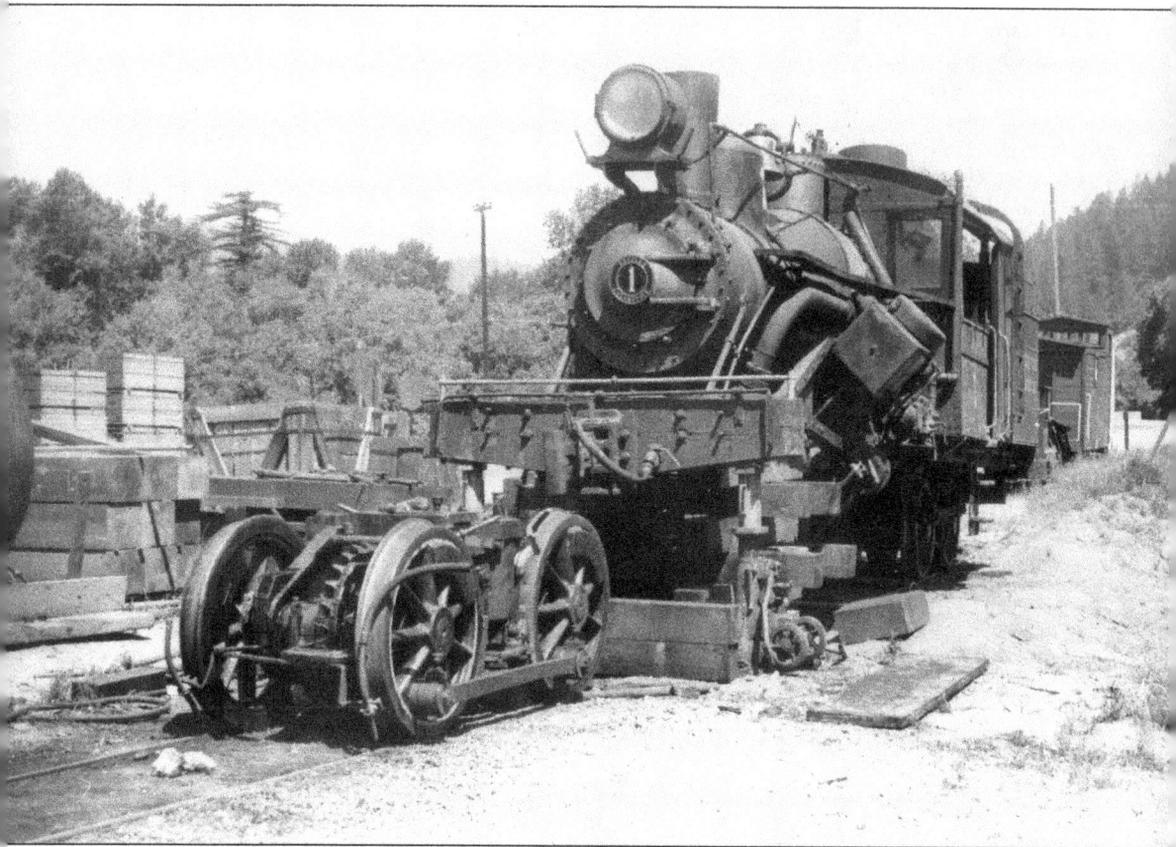

By 1965, the Heisler No. 3 was due for some work. Here, the front truck is rolled out from under the engine by the freight shed in Felton. Unlike the Shays, when a Heisler needs repair, things get difficult quickly. All the parts are tucked up under the middle of the locomotive, and getting at them is a dirty and tricky job. Notice the large ring gear on the first axle, which transfers power from the central line shaft to the axle. (Courtesy of Gene O'Lague.)

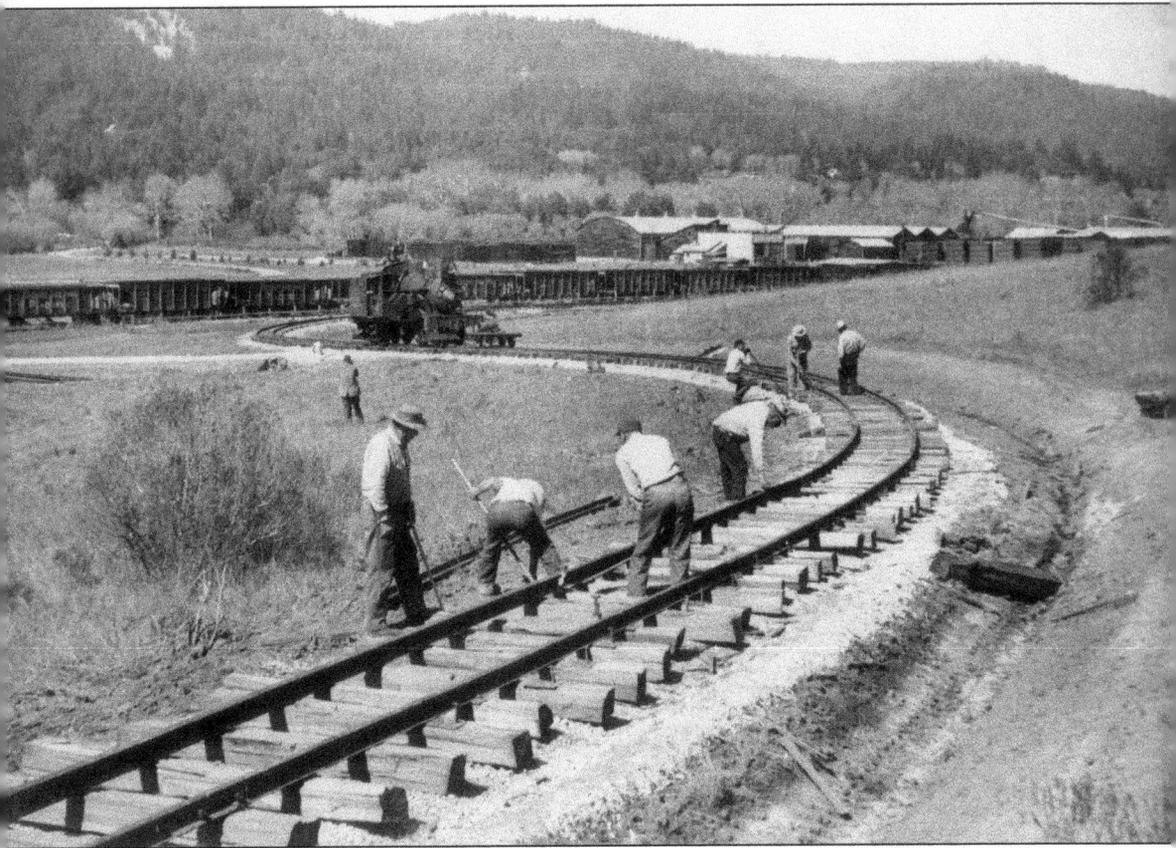

This curve, known as Schoolhouse Curve, is at the east end of the wye at Roaring Camp. Here, the grading of the south leg of the wye has commenced and the track crew is almost ready for ballast, but no rail has been laid. Behind the Heisler, many Southern Pacific sand hopper cars wait to head up to Olympia to the Lonestar Industries sand plant. Behind them is the Santa Cruz Lumber Company, which is now a ProBuild lumberyard. All of the buildings seen here still stand.

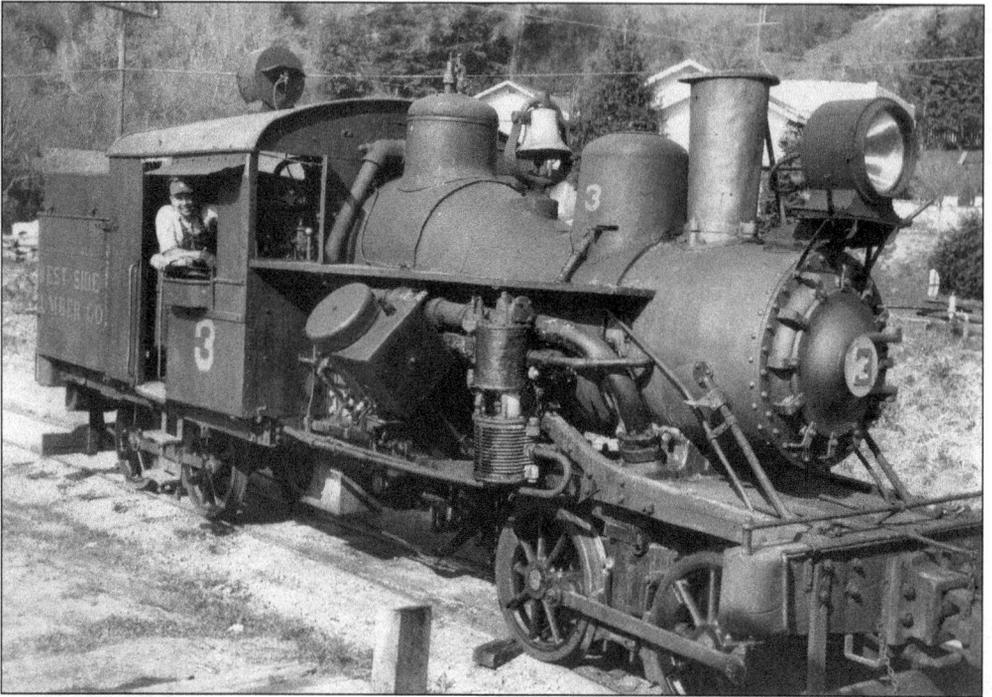

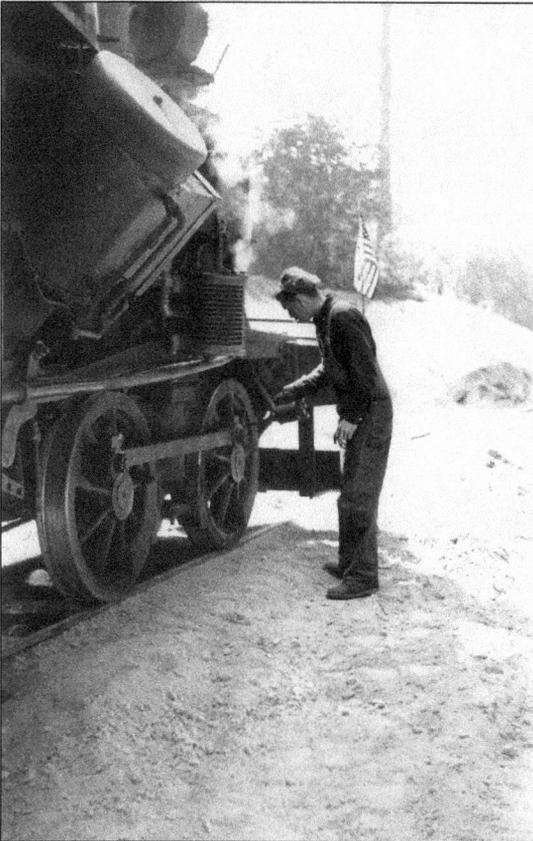

Southern Pacific engineer and longtime Roaring Camp employee Gene "Junior" O'Lague is pictured above at the throttle of the newly narrow-gauged Westside No. 3. Junior had been running and firing locomotives on the Santa Cruz and Felton branches of the Southern Pacific since the 1940s. At left, L.A. "Smokey" McGuire tends to the needs of the Heisler. Smokey later went to work as a brakeman on the Southern Pacific, and still later was promoted to locomotive engineer working out of Dunsmuir, California. (Both, courtesy of Gene O'Lague.)

Norman Clark speaks to the crowd at the dedication of Roaring Camp's new covered bridge on October 26, 1969. This bridge formed the "portal" through which visitors to Roaring Camp went back in time to the 1880s. It was designed in 1884 by Thomas Willis Pratt, and in 1969, when it was built, it was the first Pratt truss bridge built since 1896. At just 36 feet long, it holds the distinction of being one of the shortest covered bridges in the country. It underwent an extensive restoration in 2011. (Courtesy of Jeff Badger.)

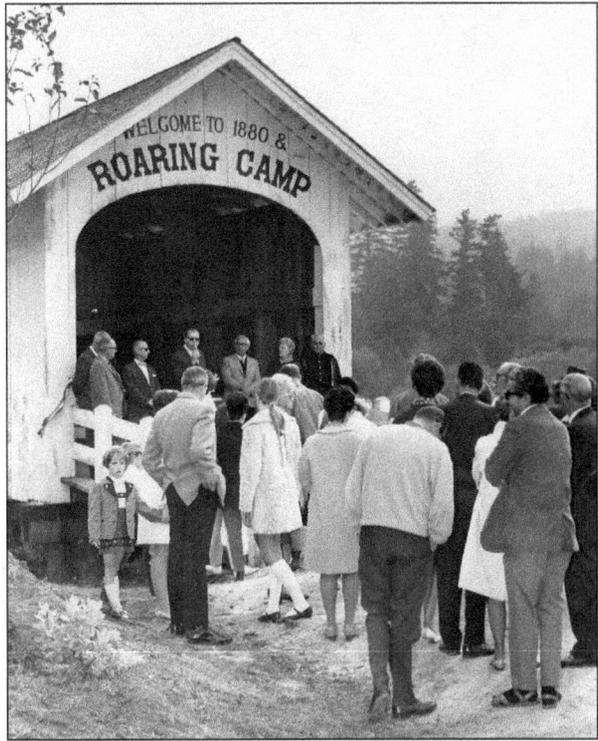

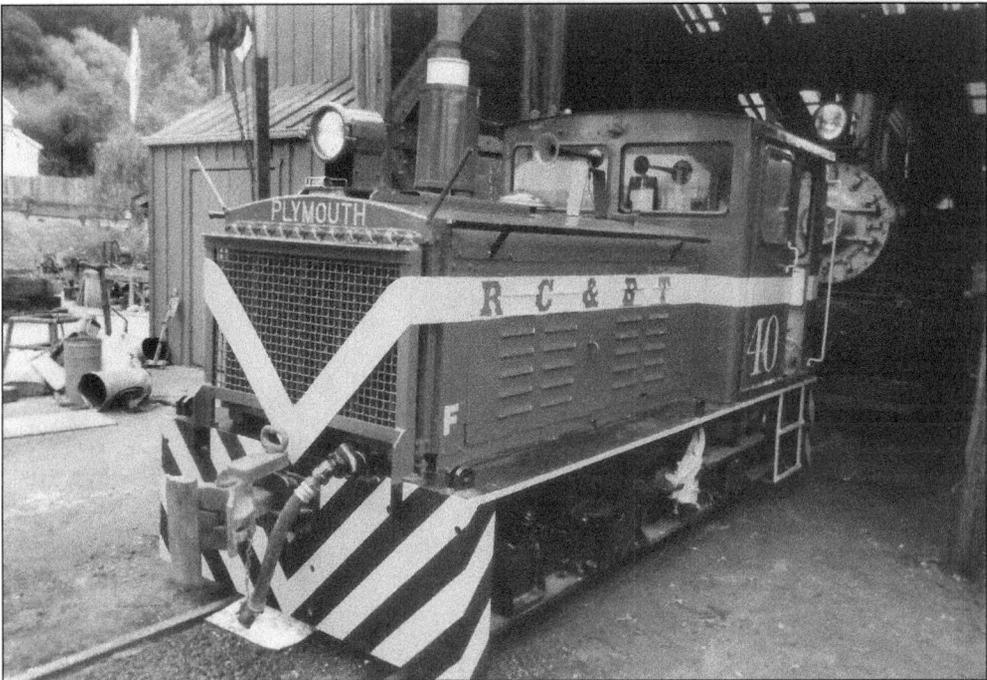

This is the No. 40, a Plymouth diesel-mechanical switch engine purchased in 1978 from Kaiser Steel in Fontana, California. It weighs 12 tons and has a Detroit 471 engine. It is used extensively on the railroad today, moving steam engines in and out of the shops and performing passenger service up the mountain on winter days. (Courtesy of Jeff Badger.)

Pictured at left is conductor Mac McJunkin. Below, in a scene directly out of a logging camp, the No. 1 is being used as motive power to relocate one of the two skid shacks that were built on the property. Today, these two shacks are still in use, one of them as an old-time photograph shop, and the other as a print shop complete with a linotype machine and printing press. (Left, courtesy of Gene O'Lague.)

A station agent reviews the schedule at the beginning of a busy summer day, possibly in the late 1960s. At the peak of vacation season, there can be a continuous run of trains to coordinate and dispatch for a timely departure—a challenging task that Roaring Camp employees always excelled at.

When the Heisler was put into operation at Roaring Camp, Norman lettered it No. 1 for the Big Trees Flume and Lumber Company, one of his many ventures associated with the construction of Roaring Camp. Part of his plan had been to create a log flume ride from the top of Bear Mountain down to Roaring Camp. When the engine arrived from the Westside, it was missing its spot plate on the smokebox door. Gene O'Lague owned a No. 1 spot plate, which he loaned to Norman, and hence the old Westside No. 3 became the second No. 1 at Roaring Camp. This caused much confusion, and the Heisler was soon relettered as No. 2 for the Roaring Camp & Big Trees Narrow Gauge. Here it is at the wye, shortly before rail was laid on the south leg. (Courtesy of Gene O'Lague.)

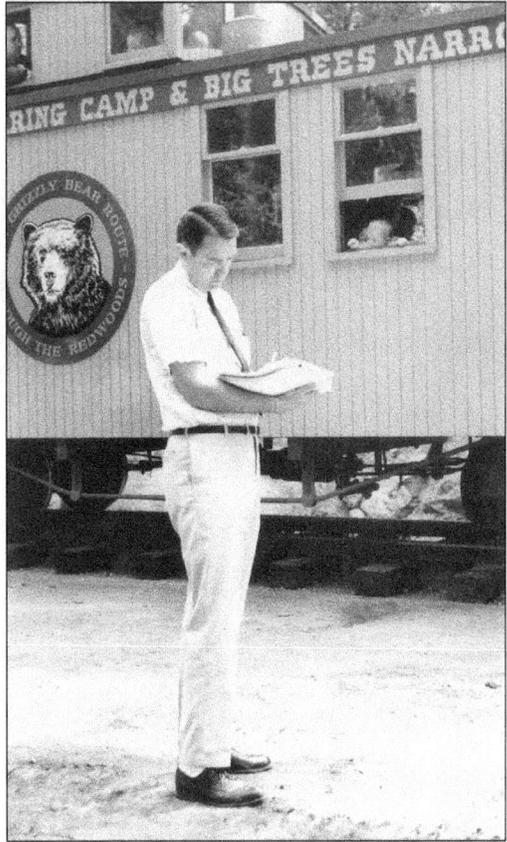

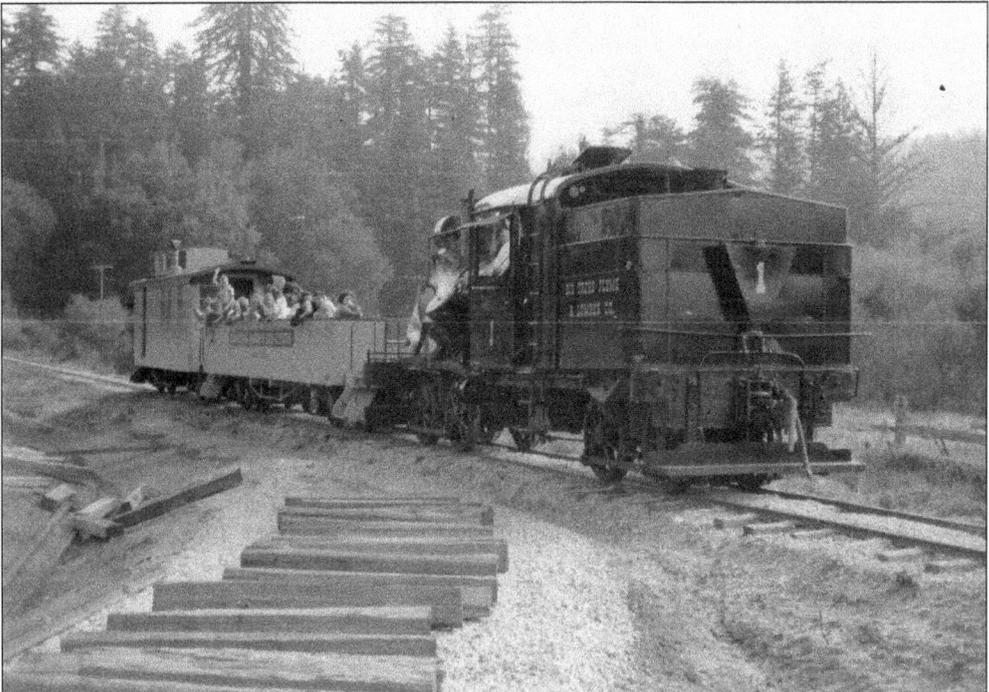

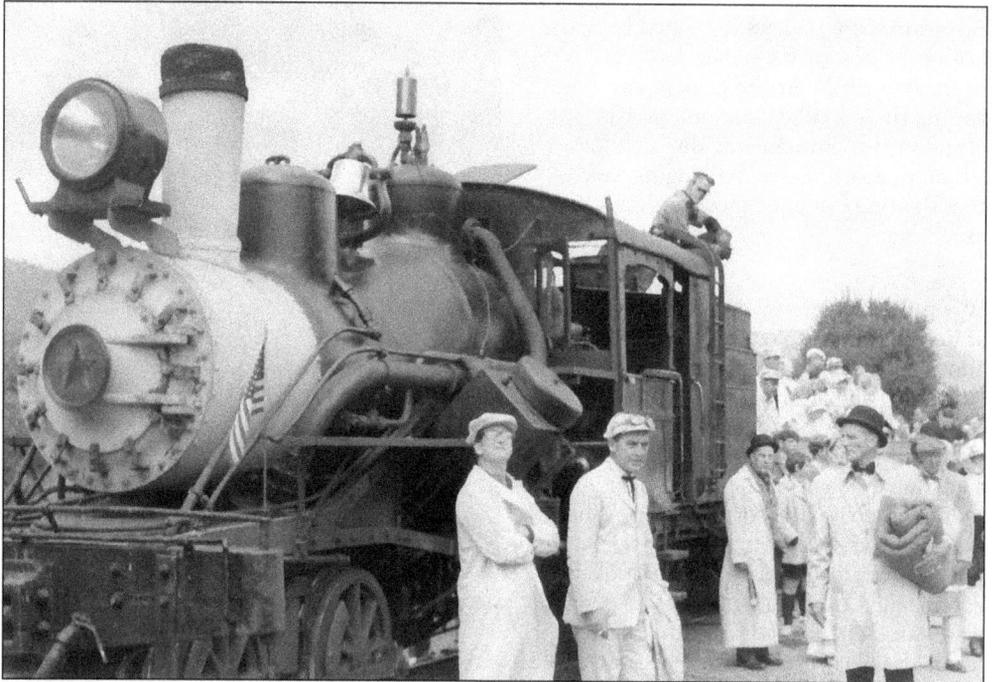

Here is the Heisler in the mid-1960s between numbers. Notice the new star spot plate, but no lettering or numbering anywhere else. The dapper-looking fellows surrounding the engine are members of a horseless carriage club who have driven their automobiles to Roaring Camp for a picnic and car show.

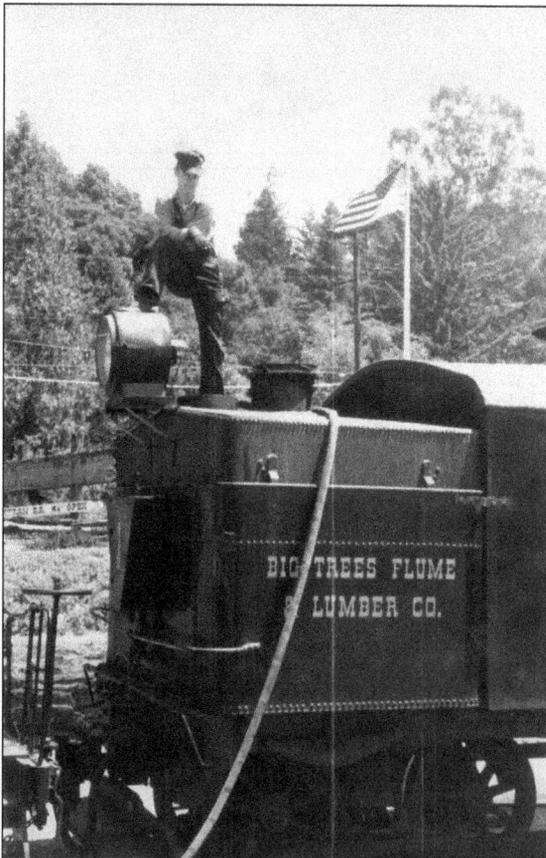

Charlie Ward refills the tender tank of the Heisler with a fire hose between trips up to the end of track in August 1965. (Courtesy of Gene O'Lague.)

Longtime Roaring Camp engineer Tom Shreve (right) and Gordon Diezel pose with Sara the dog on the front of the No. 1 in a publicity photograph. For some time, firemen would have to contend with Sara sitting on their laps while they performed their duties on the left side of the cab.

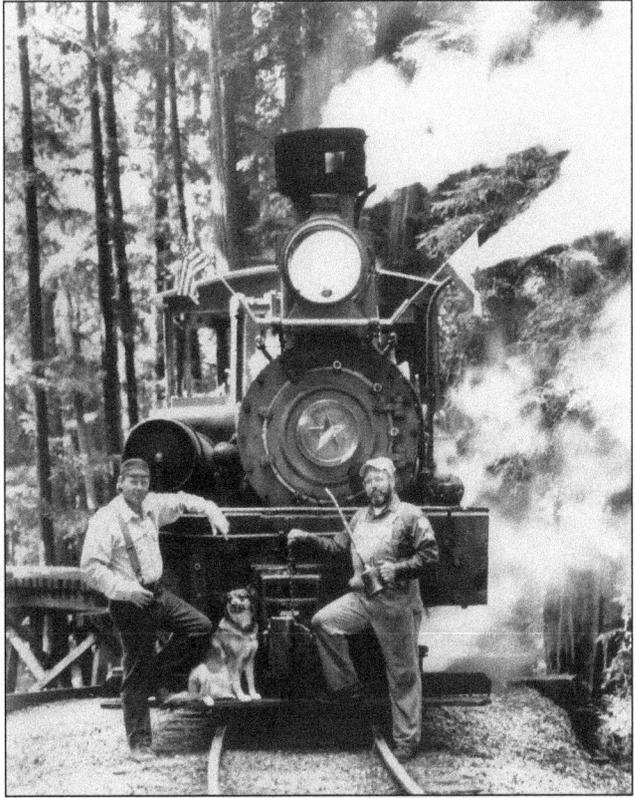

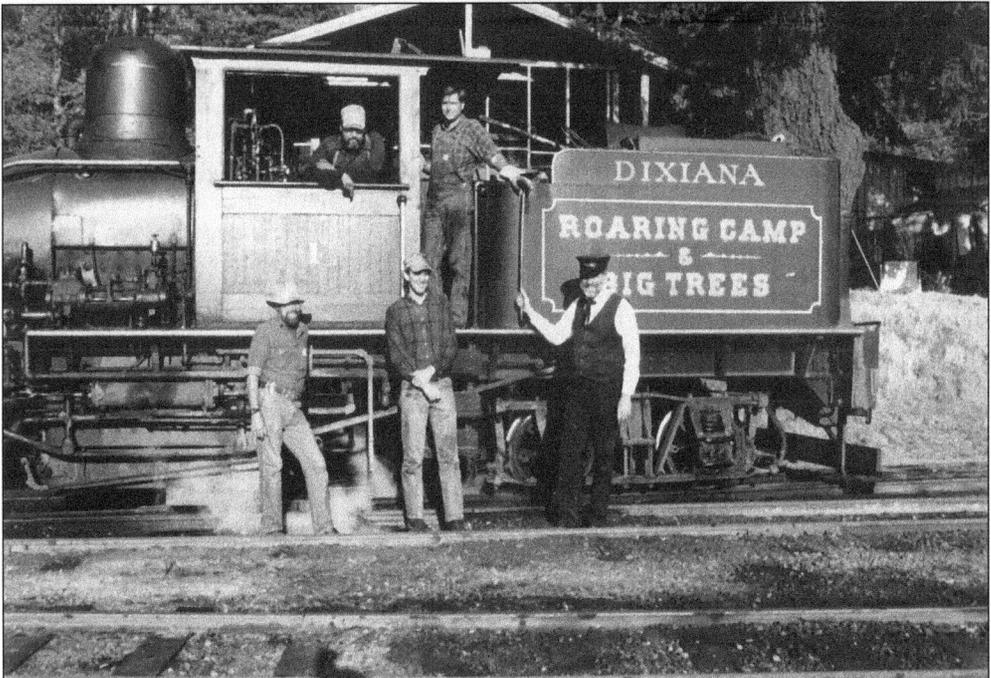

The crew poses on the No. 1 in the afternoon sun. They are, from left to right, top to bottom, Tom Shreve, Paul Boshan, Dan Ranger, Gary Guttebo, and Tim Landre.

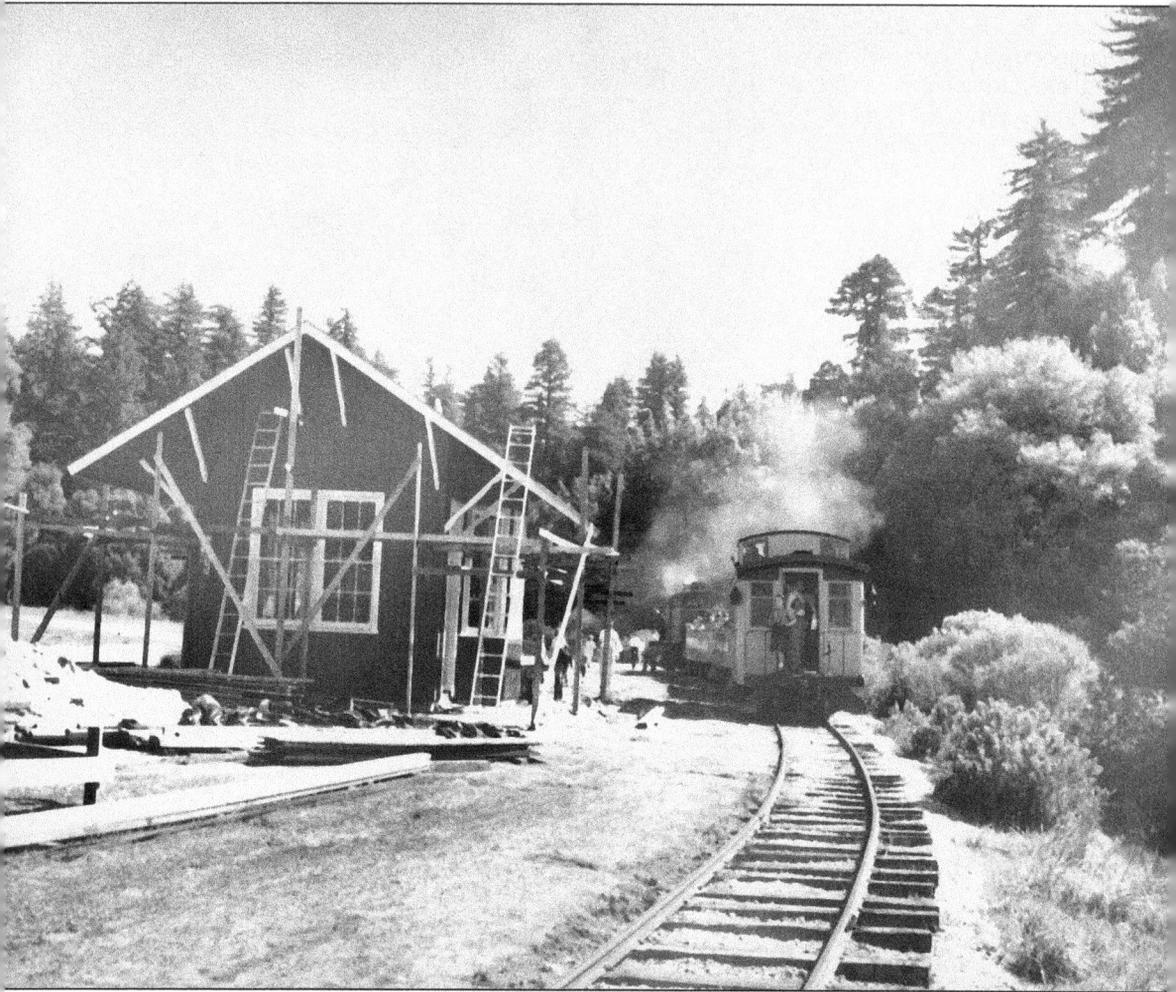

The No. 1 pulls out of Roaring Camp and heads up the hill shortly after the construction of the Roaring Camp depot. This original section of the depot, a simple one-room affair, has since been expanded on two separate occasions to include the administrative office on one side and a large, covered waiting platform on the side closest to the camera. For the past 50 years, Roaring Camp & Big Trees Narrow Gauge Railroad, which later became the Santa Cruz, Big Trees & Pacific Railway, has operated as both a tourist railroad and a common carrier, utilizing historic narrow gauge locomotives as well as more modern diesel electric standard gauge locomotives on two separate routes. The American Society of Mechanical Engineers collectively designated Roaring Camp's Shay, Climax, and Heisler steam engines as National Mechanical Engineering Historical Landmark No. 134 in August 1988, as examples of small, slow-speed, 19th-century geared locomotives. (Courtesy of Gene O'Lague.)

Gene O'Lague uses a steady hand to crack the throttle open on engine No. 1. Gene retired from the Southern Pacific in 1986, ending his career on a local freight out of Salinas, California. Visible through the cab window is the Southern Pacific Felton branch. (Courtesy of Gene O'Lague.)

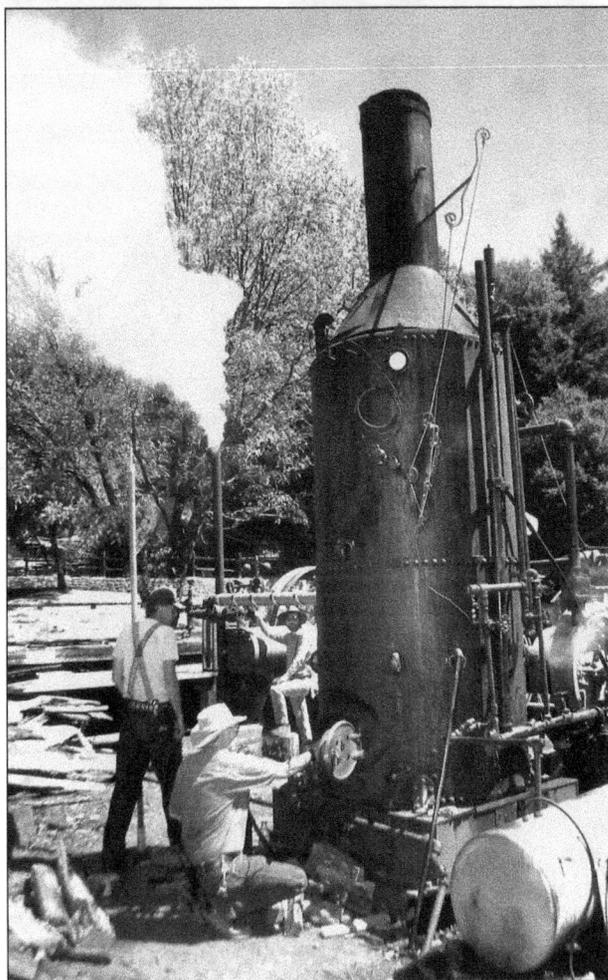

By 1978, Norman Clark had amassed enough parts to create a functioning steam sawmill. The donkey engine seen here was found by Clark and his daughter Melani in a scrapyard in Oakland. Although the donkey engine has never been operational at Roaring Camp, the boiler was plumbed up to a one-cylinder engine found in Michigan. The engine drives a pony mill, which was found near Strawberry, California, and has been built into a wooden platform with a longer carriage.

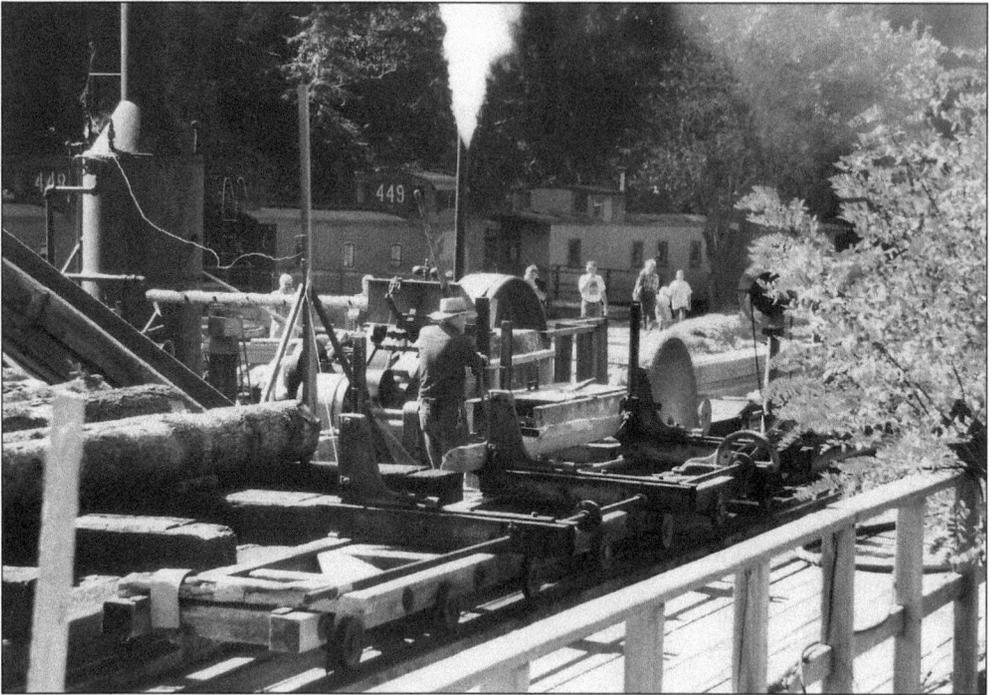

This action shot shows the mill in operation. Today, the mill is in need of rebuilding and is waiting for the right people to breathe some life into it and revive the dying art of making lumber with steam. In the background are two Atchison, Topeka & Santa Fe cabooses and one Southern Pacific caboose, which were obtained as office space. They are still used as offices today.

Veteran conductor John Ellis poses on the point of the train to Bear Mountain as it makes its way out of the depot.

Even the non-railroad employees at Roaring Camp were a part of the historical attention to detail. Here, the general store clerk, in period clothing, watches the train pull out of the depot from the front porch.

A big crowd gathers to see the No. 1 pull into the Roaring Camp depot on a busy summer day—a scene that is still seen today.

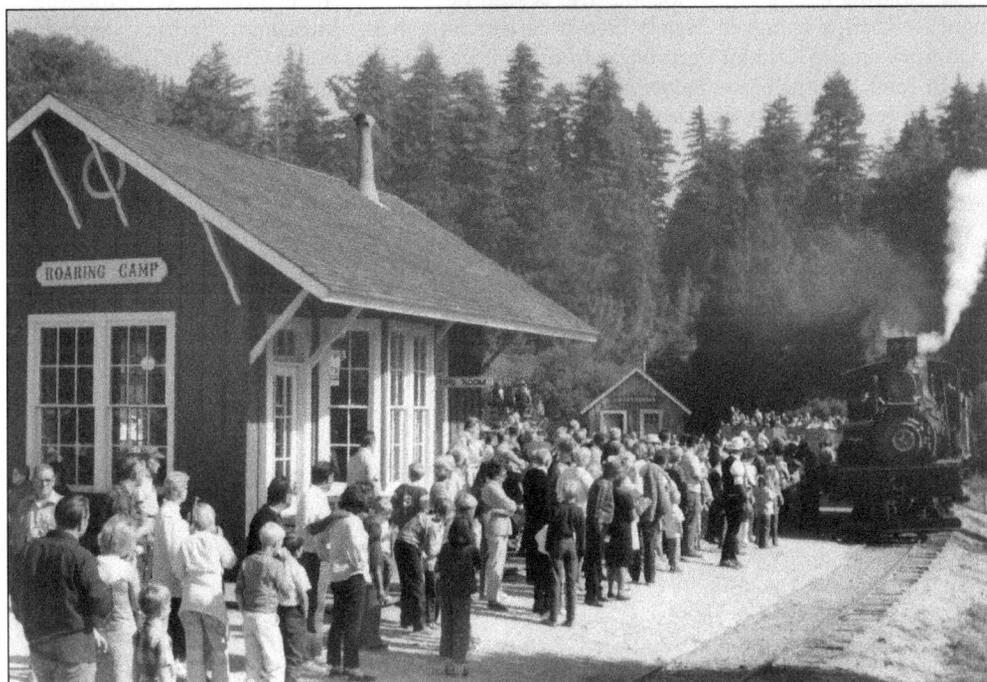

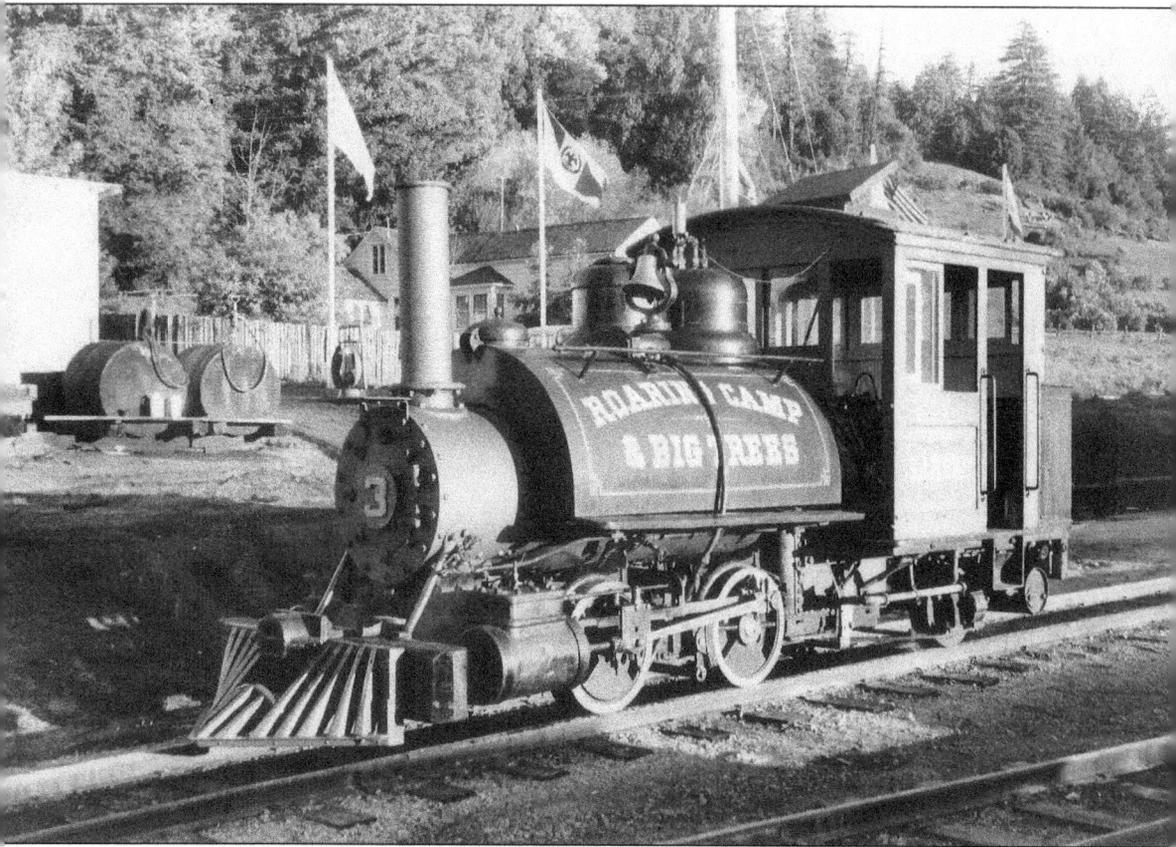

Kahuku, Roaring Camp's third locomotive, is seen here in December 1969. The engine was brought to Roaring Camp in March 1966 from the Sutro Baths Museum in San Francisco. It used to work on the Kahuku sugar plantation in Hawaii and was built by Baldwin Locomotive Works in 1890. It is the oldest locomotive at Roaring Camp and used to run past the childhood home of Norman Clark's wife, Georgiana, when she was a young girl growing up on the island of Oahu. The No. 3 still sees service during busy days in the summertime, as power on a parking lot shuttle train between the Felton depot and the Roaring Camp depot. It is the company's only rod engine, an 0-4-2T.

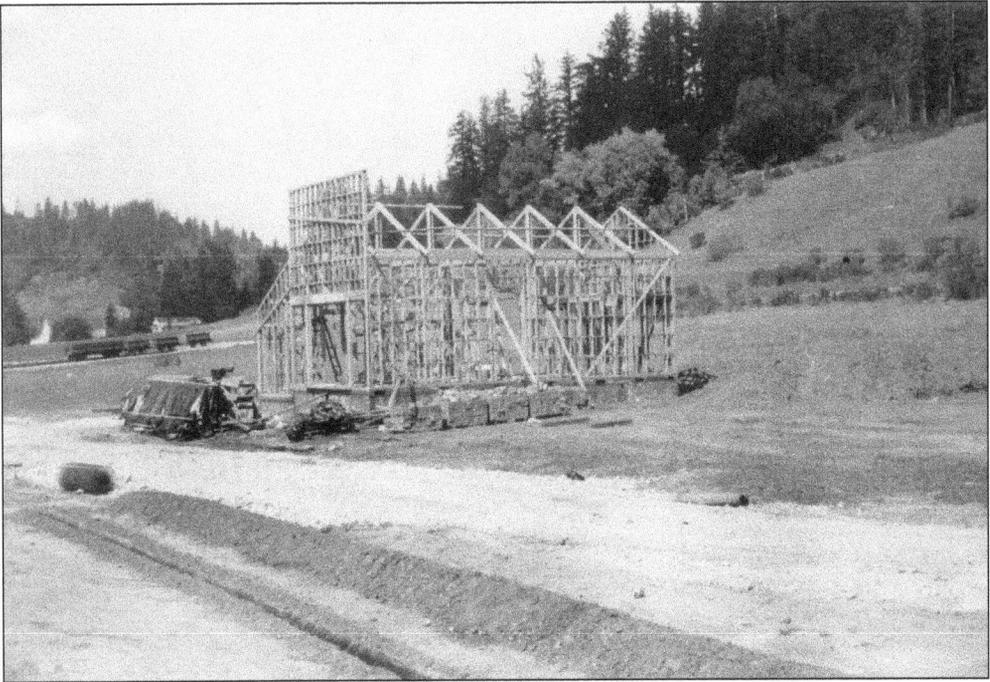

This June 1965 photograph shows the framing almost complete on the Roaring Camp General Store, the second building constructed on the Big Trees Ranch. In the background, sitting on the south leg of the wye, are a Westside Lumber Company flatcar and two four-wheeled, center-dump cars, also from Westside.

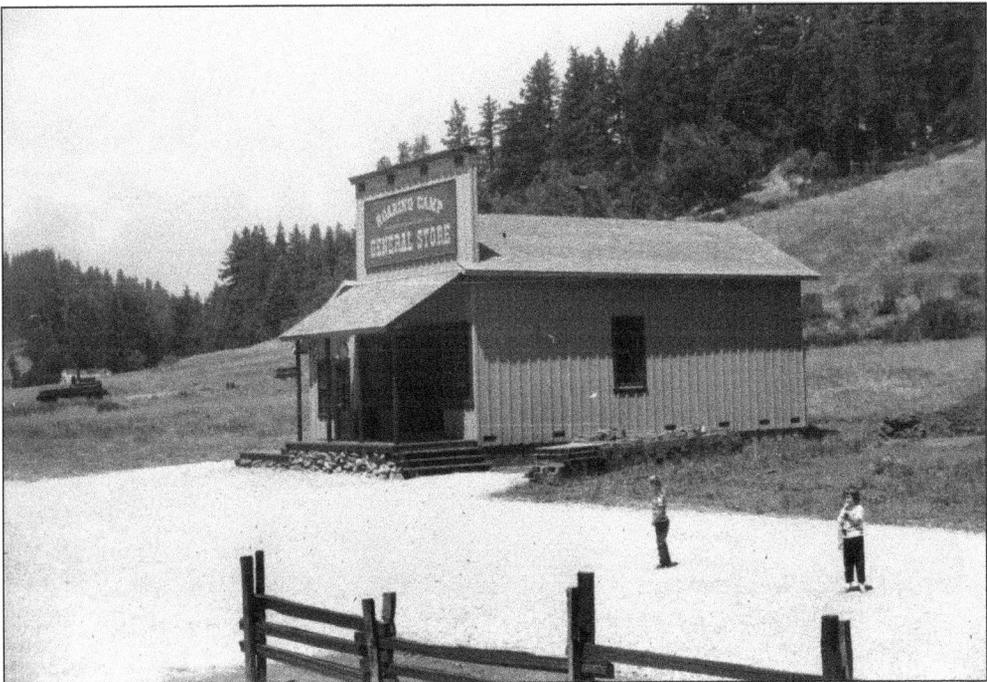

Just two months later, in August 1965, the store was open for business, selling sundries, candy, books, and historical souvenirs to passengers from the trains.

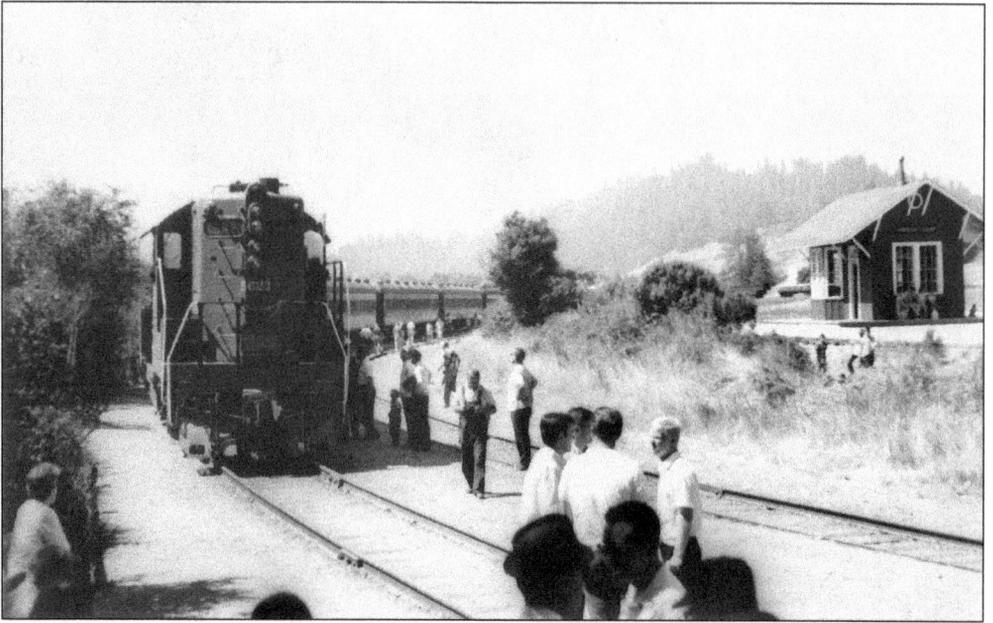

On August 4, 1963, the Southern Pacific ran a special passenger train, a "picnic excursion" for the group Railroad Fans of the San Francisco Bay Area. The trip began in San Francisco and ran to Felton via Watsonville Junction. Upon arrival, passengers were treated to a ride on the then newly laid Roaring Camp & Big Trees Narrow Gauge Railroad.

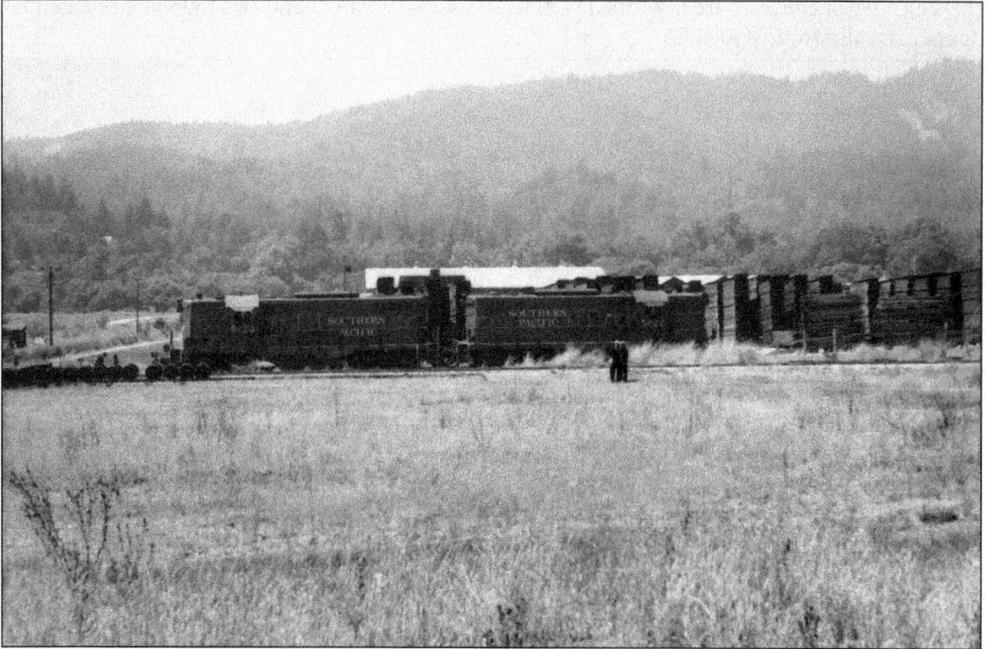

The Southern Pacific assigned "torpedo boat" GP-9's No. 5623 and No. 5622 for the trip. Engine No. 5623 was retired in 1991 and rescued from the scrapper's torch by Errol Ohman and Howard Wise the following year. The two restored the locomotive, and it is currently running on the Niles Canyon Railway in Sunol, California. Here, the power is running around the train for the return journey down the canyon.

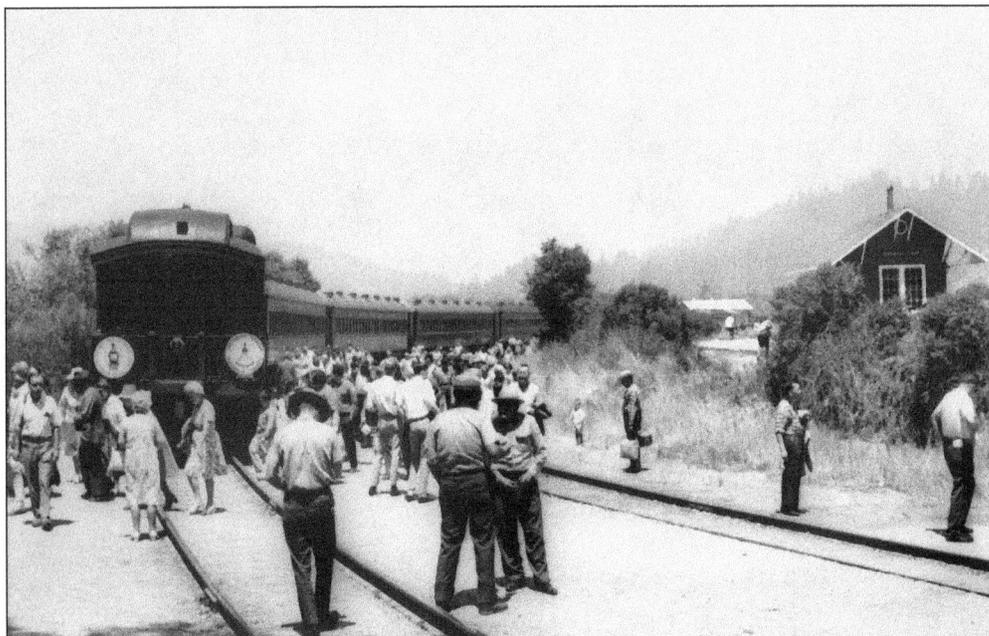

This train was the last Southern Pacific passenger train to run on the Felton branch line. Not until 25 years later, when the Santa Cruz, Big Trees & Pacific began operations, did the public have another chance to witness the majesty of the massive sequoia redwoods and the San Lorenzo River Gorge by train.

Conductor Mac McJunken (far right) and his train are seen here at the edge of the soon-to-be-constructed Indian Creek trestle.

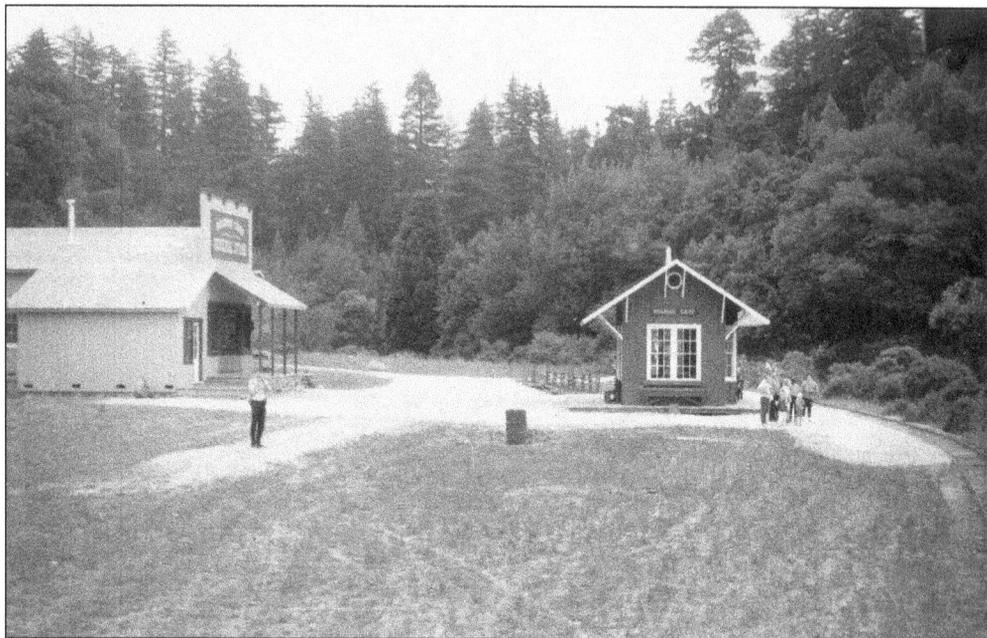

This October 1965 view of "Main Street" shows the newly completed Roaring Camp General Store and depot. The Southern Pacific line runs parallel to the narrow gauge in the dense brush on the right, and beyond that is Henry Cowell State Park.

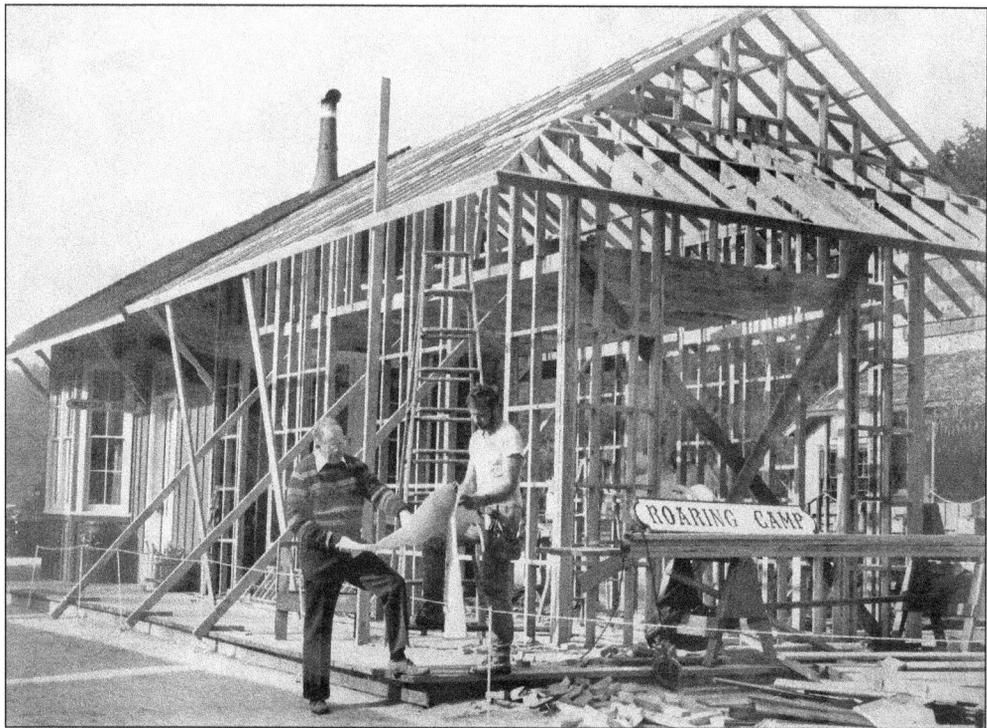

This view shows Norman Clark (left) and an unidentified carpenter consulting the blueprints for the nearly completed framing of the first expansion of the Roaring Camp depot. This wing would hold the administrative offices of the company, where they still exist today.

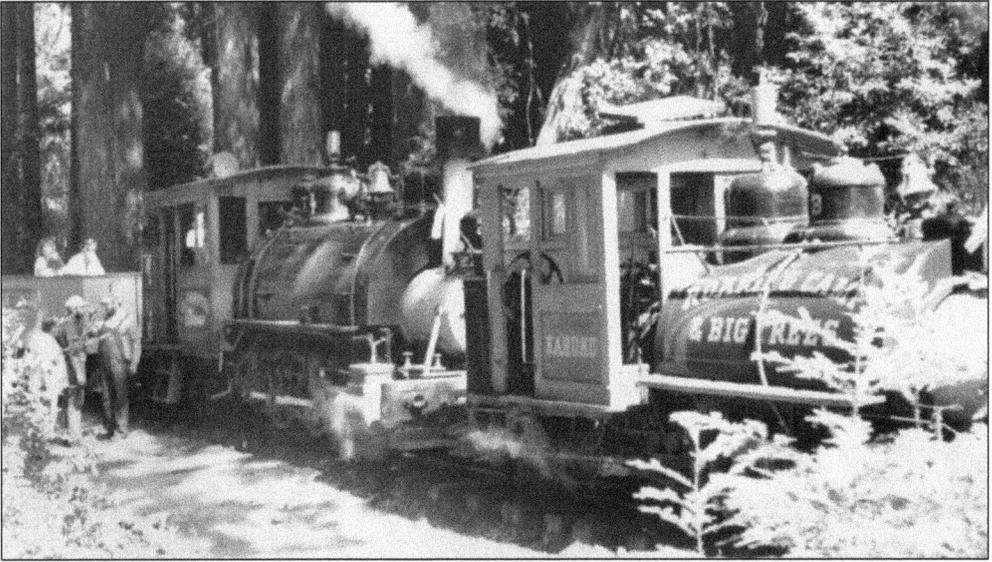

Seen here is a real rarity, which will most likely never be seen again on the narrow gauge at Roaring Camp: a double-headed, rod-engine-powered train. In 1977, Roaring Camp acquired its No. 4 locomotive from the Waipahu sugar plantation on the island of Oahu, in Hawaii. The *Waipahu*, an 0-6-2T, was built by Baldwin Locomotive Works in 1897. Unfortunately, the longer, rigid wheelbase of the locomotive gave it a propensity to hit the dirt on Roaring Camp's tight curves, and it was sold in 1988 to a theme park in Japan.

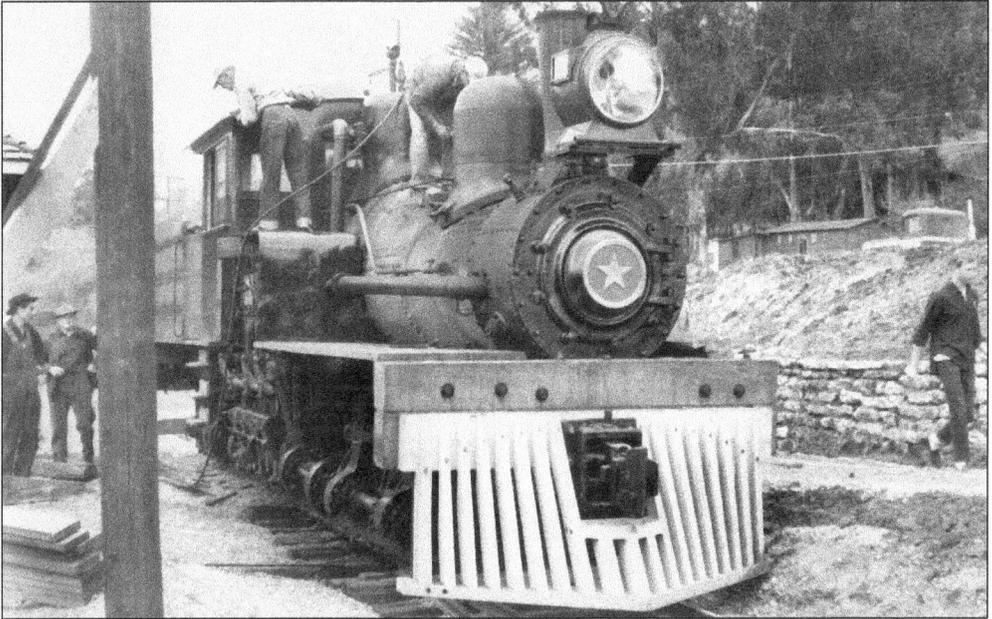

In 1962, before the railroad was even open to the general public, the No. 1 had this beautifully crafted wooden pilot fashioned by one of Roaring Camp's employees. However, there is a reason that logging locomotives do not have pilots, and this one was very short-lived. By the time the first revenue train was run in 1963, it had been smashed and removed. Here, the locomotive is sitting on a stub switch next to the Felton depot, which led to a section of dual-gauge track on a spur in the adjacent Southern Pacific yard.

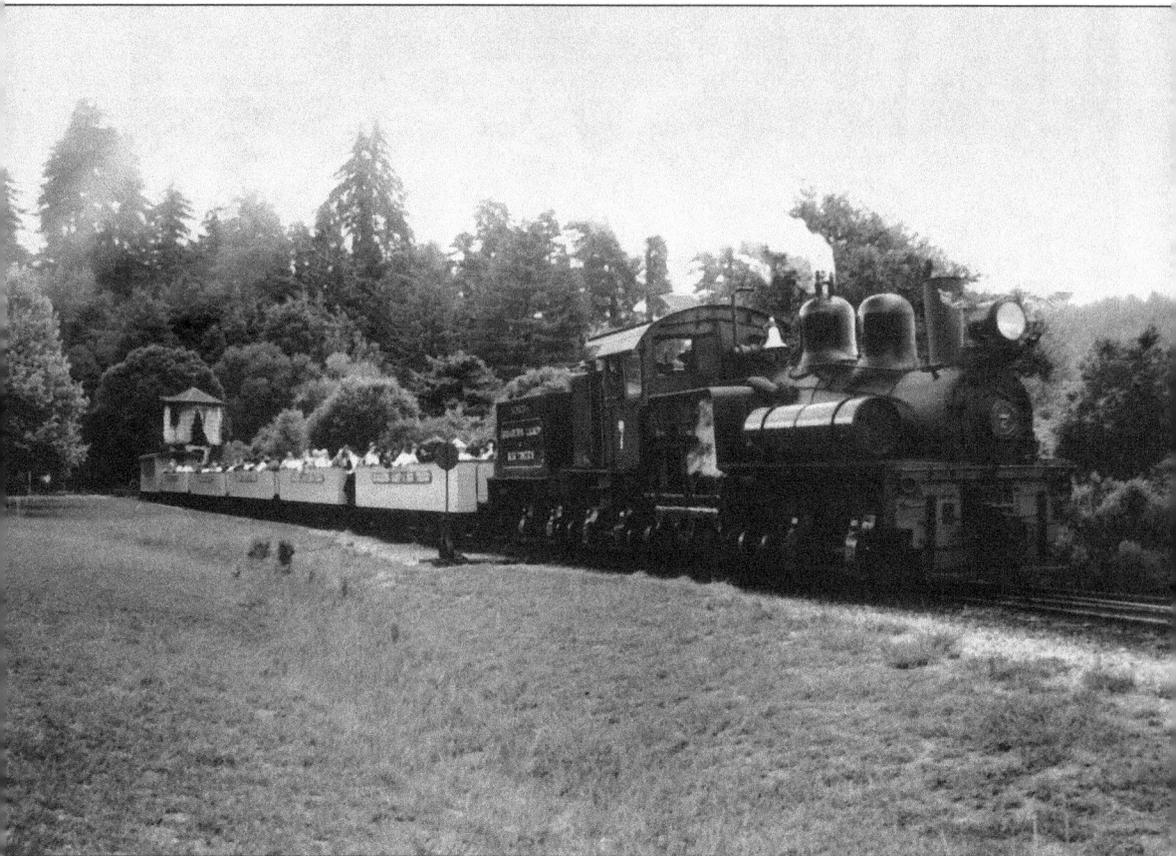

In 1986, Roaring Camp purchased its seventh locomotive, the Westside Lumber Company No. 7. The 60-ton, three-truck Shay had been on display in Sonora, California, since Westside ceased operations. It was built by Lima Locomotive Works in 1911, and it is the largest of Roaring Camp's steam engines. It underwent a major mechanical overhaul starting in 2007, had major boiler work done in 2012, and is in regular service.

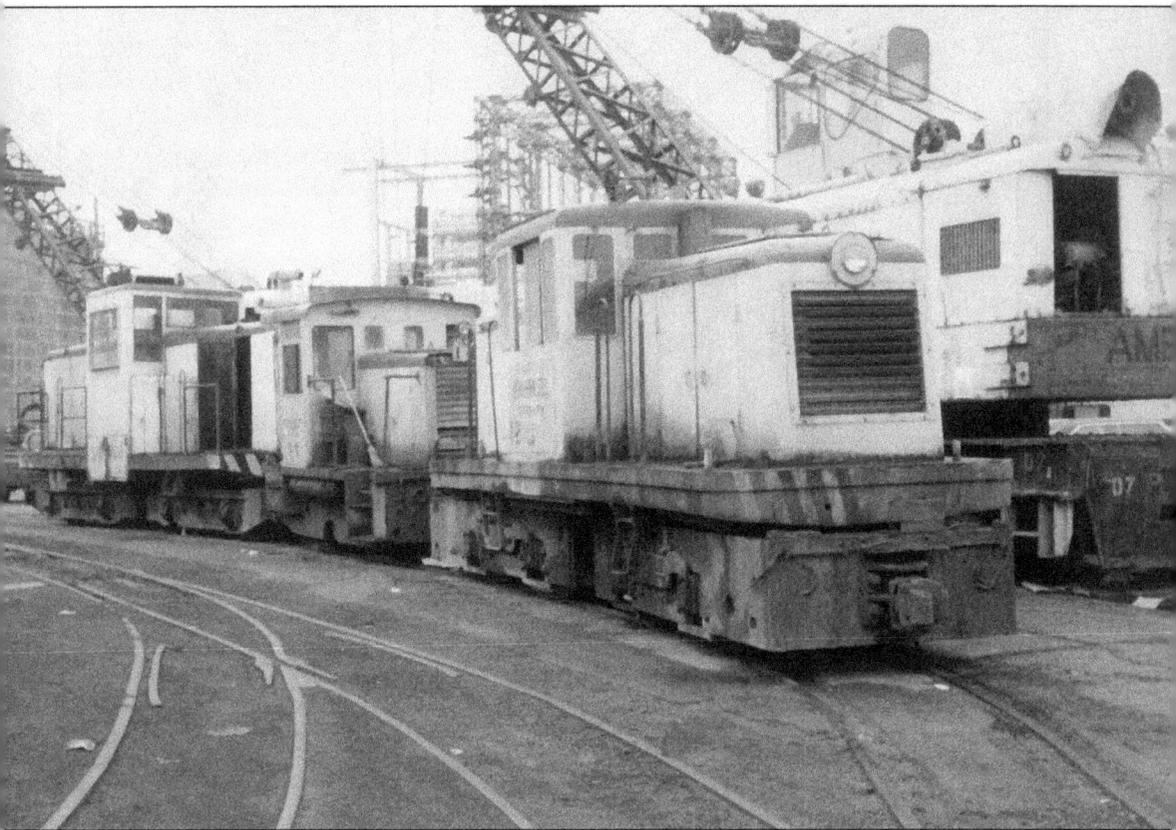

Roaring Camp has been through several diesel locomotives. The locomotive in the center here, as well as the one closest to the photographer, were purchased by Roaring Camp in the 1980s from Bethlehem Steel's plant in Los Angeles. They were numbered 50 and 60 respectively. No. 60 never ran under its own power at Roaring Camp and was sold in 2010 to the Georgetown Loop Railroad in Colorado. The No. 50 was sold to the Kauai Plantation Railway in Hawaii in 2010.

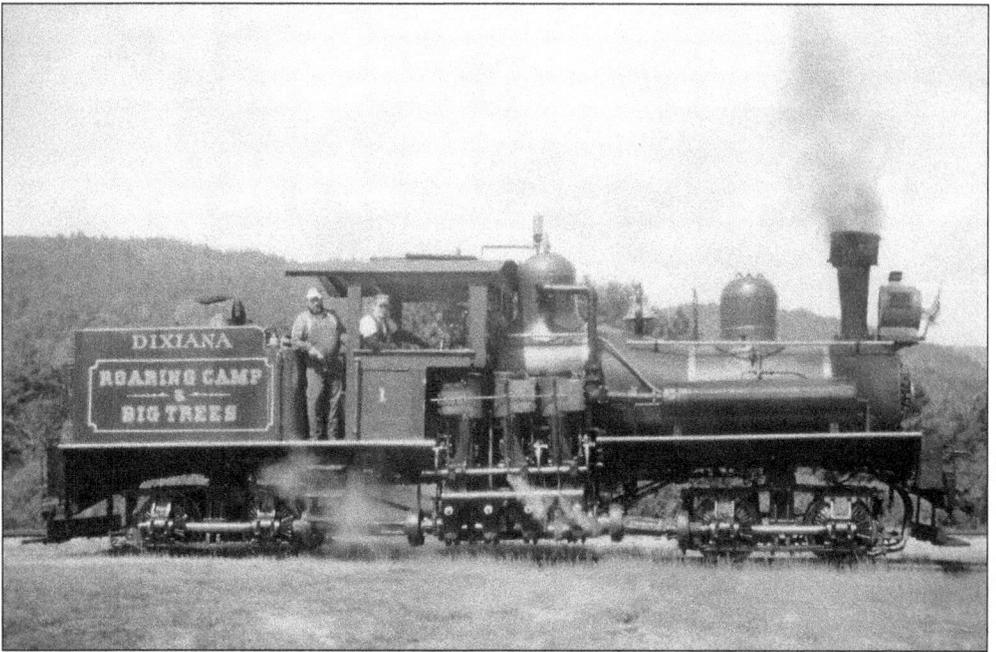

Tom Shreve (left) celebrated his 40th year with Roaring Camp in 2012 and is seen here in a publicity photograph with Darrel Tillcock on the No. 1. Shreve started serving food at Roaring Camp in 1972 and is now senior engineer and an expert on the idiosyncrasies of these old logging engines. Tillcock spent many years with the Southern Pacific and Mare Island Railroad and is currently an engineer on the Napa Valley Wine Train.

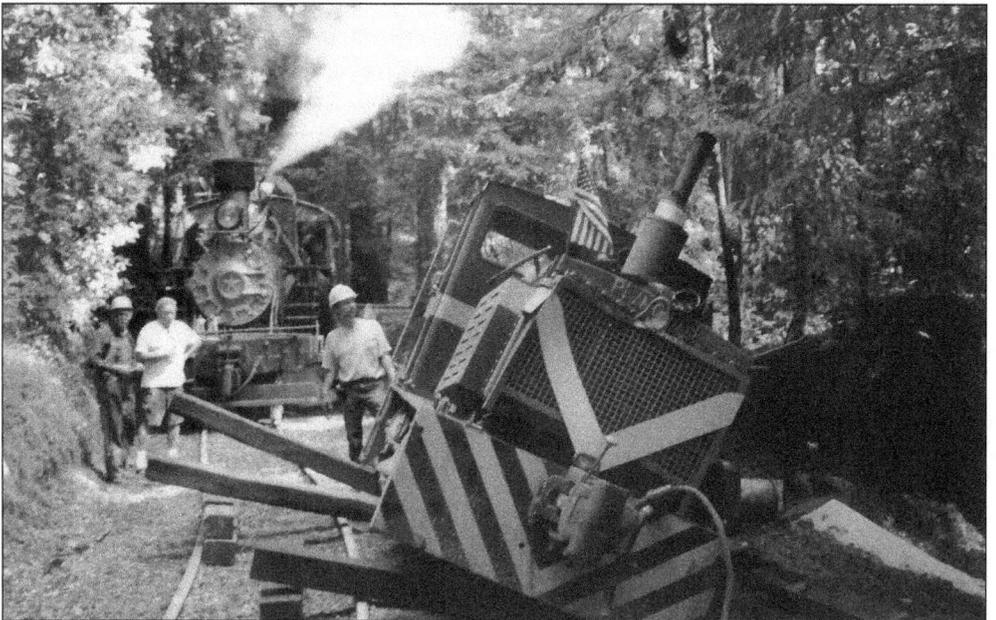

Railroading on an 8.5-percent grade is serious business. Engine No. 40 was on the hill with a work train that got away, and this was the result. The No. 2 came up to rescue it and tow it back to the shops. The locomotive has since been rebuilt and sees regular service on the line. (Courtesy of Nathan Goodman.)

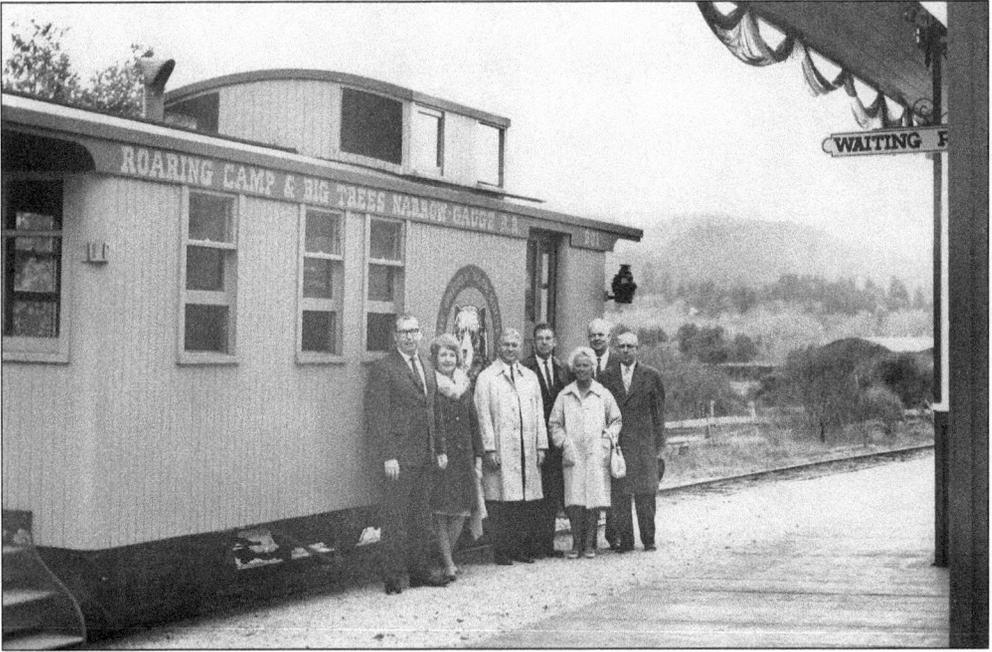

Norman Clark (far left) and company stockholders pose beside the line's wooden caboose in front of the Roaring Camp depot in 1965. Notice the older Grizzly Bear Route herald with Norman the Bear on it.

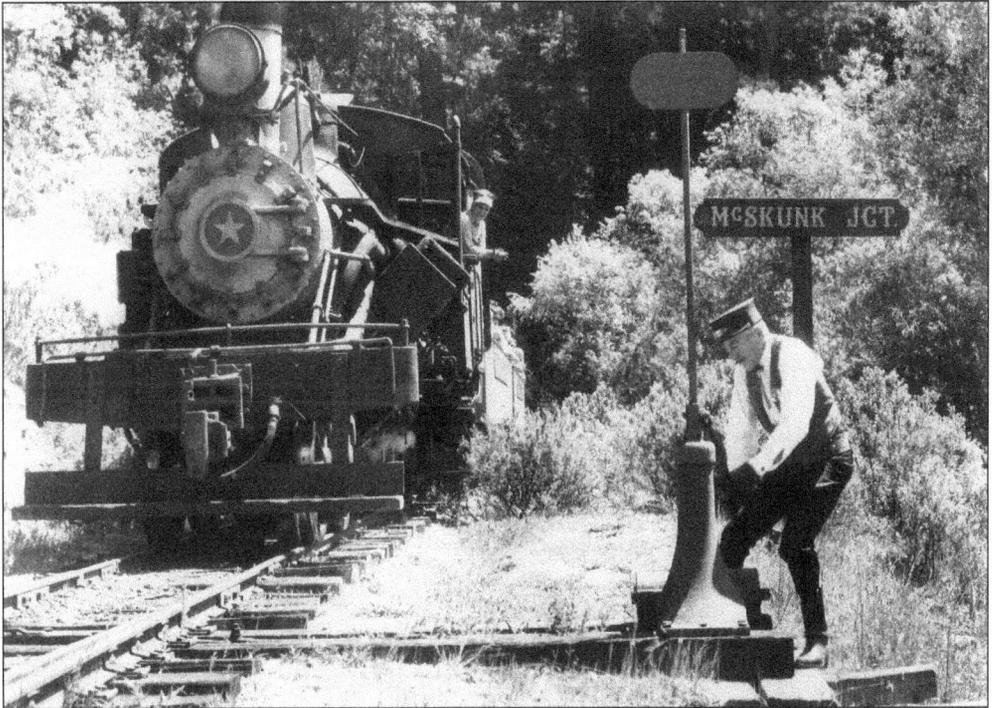

Conductor Mac McJunken lines the switch at McSkunk Junction, allowing the No. 2, *Tuolumne*, into Roaring Camp. The story goes that McSkunk Junction got its name from McJunken, who stepped off the train here one day and had a run-in with a skunk.

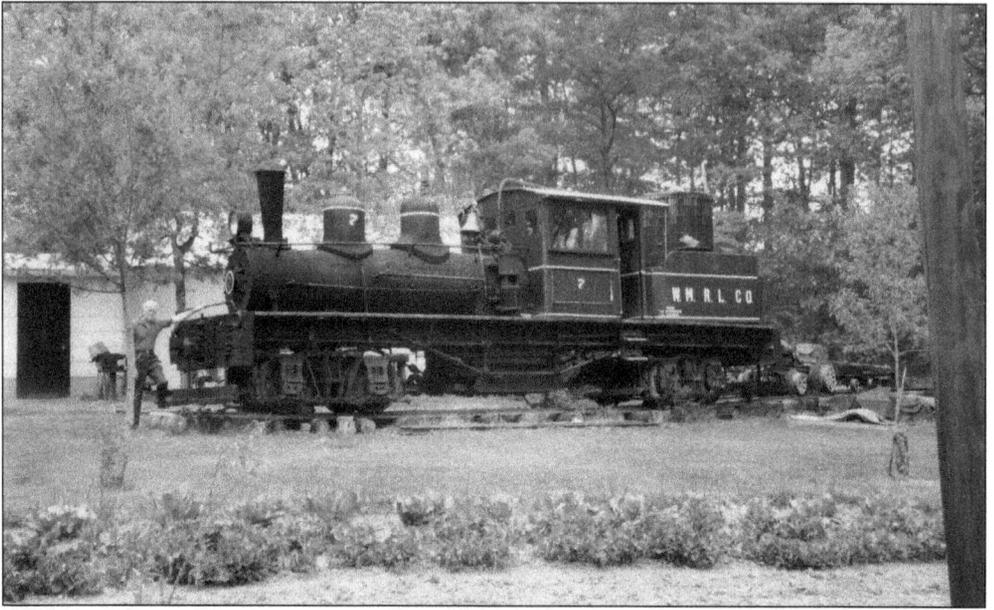

This is Roaring Camp's No. 6, formerly the W.M. Ritter Lumber Company No. 7, from West Virginia. Both the No. 1 and the No. 6 were owned by this company at one time. It was built in 1912 and acquired by Roaring Camp in 1988. The locomotive was found in Daisy, Kentucky, in the backyard of a man who had built a railroad around his property to run it on. It was not operational at the time of purchase, and still needs to be re-gauged before it can be run at Roaring Camp, as it is currently 42-inch gauge.

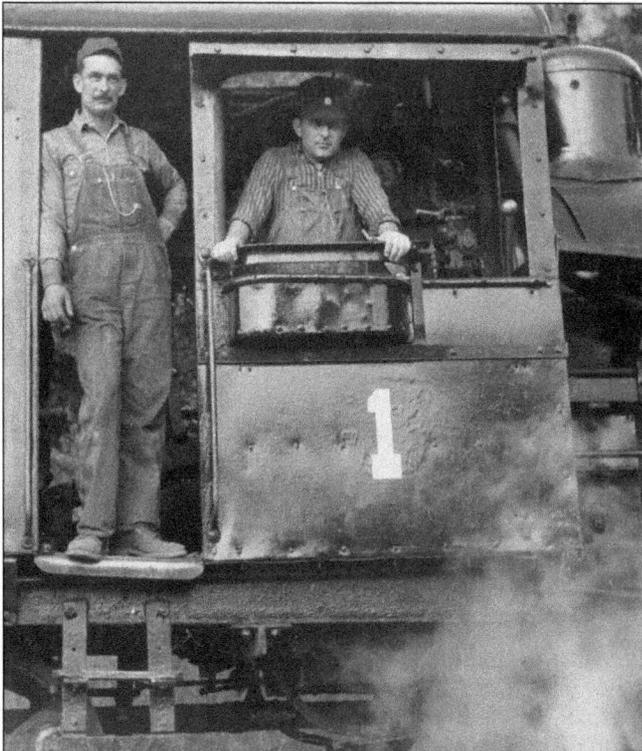

L.A. "Smokey" McGuire (left) and Jim Vale are seen here on the Heisler No. 1—the former Westside Lumber Company No. 3—in 1965 or 1966. They are on duty, hauling bridge timbers to the Spring Canyon corkscrew trestle construction site. In this photograph, the engine still has the extended window seat box, which was later removed. These had been added at Westside to assist with switching the wider standard gauge cars. (Courtesy of Jim Vale.)

Four

BUILDING BRIDGES

The first of the three bridges on the Roaring Camp & Big Trees Narrow Gauge Railroad was constructed over the smallest of spring-fed creeks. This bridge became known as the Indian Creek trestle and spans a large gulch surrounding the small creek. The bridge was built on a curve, passing close by several 2,000-year-old redwood trees, and it is about 35 feet tall at its highest point. The bridge is also the tightest turning railroad bridge in the United States. Designed to carry the weight of a modern—at the time—standard gauge freight locomotive, it was built by Southern Pacific bridge and maintenance-of-way crews in their time off. The bridge sits on poured concrete footings, which were made by rolling cement trucks up a ramp onto narrow gauge flatcars. These were then shoved up through Big Trees to the bridge site with one of the steam locomotives. By making many trips from Roaring Camp up to the bridge site, the footings were completed, and the wooden bents were constructed on top of them.

After spanning the gap, construction continued up the hill. Shortly after crossing Indian Creek, the tracks reached their maximum gradient of 8.5 percent. About half a mile later, construction was started on two massive wooden trestles at Spring Canyon, which proved to be true feats of engineering.

These trestles were built with driven piles instead of concrete footings and were arranged in a corkscrew loop in a narrow canyon. The tracks passed over the lower bridge, regaining solid ground as they simultaneously passed through the pilings and under the high bridge. After looping around and gaining elevation, the tracks leapt out over the high bridge more than 80 feet above the ground and 45 feet above the lower bridge. After passing over the high bridge, the tracks came to solid ground again on a huge earthen fill made by removing soil from cuts farther up the line. These two bridges allowed the railroad to continue at a steady five-percent grade through the entire loop. Passengers riding in the last car on long trains would be able to look out the windows and see the locomotive that was pulling their train as it looped around on the bridge above or below them.

During all this construction, more passenger cars had been built, and regularly scheduled passenger trains were running up to whatever point the construction crews had reached. Beyond the bridges at Spring Canyon, it was a short half mile to the summit.

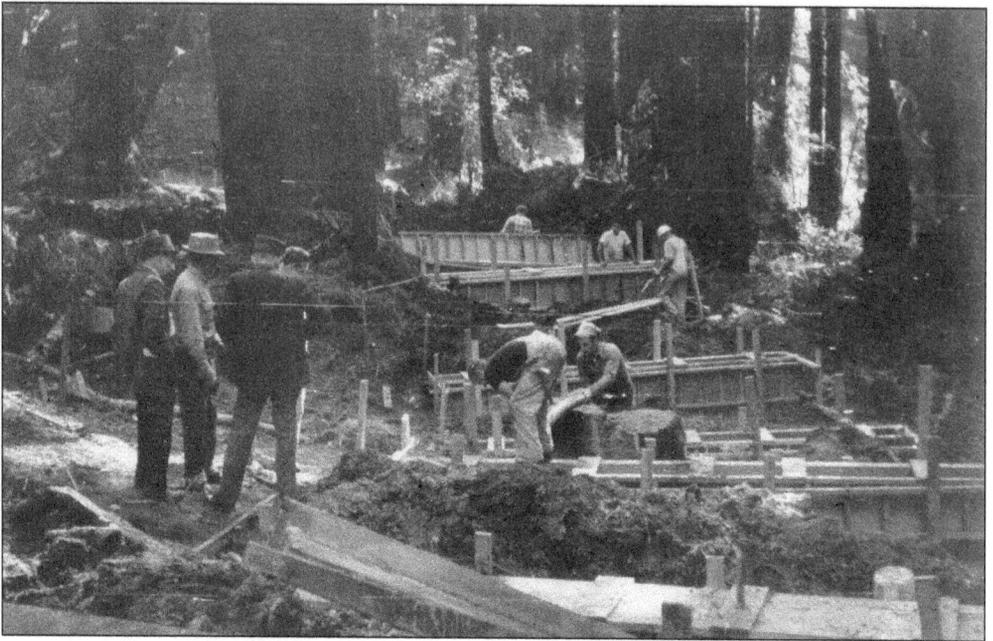

Conductor Mac McJunken (left center, with his back to the camera) and a few of his passengers inspect the concrete footings being poured at Indian Creek, which supported the line's first trestle. Passenger trains were continually bringing people up to wherever the end of track happened to be that day, where they stopped for a brief inspection of the work site before returning to the Felton depot. (Courtesy of Gene O'Lague.)

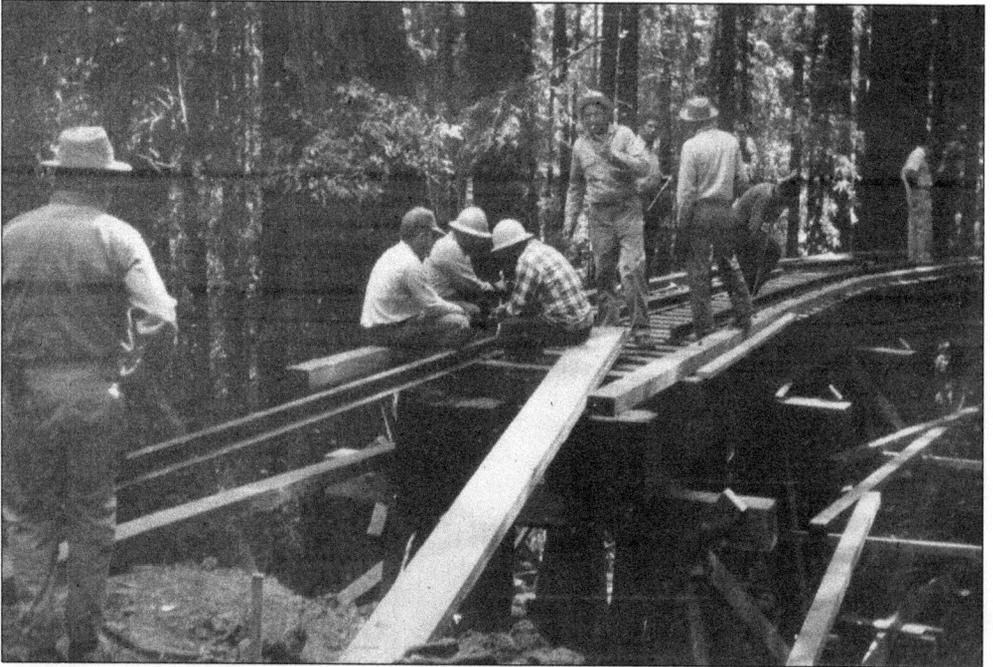

Here, the bridge crew has almost completed the first bridge at Indian Creek. The sharp curvature of the bridge can be seen, as well as some of the large, old-growth redwoods that the bridge dodges as the line continues up the hill. (Courtesy of Gene O'Lague.)

This engineer's seat view out of the front of the No. 1 shows what it took to get concrete up to the bridges. Where footings were necessary, many trips had to be made, one concrete truck at a time. The trucks were loaded onto one of the old Westside Lumber Company flatcars and shoved up to the work site. (Courtesy of Gene O'Lague.)

The image below also shows bridge footings being poured. As the train brought up concrete trucks one by one, the concrete was dumped into a concrete pump and delivered through the hose seen here into the molds. (Courtesy of Gene O'Lague.)

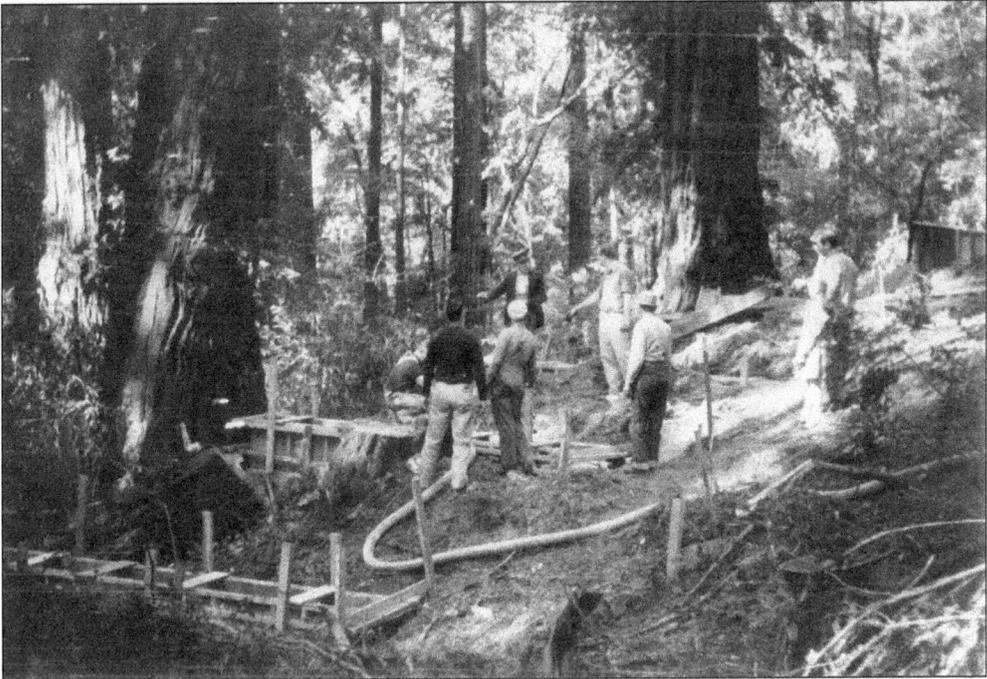

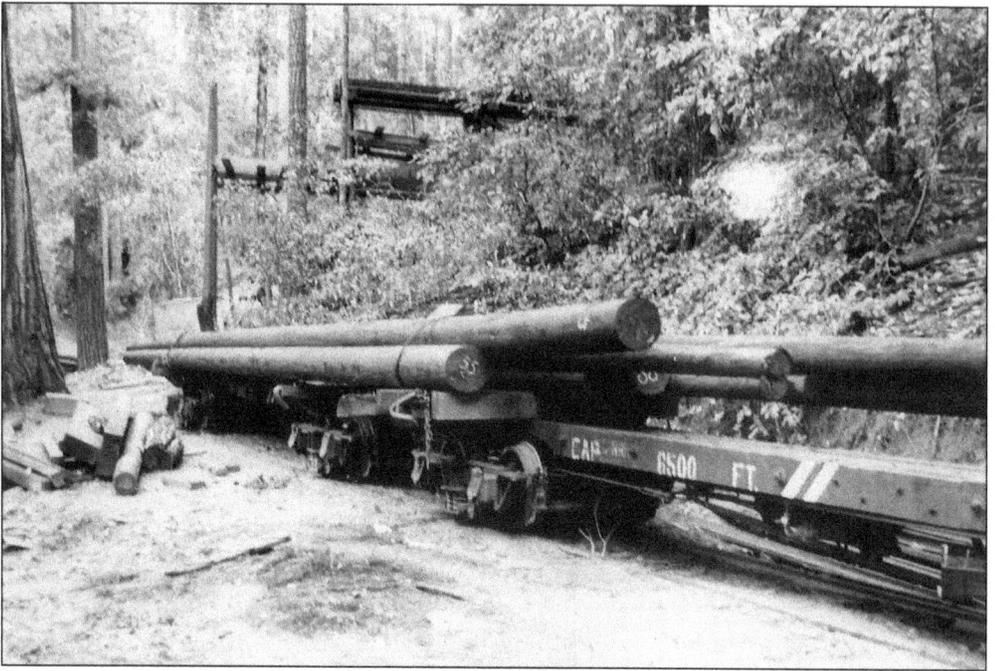

When the tracks reached Spring Canyon, much longer piles were necessary, and the railroad acquired a couple of Westside Lumber Company skeleton cars to bring the piles to the work site. In the background are the beginnings of the high bridge at Spring Canyon. The cars are sitting approximately where the Spring Canyon switch on today's switchback is.

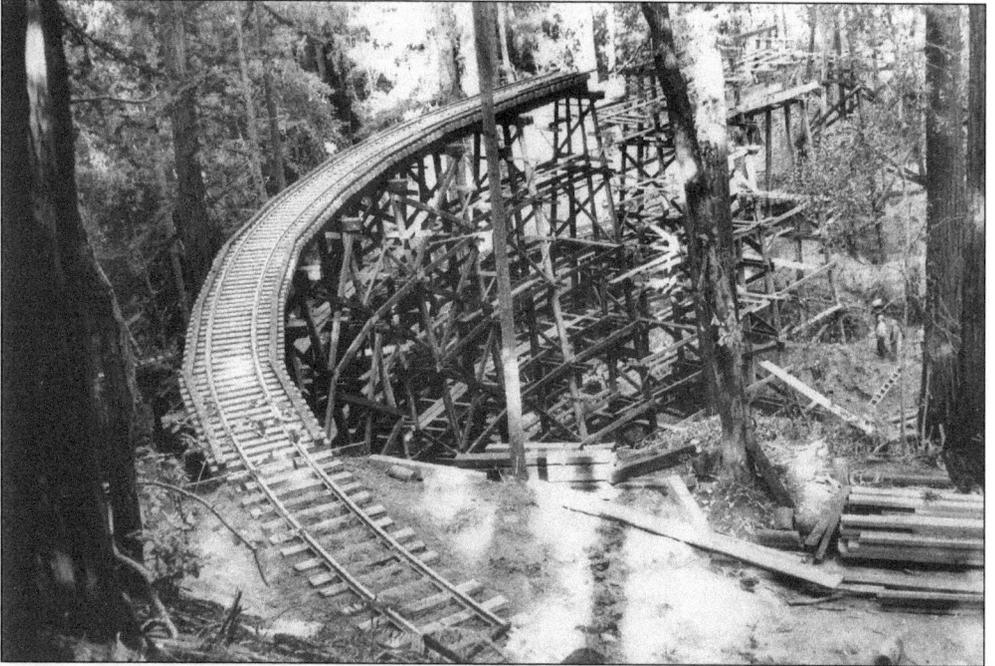

The high bridge at Spring Canyon is seen here under construction. The spot where this photograph was taken from is almost exactly where track was eventually laid as part of switchback construction in 1976. In the left background is the completed lower bridge.

In 1966, the first revenue train used the bridges at Spring Canyon. This image was snapped as the Heisler, lettered No. 1 for the Big Trees Flume and Lumber Company, pulls across the high bridge. Notice the man in the cab gangway looking down, likely wondering if it is going to work.

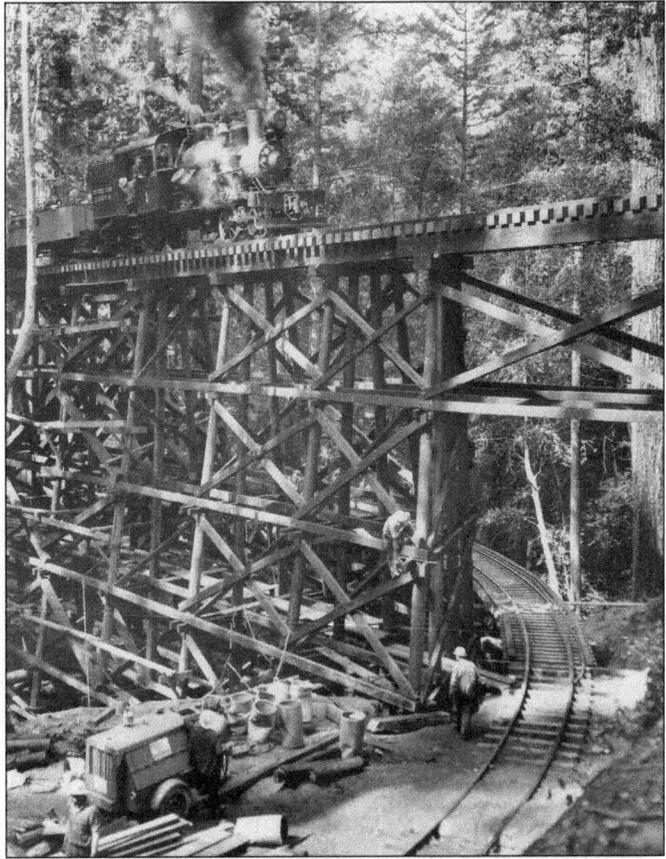

As clearly seen here, the low bridge ends just as it crosses under the high bridge. Today, this is one of the eeriest spots on the property, as the remains of both old bridges still stand and are slowly being taken over by forest.

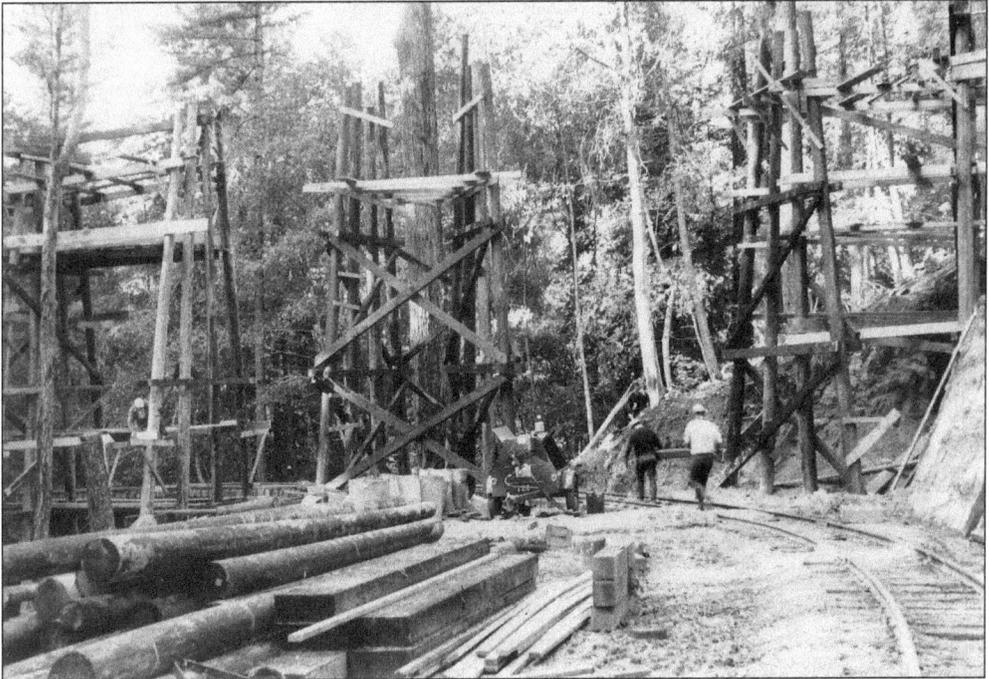

This photograph was taken at the bottom of the 8.5-percent grade, just uphill from the Indian Creek trestle, shortly after the bridge was finished but before rail was laid up the hill. Notice the hand-split redwood ties. (Courtesy of Gene O'Lague.)

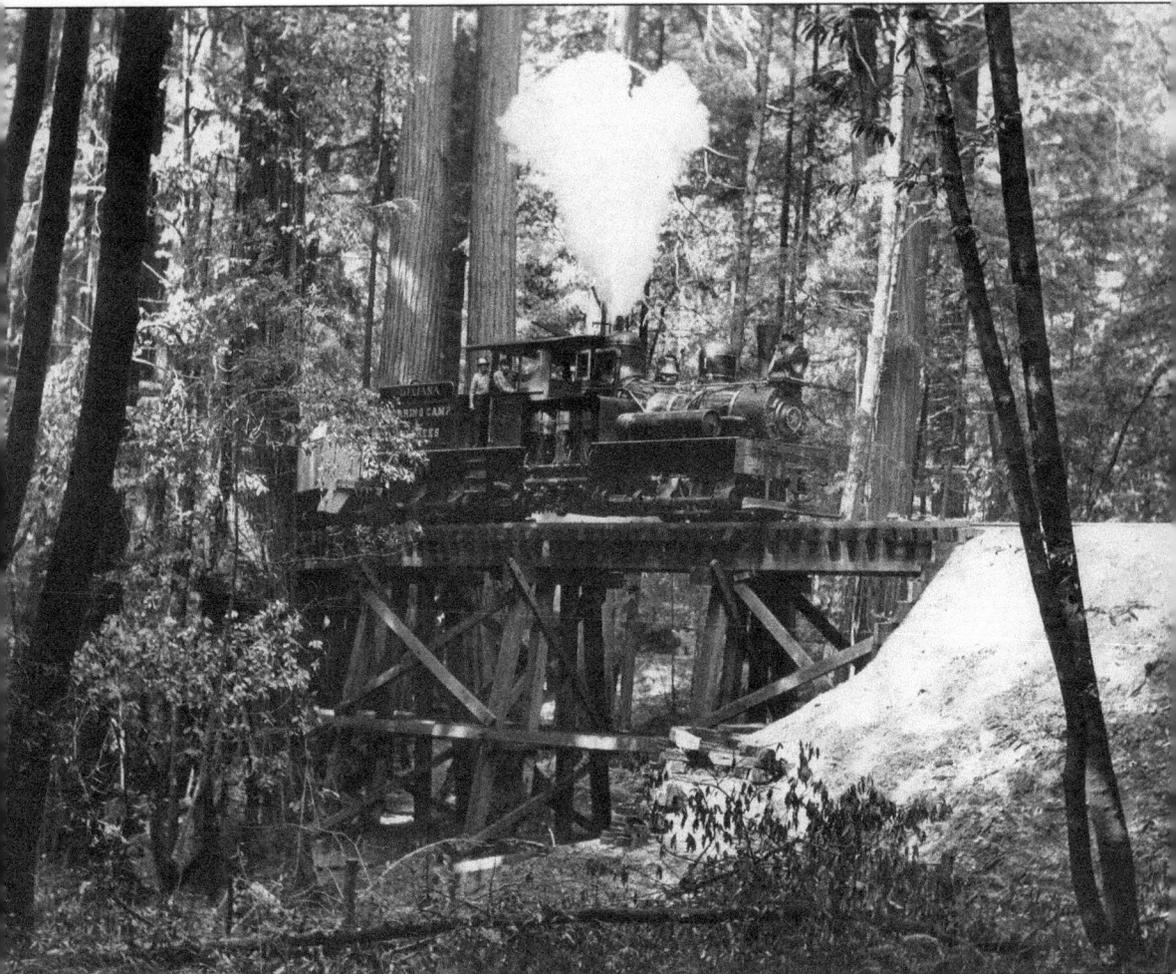

The No. 1 wraps its train around several clusters of old-growth redwoods as it snakes up the hill over the newly completed Indian Creek trestle. This trestle forms a significant portion of a horseshoe loop that gains the railroad approximately 50 feet of elevation, and it is the tightest-turning railroad bridge in the United States.

This man, identified as Uncle Ira, is in the fireman's seat of the No. 1 in May 1963. He was most likely Norman Clark's great-uncle and was also most likely the fireman on Roaring Camp's first revenue train, on April 6, 1963. (Courtesy of Gene O'Lague.)

The bridges were constructed in the same fashion that they would have been constructed 100 years before, using much of the same technology. Here, a plumb bob strung from the top of the bridge lays out the spot for a pile to be driven. (Courtesy of Gene O'Lague.)

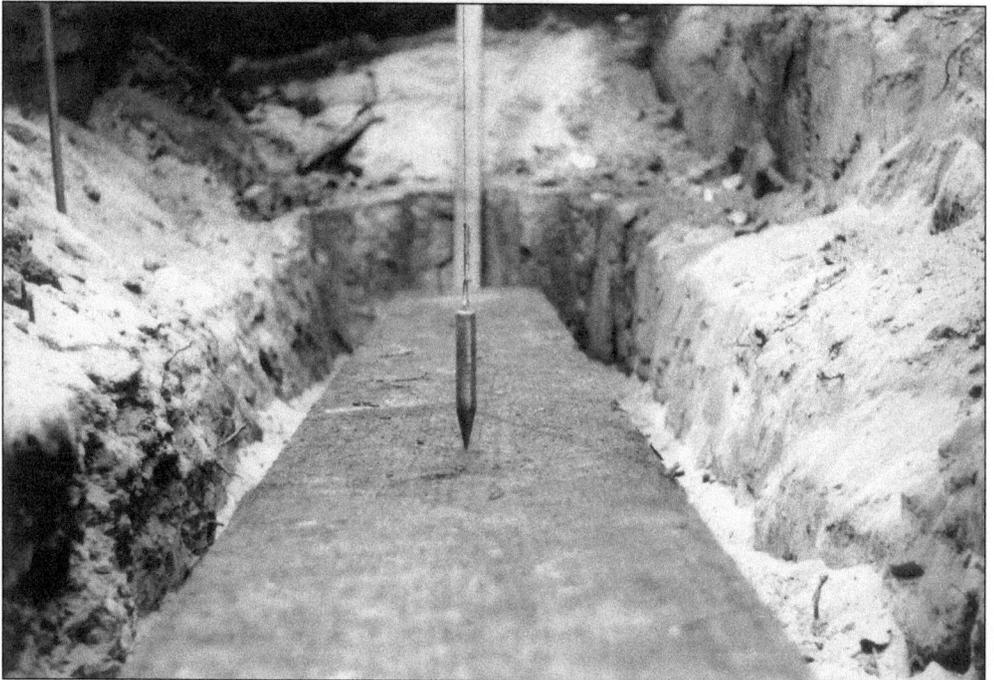

This construction photograph of the nearly completed low bridge at Spring Canyon shows how heavily built these bridges were. Notice the huge, 24-by-24-inch beams that the ties are sitting on. The bridges were all built to the requirements of the time as far as loadings were concerned, and were supposed to handle the weight of a GP-9.

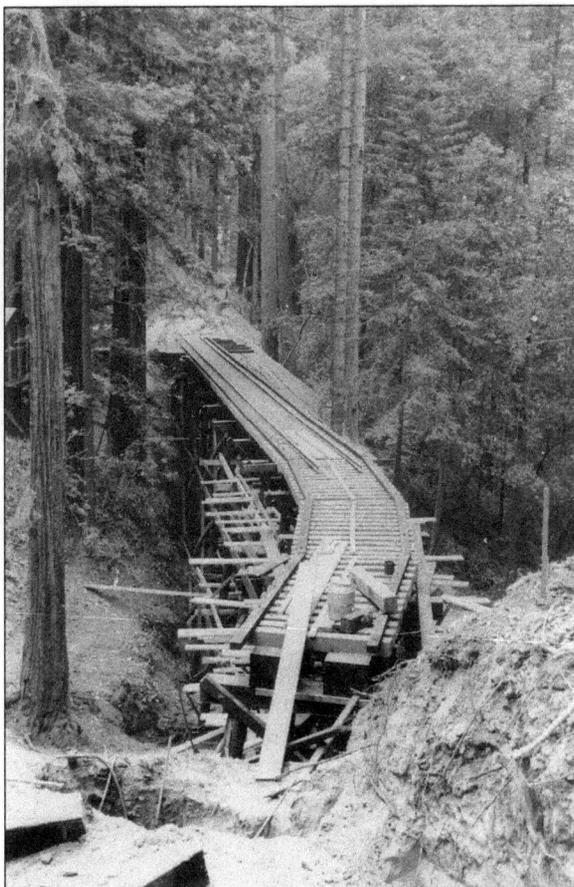

Grading work proceeds uphill from the 8.5-percent grade, approaching Grizzly Flats, in 1964.

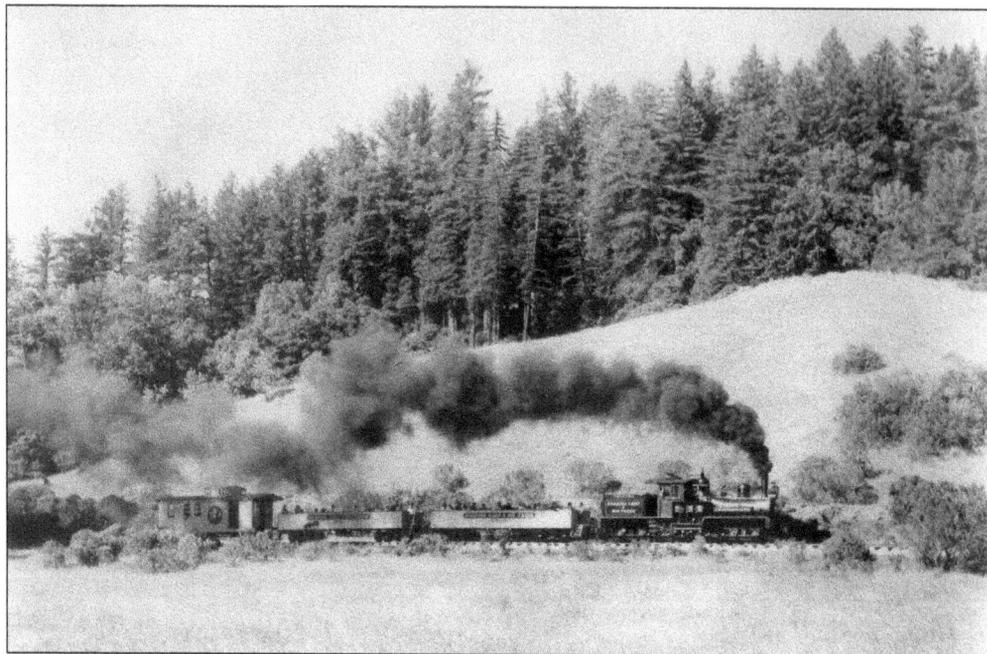

The No. 1's fireman lays on it a little as the train heads around the top of the meadow on its way to the end of track. Soon, after the building of Indian Creek trestle and the laying of rail up the 8.5-percent grade, the railroad passed across the top of the hill in the background, at about the point where the trees begin growing. Today, this grassy hill has been reclaimed by the forest and looks entirely different.

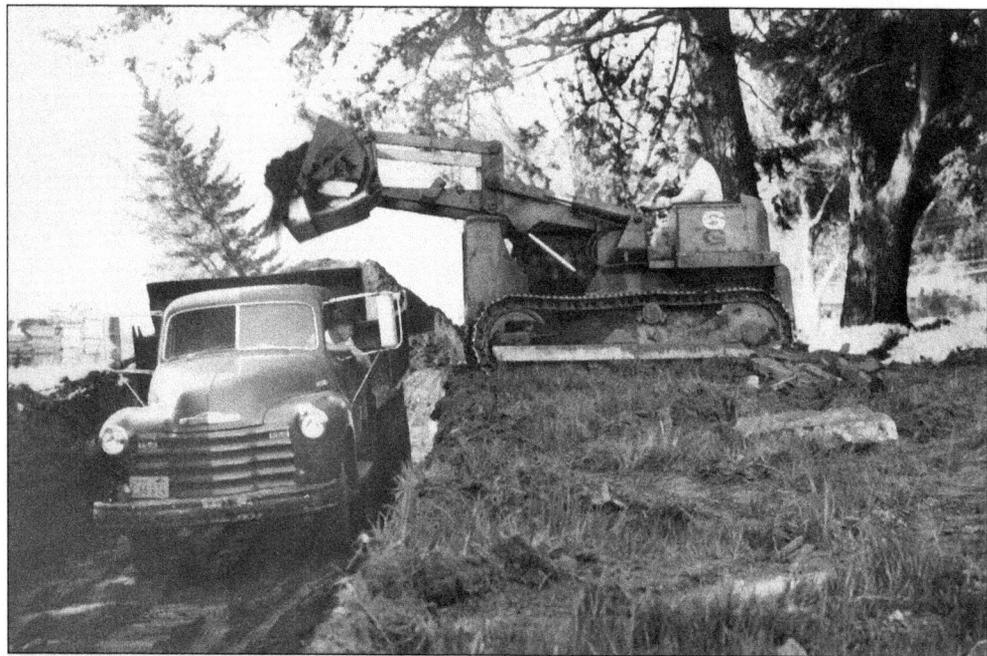

By the late 1960s, construction had begun on a three-stall engine house to store the locomotives. Here, Norman Clark runs the company's Allis-Chalmers tractor, loading a 1947 Chevrolet dump truck while working on grading for the railroad's new yard in front of the engine house.

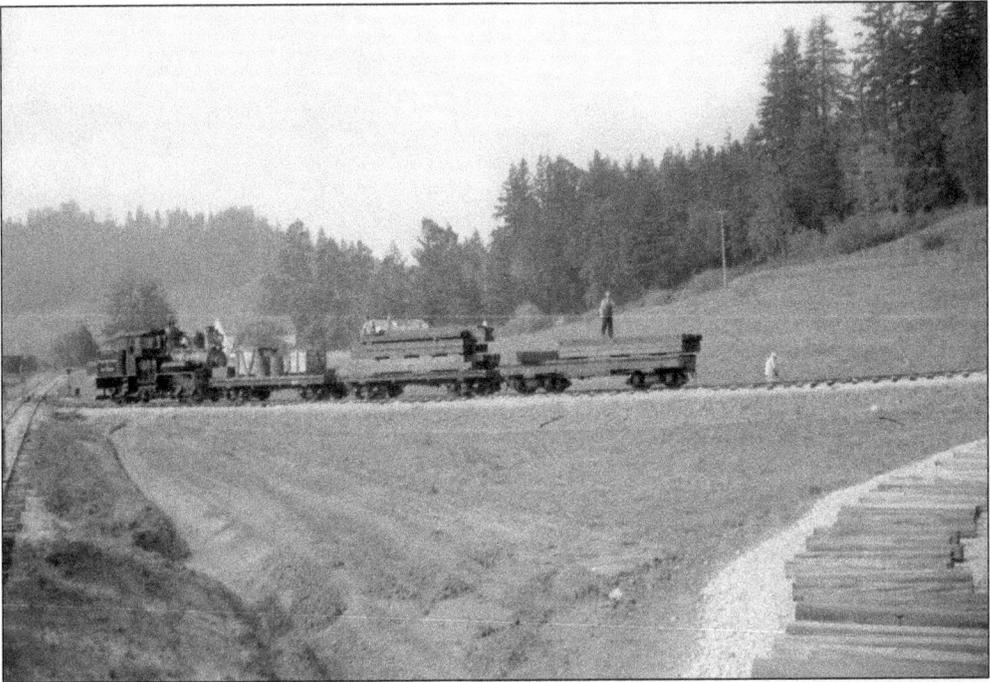

This 1963 photograph of the wye shows the No. 1 with three Westside Lumber Company flatcars loaded with bridge timbers destined for the Indian Creek trestle.

This busy double-headed train, with the No. 1 and the No. 2, is headed upgrade just above Deer Valley in 1965. Such displays of careless firing would not be tolerated today.

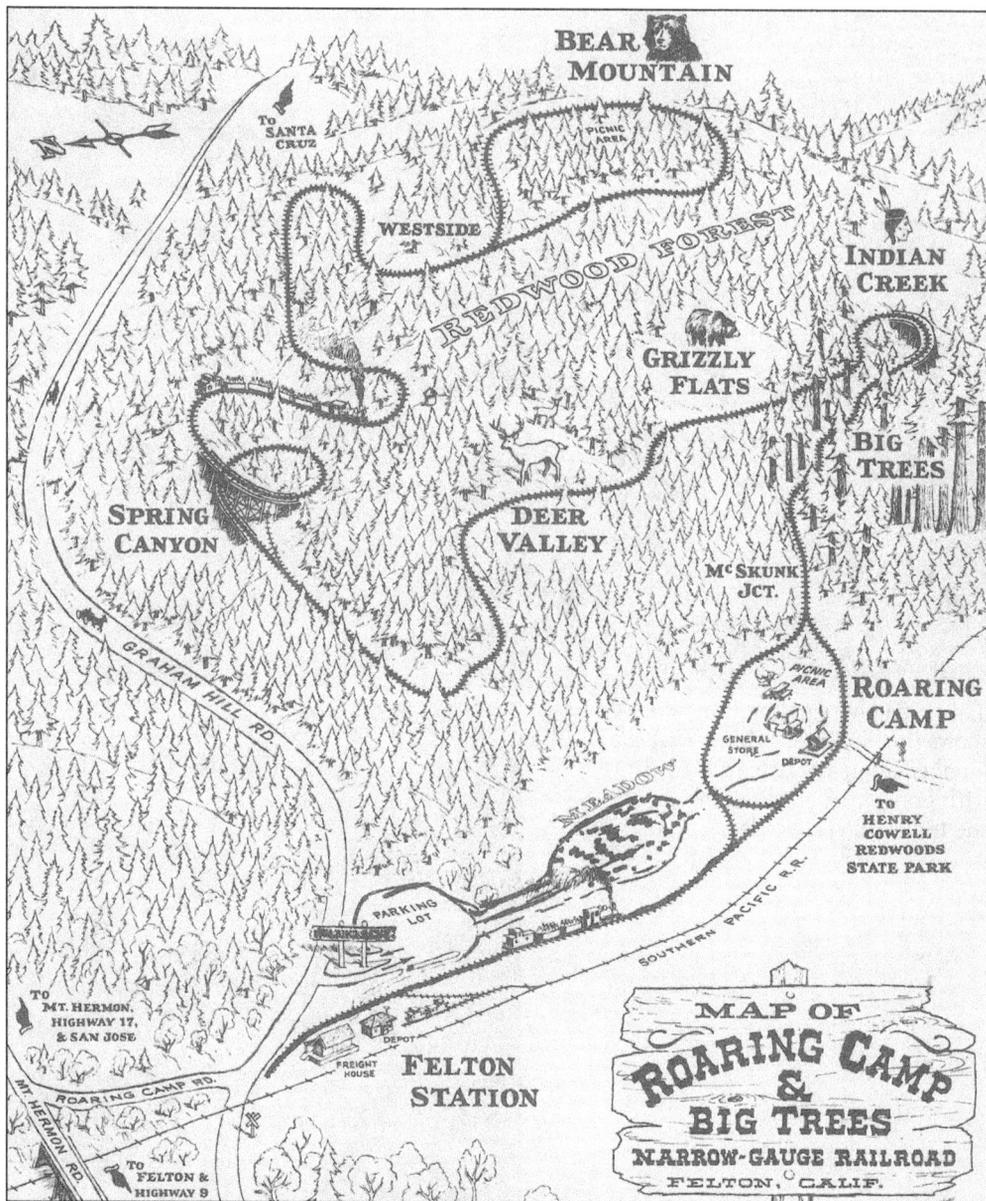

The man responsible for the narrow gauge railroad's layout and the bridge construction is Bradley J. Honholt, a civil engineer based in Los Gatos. He worked together with Norman Clark to lay out the complete roadbed, taking particular care to cut as few trees as possible. Honholt designed and supervised the entire construction, including the trestles.

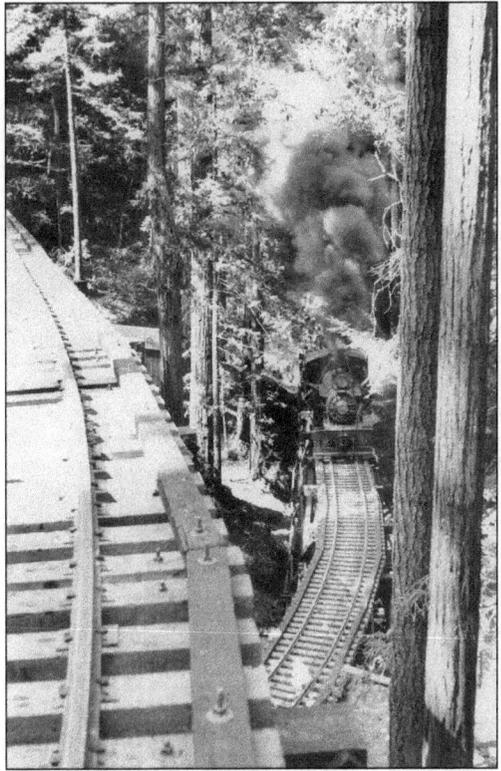

At right, the Heisler pulls out over the low bridge at Spring Canyon with a load of excited and perhaps nervous passengers on board the first train over the bridge. If trains were long enough, passengers could see the locomotive above or below them on the other bridge as the train made the corkscrew loop. Below, just moments later, the Heisler charges out across the high bridge.

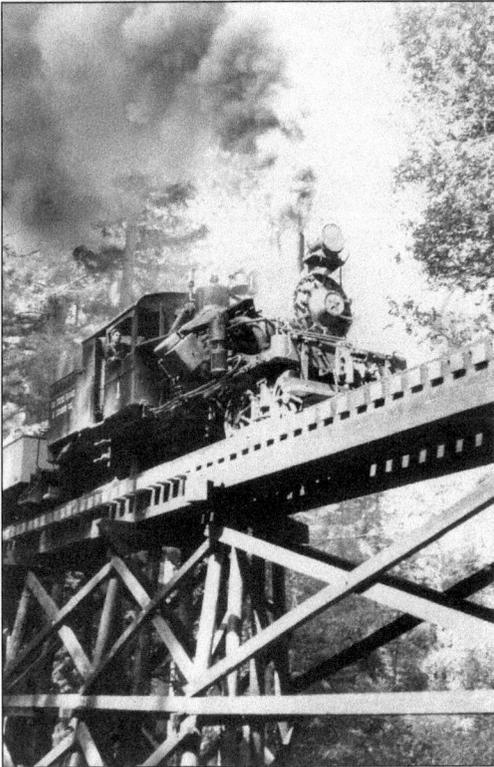

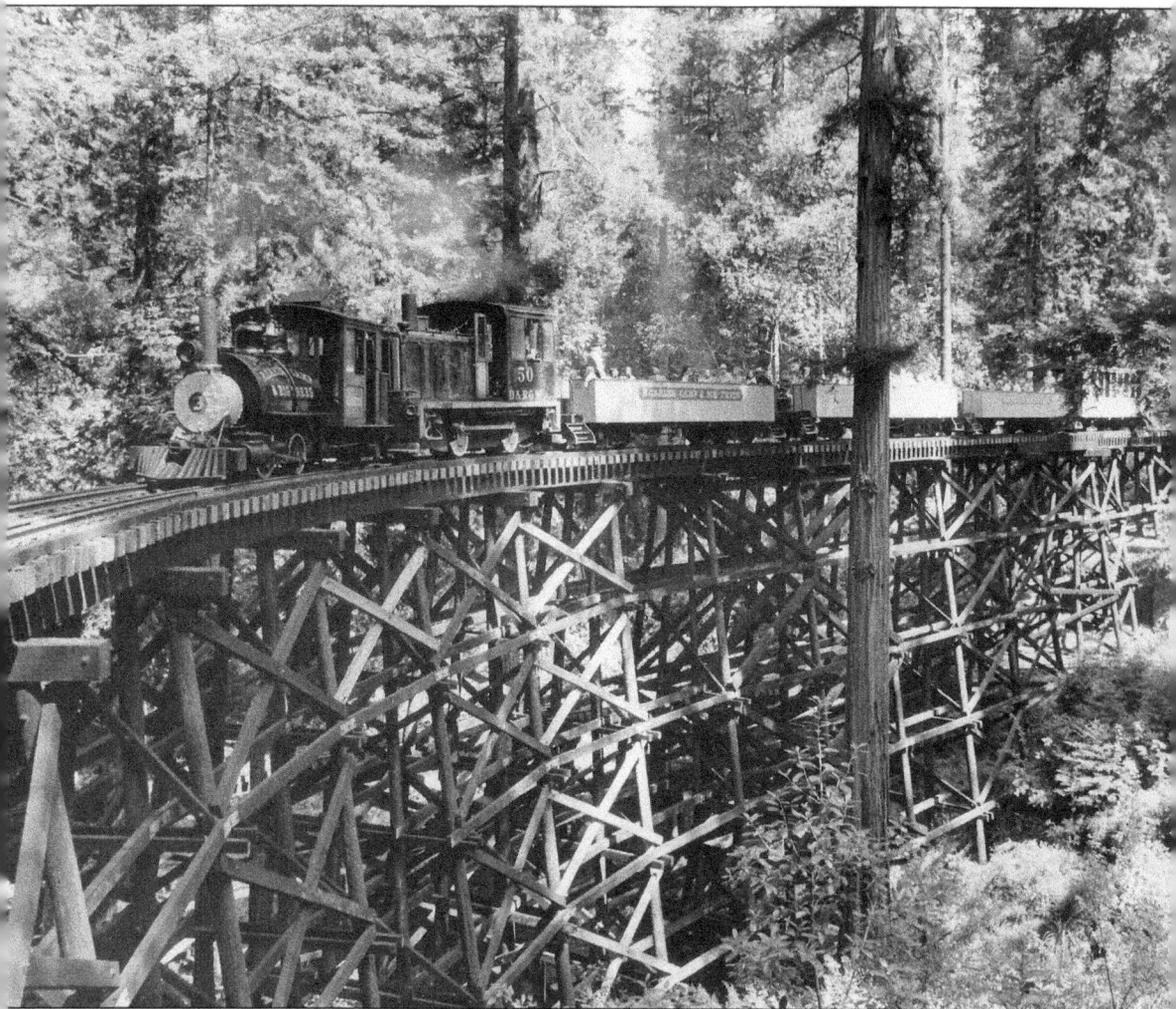

Former Sumpter Valley No. 101, also former D&RGW No. 50, helps No. 3, *Kahuku*, over the high bridge on its way up to Bear Mountain in 1974. This was one of the relatively few times the No. 3 went up the hill. (Courtesy of Jeff Badger.)

Five

WATER AND FIRE

On June 27, 1976, the trestles at Spring Canyon went up in flames. The train to Bear Mountain was on its way back down the hill, and, as they arrived at the top of Spring Canyon, the crew and passengers discovered they were stuck. Over the course of the afternoon, volunteers assisted the California Department of Forestry firefighters in extinguishing the blaze. The *Santa Cruz Sentinel* reported that many people in the area had heard an explosion or something of the sort at approximately the same time that the fire started. The fire was deemed suspicious, and arson was suspected.

Unfortunately, the bridges were a total loss. Roaring Camp's insurance company determined that they would not fund a wooden replacement, only a steel one. Steel trestles, of course, did not fit with Clark's attention to detail and his commitment to historical accuracy. Not to be daunted, Clark vowed that the bridges would be rebuilt eventually, and immediately began laying out a bypass around the area where the fire had occurred, while continuing to run half-fare trains up to Spring Canyon and back.

The bypass took the form of a switchback up the side of a hill adjacent to the trestles. The switchback was constructed over the course of four months and brought the ruling grade on the railroad up to 9.25 percent, making it the steepest narrow gauge railroad in the United States. On October 9, 1976, the switchback was opened with a golden-spike ceremony, and trains were once again able to travel to the top of Bear Mountain. The rains come down in sheets in the Santa Cruz Mountains in wintertime, and as the South Pacific Coast Railroad and the Southern Pacific can attest, keeping a railroad open through the area can be full of challenges. In addition to fire, Roaring Camp has seen its share of mudslides, washouts, downed trees, and all the common difficulties of mountain railroading. To this day, no train leaves the depot without a chainsaw, a shovel, and a length of chain, to be used for towing trees out of the way if necessary

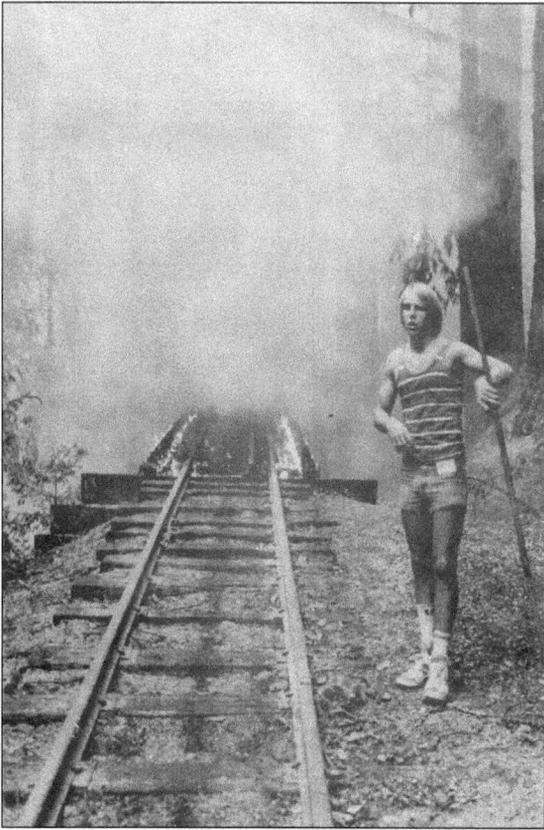

A local volunteer acting as firefighter for the day stands next to the flaming and smoking lower trestle at Spring Canyon on June 27, 1976.

In just four months, the switchback was constructed up the steep hill adjacent to the trestles. Eventually, a portion of the high bridge over what became the switchback tail track had to be pulled down due to safety concerns, however, the rest of the remains still stand today.

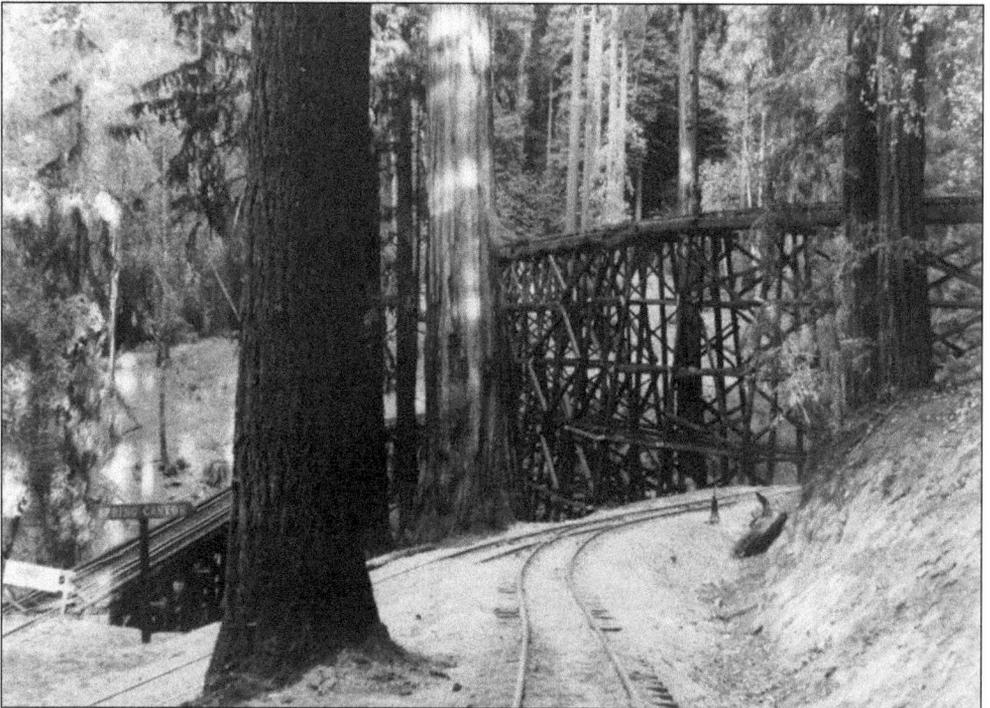

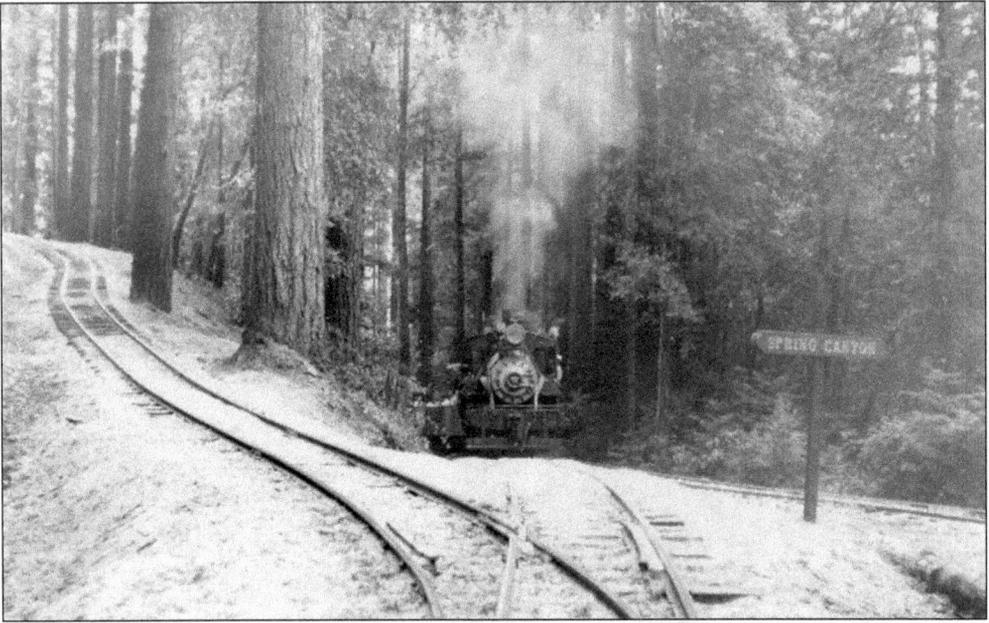

The Heisler approaches Spring Canyon heading upgrade. The track to the lower bridge is on the right, and the lower switchback switch is in the foreground. After passing, stopping, and lining the switch, the crew would then back the No. 2 up the 9.25-percent grade on the ladder track to reach Hallelujah Junction. This is now the steepest portion of the railroad and the steepest narrow gauge track in the United States.

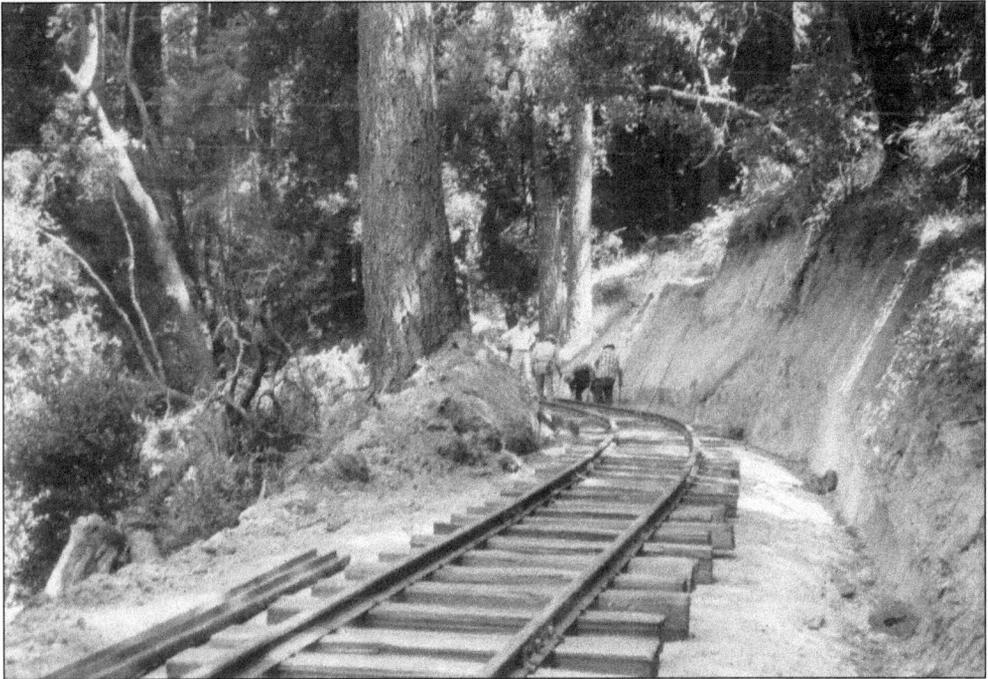

Track work continues above Hallelujah Junction. The trestles at Spring Canyon are down the hill to the left. From near this point, today's passengers can look down on the burned remains of the high bridge.

Tom Shreve stands in a six-foot-deep washout that occurred in the winter of 1982 at Deer Valley. Due to heavy rains, the hillside slid out from under the railroad, leaving it suspended. As seen in the right side of the image, railroad ties were used to crib up the tracks.

More cribbing has been added, and soon after, fresh ballast and soil were dumped here, burying the cribbing and supporting the railroad. This area of the railroad is still moving slowly today. Although a drainage system has been constructed to prevent this from happening again, this 40-foot section of railroad track needs to be raised every few years and have fresh ballast dumped.

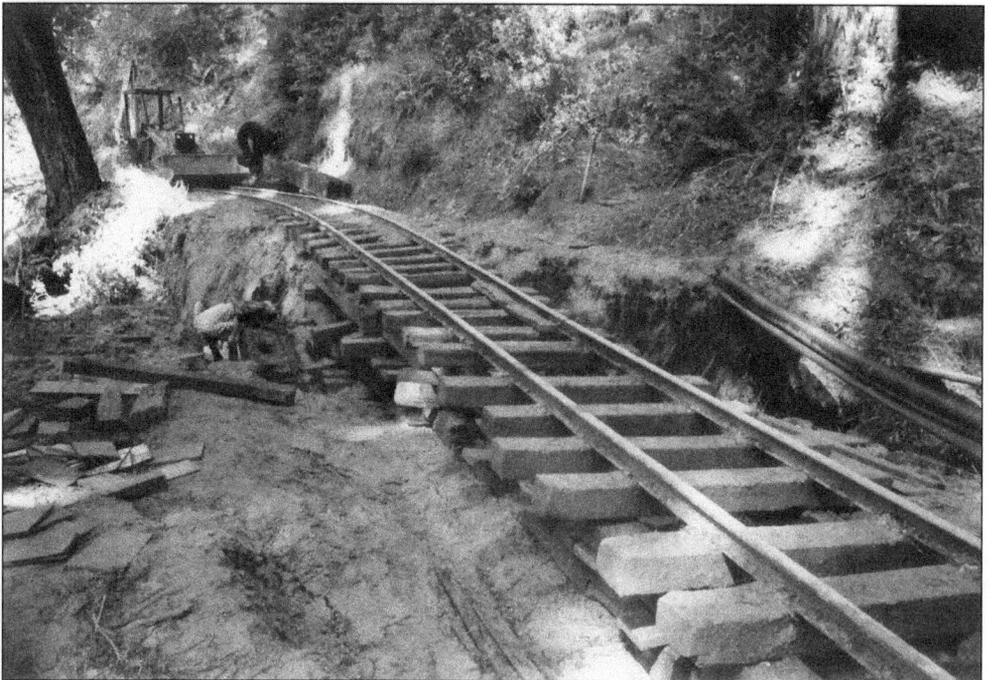

The 1982 washout was certainly not the first time that severe winter storms had wreaked havoc on the railroad. This is what visitors saw next to the door to the Felton depot shortly after Christmas in 1965. Notice that full fare was $1.50 for passage over the two miles of track that had been constructed at that time. The bottom of the sign proudly proclaims that the railroad has carried 108,998 passengers in 358 days.

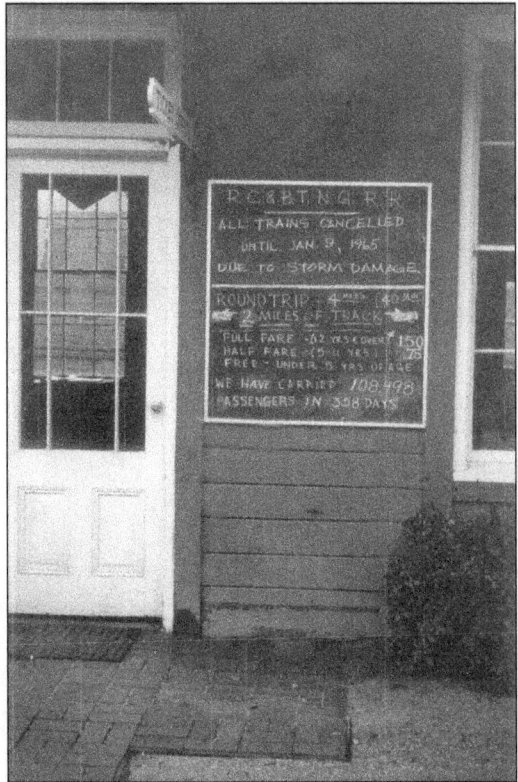

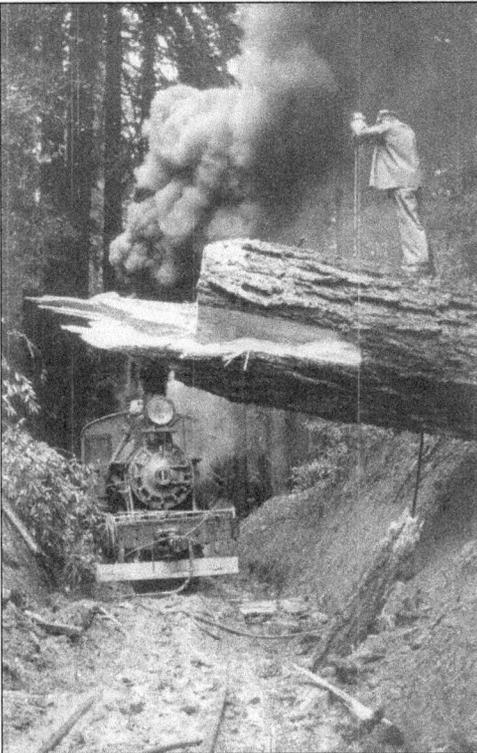

This is a scene that repeats itself with regularity. In March 1965, the Heisler is being used to clear a large Douglas fir tree that came down across the tracks in a windstorm.

The same scene is seen here in 2007. Again, a large Douglas fir came down, taking two redwoods with it. On the left, with his back to the camera, is fireman Christopher Butler, and on the right are several workers from a tree service company. After the tree was cut into sections, the logs were chained to the locomotive and dragged out of the way. (Courtesy of Nathan Goodman.)

Six

SANTA CRUZ, BIG TREES & PACIFIC RAILWAY

In 1981, severe winter storms damaged the Southern Pacific line between Santa Cruz and Olympia. Rather than invest the money to make the necessary repairs, the Southern Pacific elected to simply stop serving the two customers on the line and began negotiating a sale. Upon hearing this news in March 1983, Clark saw an opportunity to realize his original dream of operating passenger service on the line. On February 14, 1985, after 21 months of negotiations with the Southern Pacific, Clark announced that the purchase was complete.

Clark's new railroad was called the Santa Cruz, Big Trees & Pacific Railway (SCBT&P), and work immediately began to reopen the line. Cars and locomotives were procured from across the country. Several flatcars were available south of Santa Cruz, near Salinas, at the old Spreckles Sugar Company. They had been determined to have no value and were about to be scrapped. The cars, built between 1895 and 1915, were donated to the railroad and then trucked in. They were destined to be turned into open-air sightseeing cars, similar to those used on the narrow gauge. Four of them are still in passenger service to this day, and two others are used as maintenance-of-way cars.

As part of the negotiations surrounding the sale of the line, Clark ended up with the Lonestar sand plant's switch engine, a 45-ton Whitcomb locomotive that was the first power on the line. On October 12, 1985, almost 110 years to the day from the opening of the original Santa Cruz & Felton Railroad, the SCBT&P ran its first revenue train as far south as Rincon, about two miles from Roaring Camp. Rincon had been an important stop on the South Pacific Coast Railroad because of the huge lime works Henry Cowell owned there.

Tragically, on December 2, 1985, Norman Clark died of pneumonia, resulting from his tireless work reopening the line the rest of the way to Santa Cruz. He was succeeded by his wife and longtime vice president of operations, Georgiana Clark. On October 12 1986, exactly one year after the line was opened, Georgiana saw her late husband's goal realized, with the first through-train to Santa Cruz. On April 11, 1987, the first train arrived at the Santa Cruz Beach boardwalk.

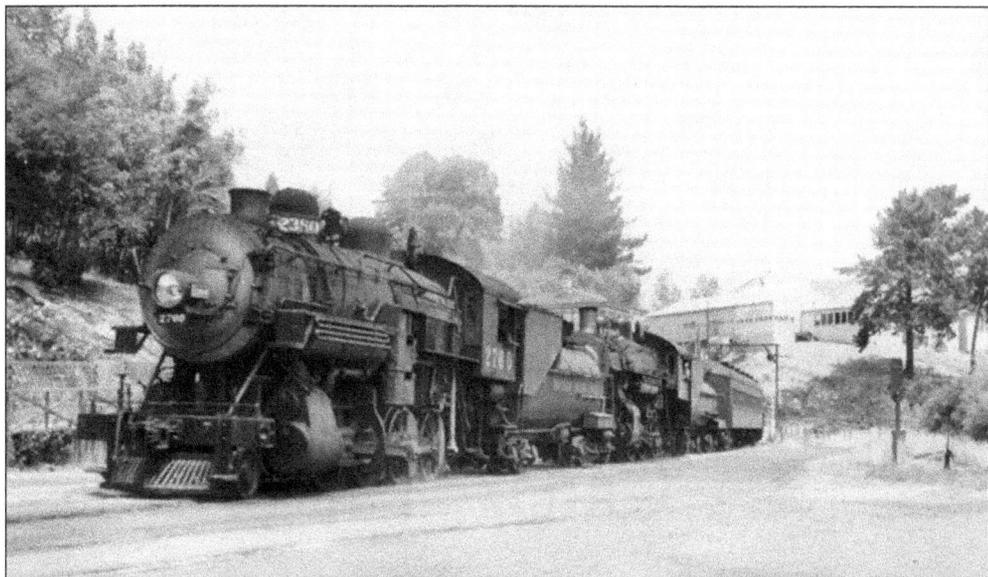

Southern Pacific No. 2760 leads a double-headed passenger train out of Mission Hill Tunnel in Santa Cruz. This is the final tunnel on the route over the hill from San Jose. As the train rounds the curve, it will run down the middle of Chestnut Street until it reaches the Santa Cruz yard and depot. The switch stand and spur in the right foreground led to the site of the first railroad yard in Santa Cruz proper. Eventually, the yard was moved to its current location south of Laurel Street because of the need for more space. The area on the right is now occupied by duplexes. (Courtesy of Will Whittaker.)

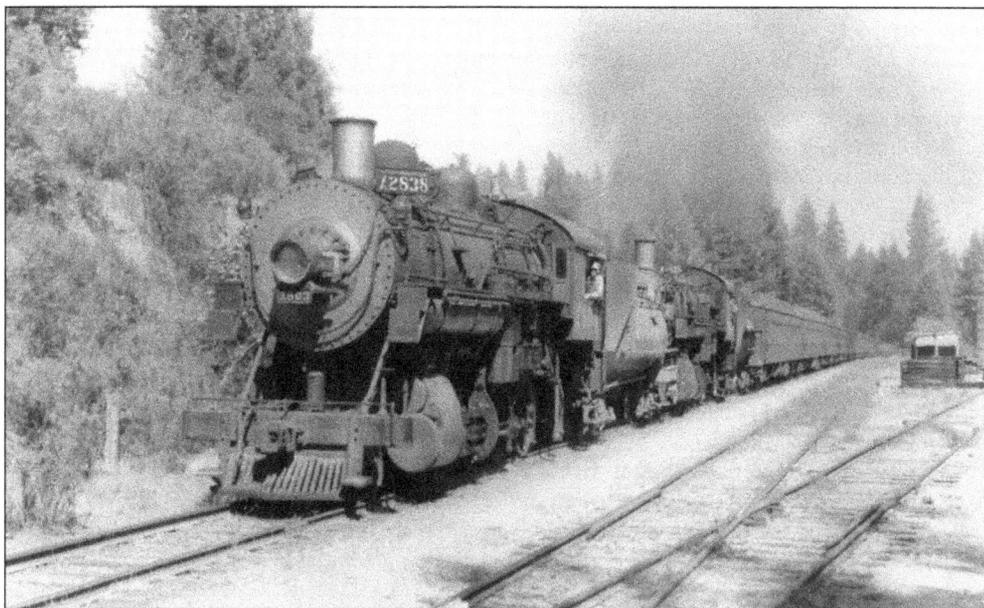

Southern Pacific No. 2803 pulls a long double-headed passenger train bound for San Francisco north through Rincon in 1938. The train has just crested the stiff three-percent grade out of Santa Cruz, and from there, it is flat the rest of the way to Felton. After the stop in Felton, the grades pick up again to take the train to the summit tunnel and then down into Los Gatos and San Jose. (Courtesy of Will Whittaker.)

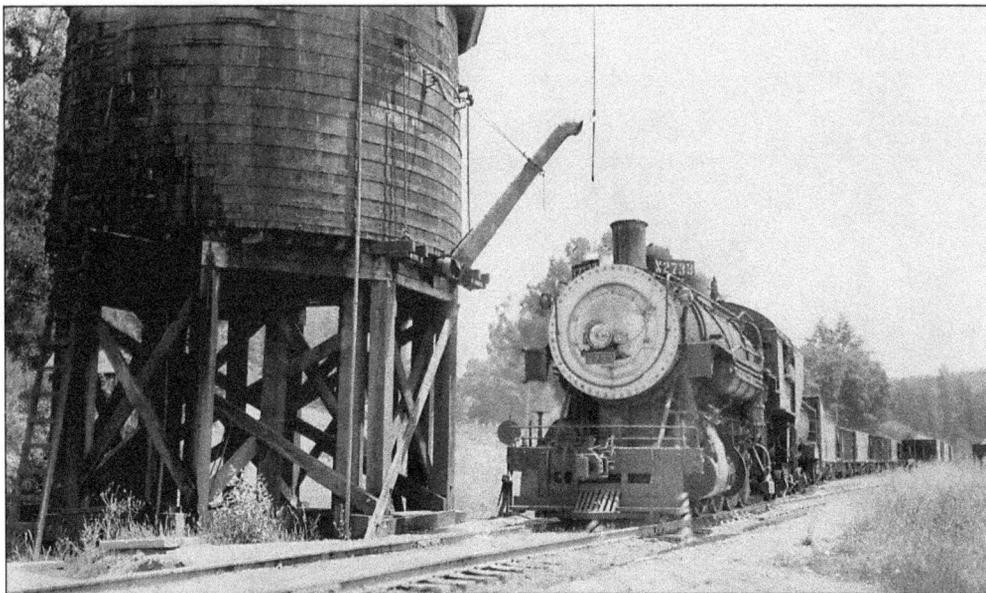

Southern Pacific No. 2733 is seen here on the head end of the "Sand Job" train at the Felton water tank. Judging by the trackside conditions and the abundance of hopper cars in the yard, this photograph was taken well after the mountain route had been abandoned in 1940. (Courtesy of Will Whittaker.)

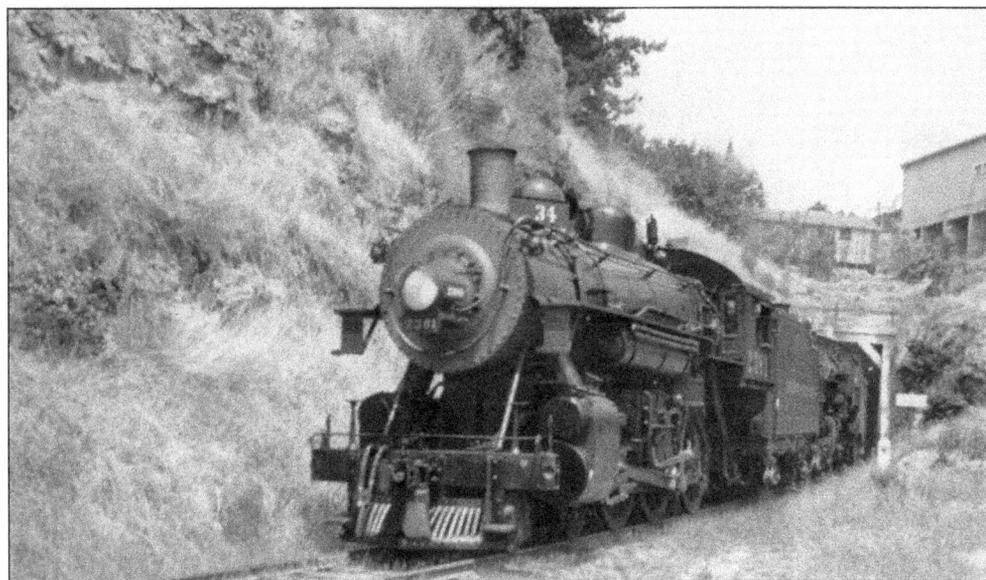

Southern Pacific No. 2381 leads train 34 out of Mission Hill Tunnel heading south. This site was where the original South Pacific Coast Railroad's Santa Cruz depot stood. Today, the Santa Cruz, Big Trees & Pacific trains travel through this same tunnel portal on their way to the beach in Santa Cruz. (Courtesy of Will Whittaker.)

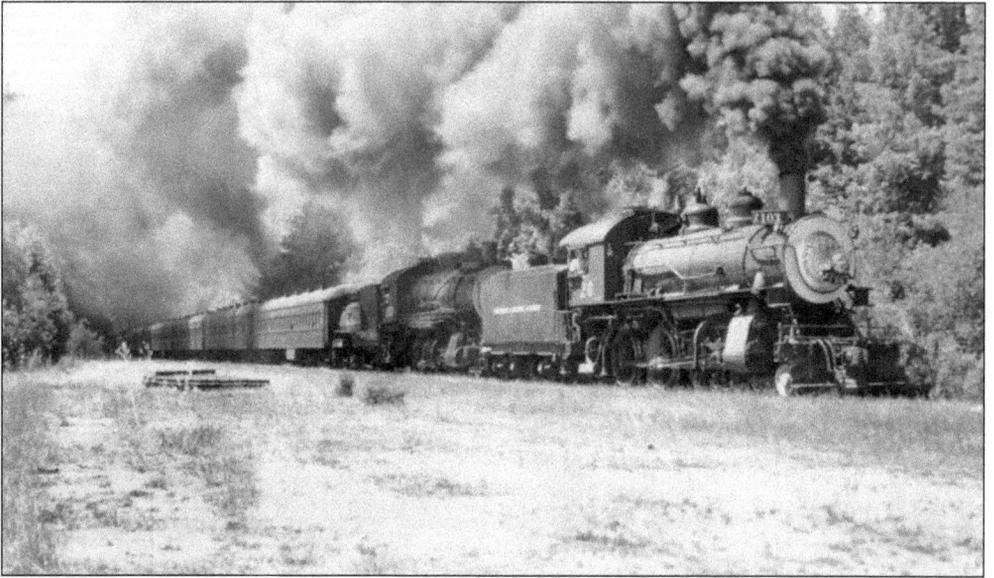

On July 23, 1950, a double-headed railfan special was run throughout Santa Cruz County on Southern Pacific trackage, using San Diego & Arizona Eastern Nos. 26 and 130. Here, the special train puts on a show headed southbound to Santa Cruz at Rincon. (Courtesy of Will Whittaker.)

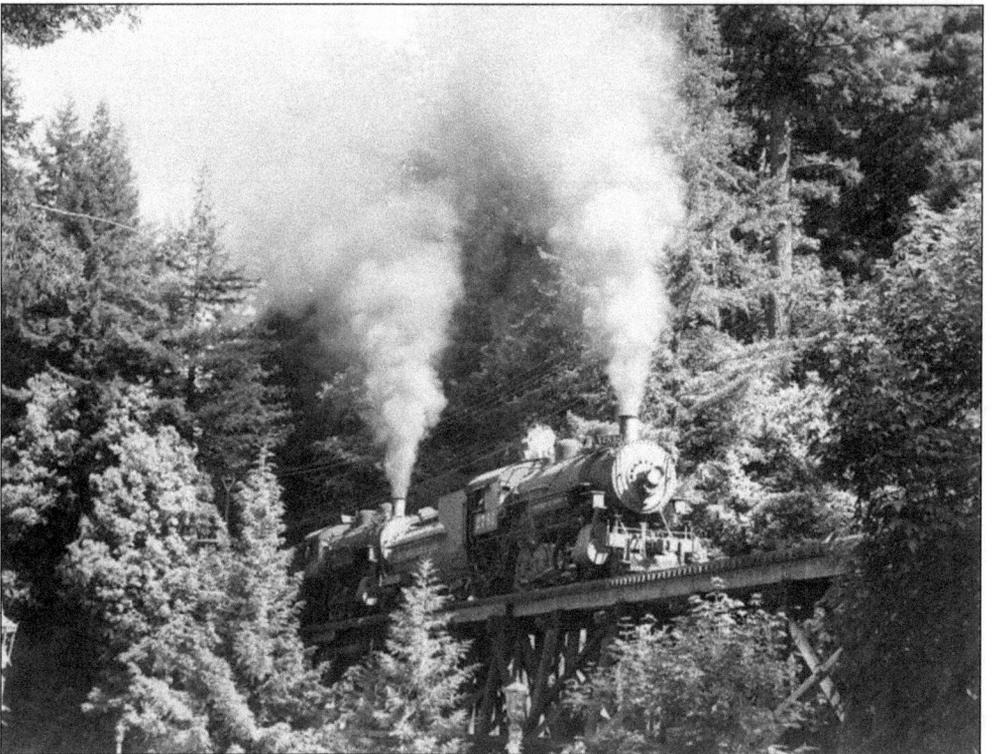

Southern Pacific No. 2781 and a helper cross the trestle at Shady Gulch. Today, on the Santa Cruz, Big Trees & Pacific, this spot is also known as Powder Creek, after the California Powder Works, which used to make gunpowder in the valley below and was one of the South Pacific Coast Railroad's big customers. (Courtesy of Fred Stoes.)

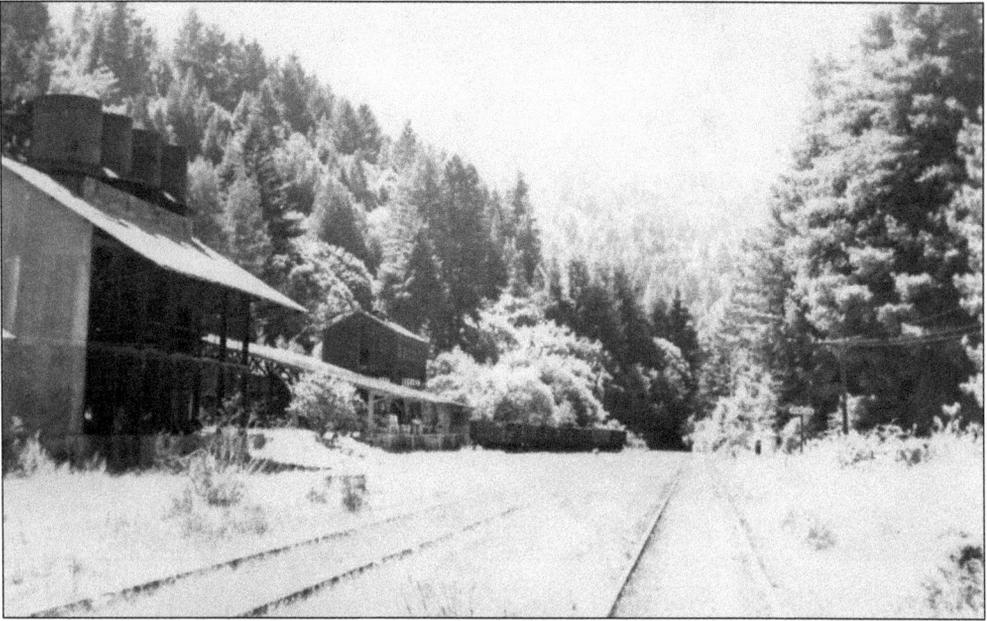

Seen here are the limekilns at Rincon, which is the highest point on the railroad between Felton and Santa Cruz and used to be the site of several limekilns owned by Henry Cowell. The kilns shown here ran until shortly after World War II, but the first kilns on the site were built in the 1870s. Old-time residents of Felton could always identify the kiln workers, as they often had burns and scars on their faces. (Courtesy of Jim Vail.)

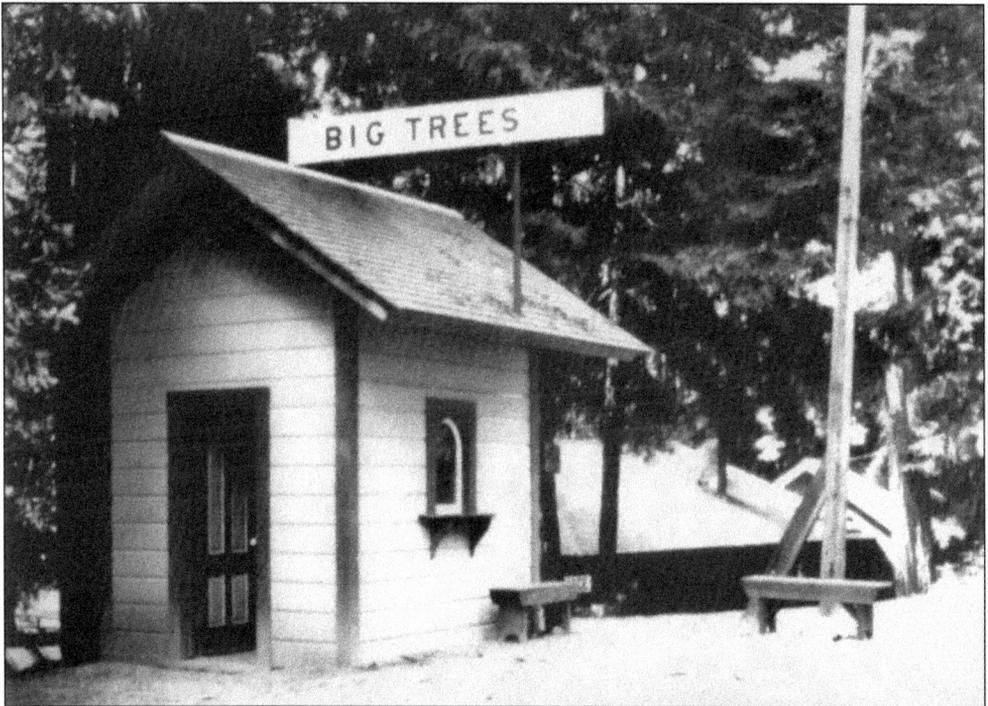

This small structure at the Big Trees station served as the official stop for trains carrying passengers to visit the giant redwoods at the Welch Big Trees Grove and later Henry Cowell State Park.

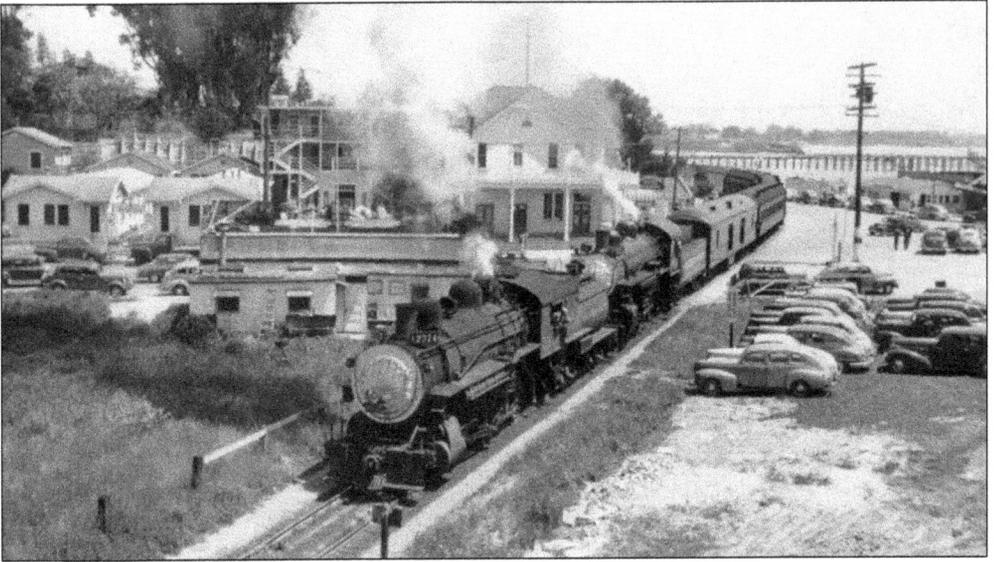

Trains have been rolling down Beach Street for more than 100 years. The Southern Pacific Suntan Special is seen above in the 1940s, and the Big Trees Beach Train is seen below in the 1980s, both at the same location, leaving the street trackage on Beach Street and entering the Santa Cruz yard. (Above, courtesy of Will Whittaker.)

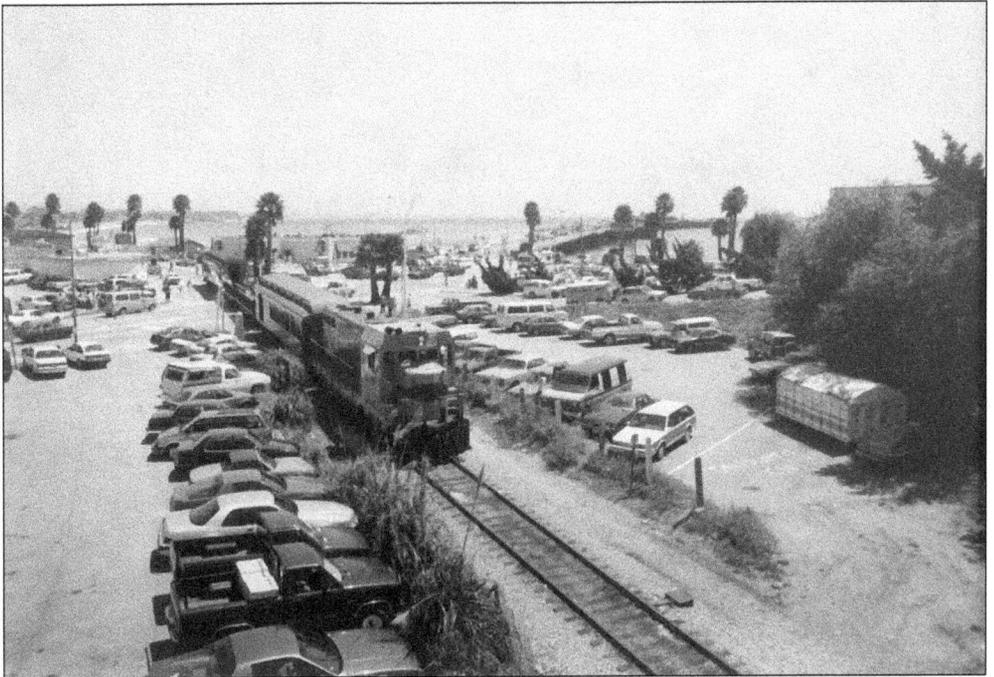

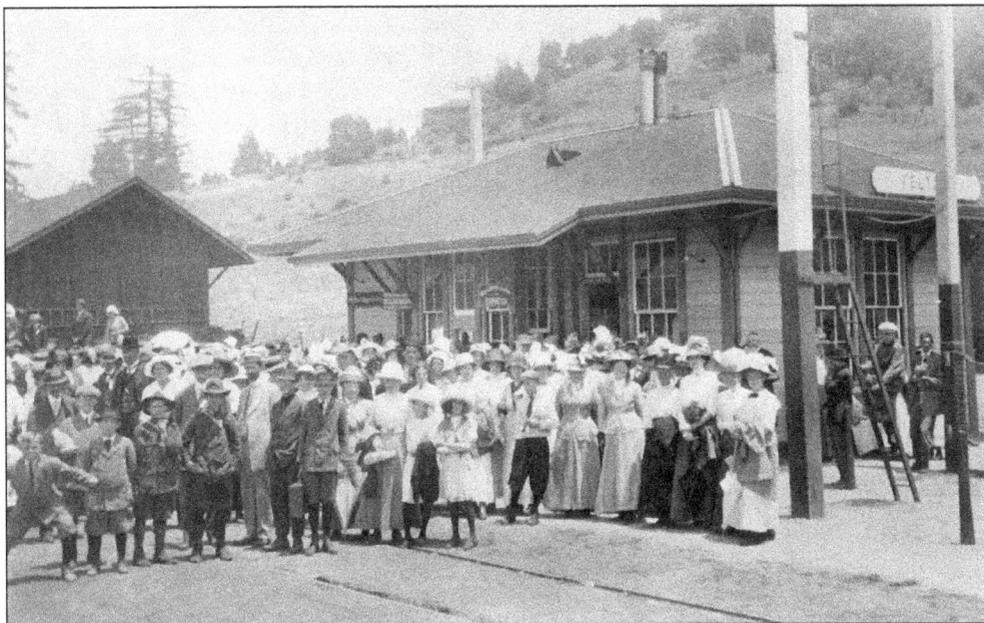

Passengers and patrons have assembled for this photograph on a busy day at the Felton depot in the early 1900s.

Southern Pacific's Felton local, the "Sand Job," passes through the Felton yard on its way from the Lonestar Industries sand plant in Olympia to Santa Cruz, and eventually to Watsonville in the waning days of the Southern Pacific's ownership of the branch line.

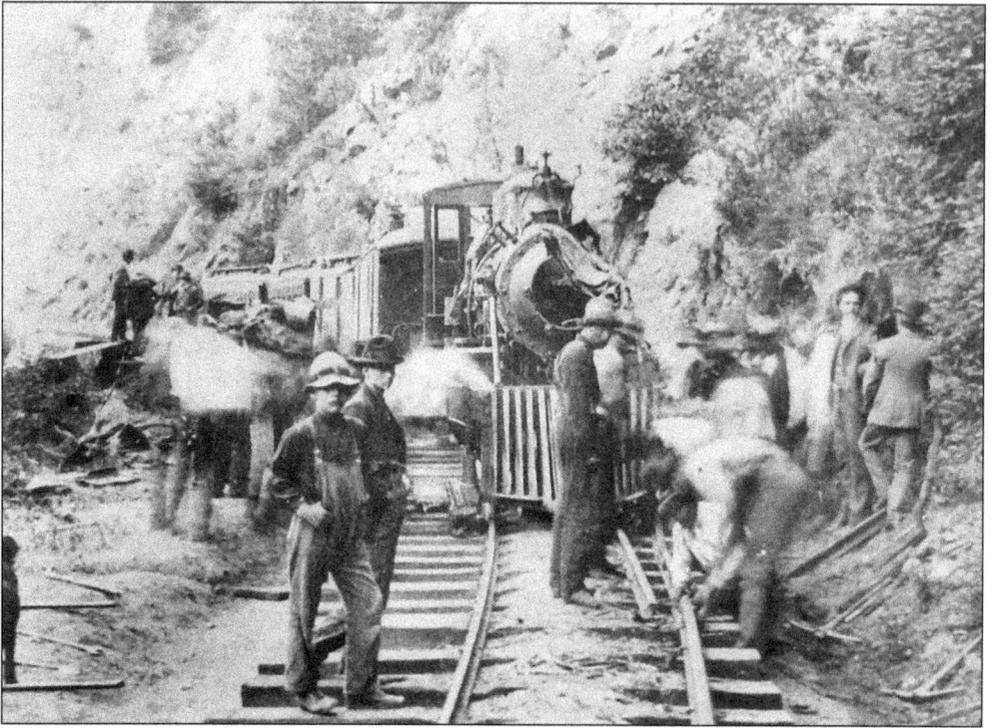

The minor mishap above occurred in the late 1870s on the South Pacific Coast Railroad at Inspiration Point, and was blamed on excessive speed. The locomotive hit the dirt and bounced off the rock cliff but was towed off, rebuilt, and saw many more years of service. Below is the same site more recently, seen from the engineer's seat of Santa Cruz, Big Trees & Pacific locomotive No. 2641. (Below, courtesy of Beniam Kifle.)

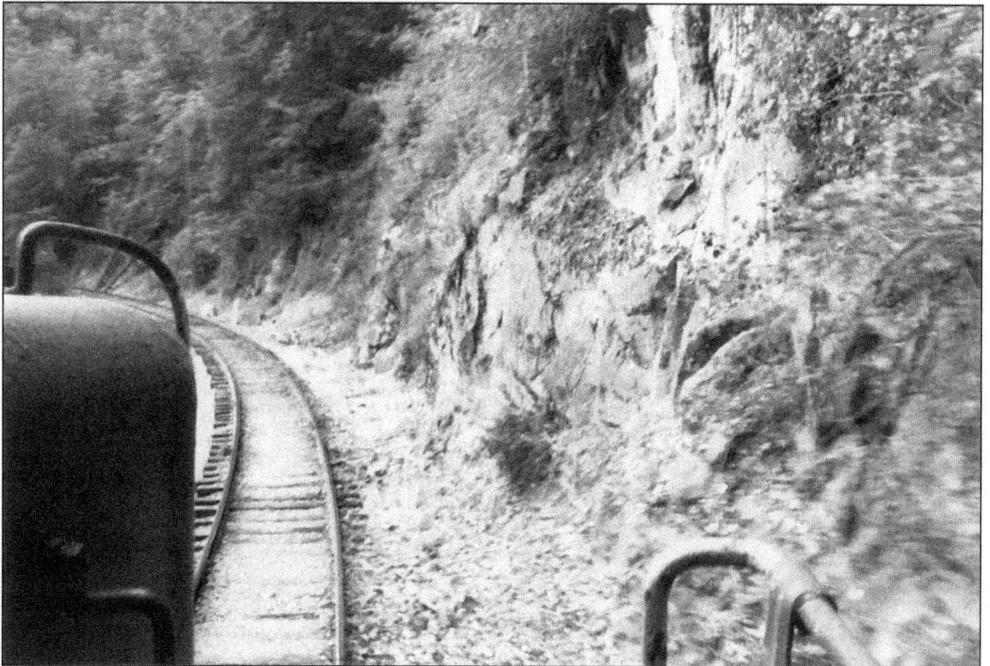

STARTING SUNDAY MAY 29!

Every Sunday this summer
AND MONDAY, JULY 4 AND MONDAY, SEPT. 5 (LABOR DAY)

SANTA CRUZ BEACH
AND BACK!

on the "Sun-Tan Special"

$2 25

ROUND TRIP

FROM SAN FRANCISCO

AND OAKLAND

From BURLINGAME $2.00 Roundtrip	*All fares plus Federal tax*
From PALO ALTO 1.75 Roundtrip	GO AND RETURN
From SAN JOSE. 1.50 Roundtrip	SAME DAY

S·P The friendly Southern Pacific

See reverse side for details and schedule ➡

This Southern Pacific promotion advertises the "Sun-Tan Special," the train that would bring beachgoers from the San Francisco area to the boardwalk in Santa Cruz. Until 1939, the train arrived via "the hill," passing through Felton and the current location of Roaring Camp. When the Southern Pacific closed its Mountain Division, the train was rerouted via Watsonville Junction.

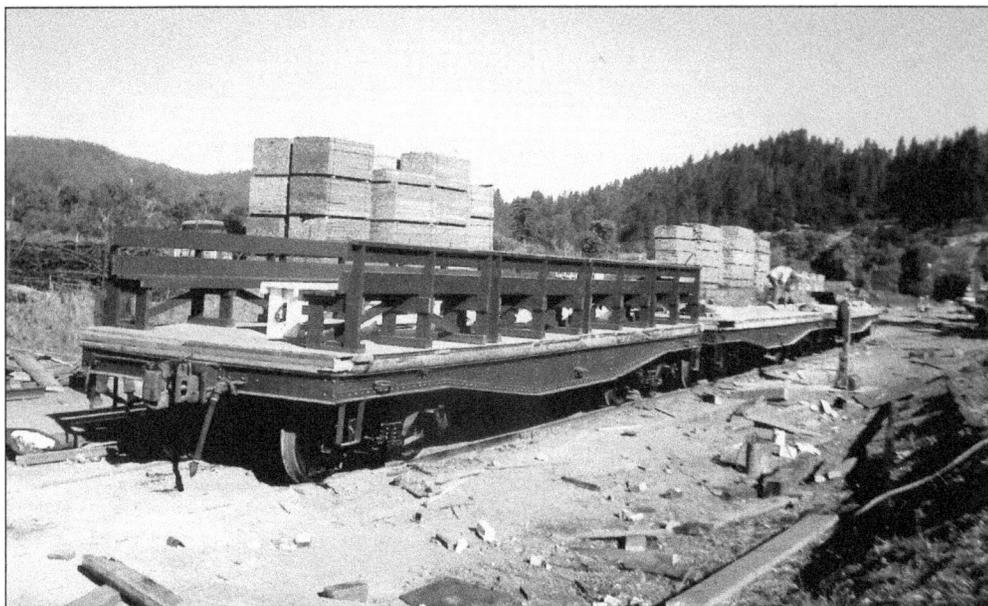

These 1920s-era flatcars were donated to the Santa Cruz, Big Trees & Pacific by the Spreckels Sugar Company, a few miles south of Salinas. Upon their arrival, the flatcars were converted to open-air excursion cars, seen here under construction here in the Felton yard. Luckily, they did not have to go far to buy wood for the project, as the San Lorenzo Lumber Company was right next door.

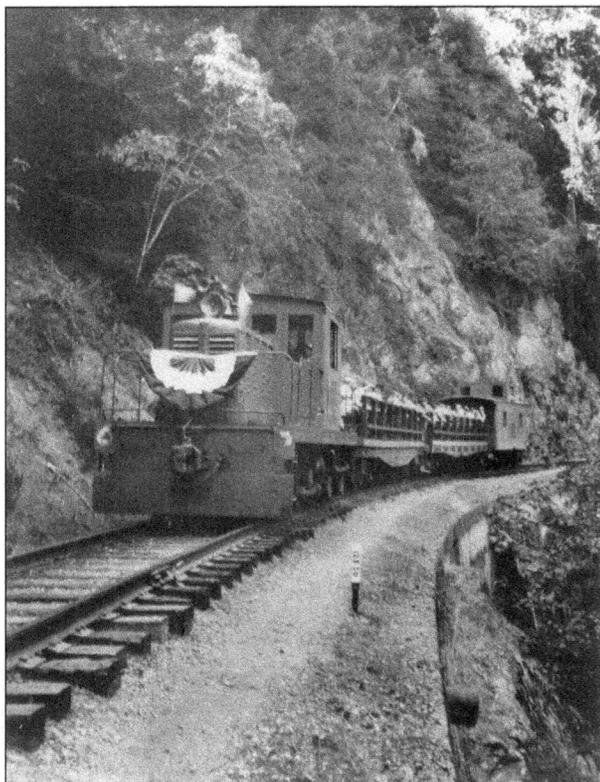

The first Santa Cruz, Big Trees & Pacific passenger train bound for Santa Cruz comes around Inspiration Point on September 6, 1986. The point features a spectacular view of the San Lorenzo River Gorge 100 feet below the tracks, which pass over a concrete arch built in 1909 as part of the Southern Pacific's standard-gauging of the line.

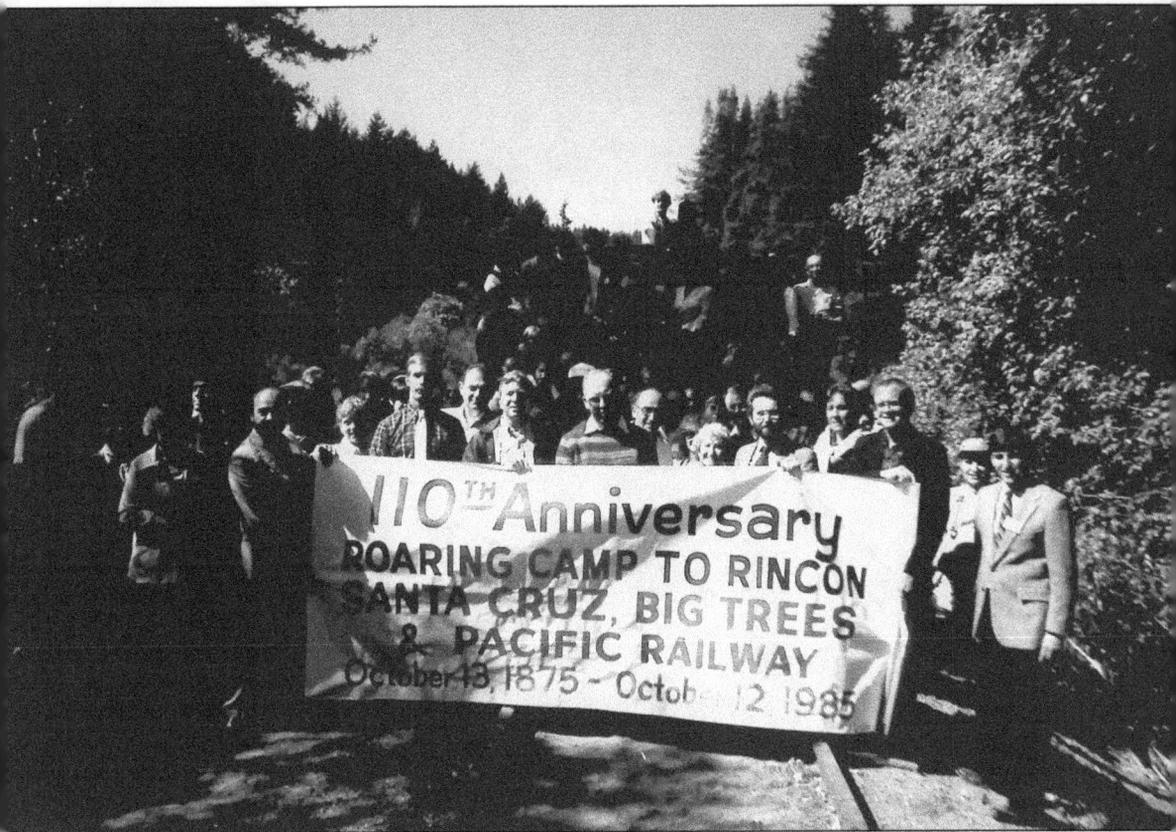

On October 12, 1985, Norman Clark (center, directly behind banner, with striped sweater and glasses) and the employees of Roaring Camp celebrated the 110-year anniversary of trains running between Felton and Rincon, about 1.5 miles to the south. Sadly, Clark did not live to see his train arrive in Santa Cruz.

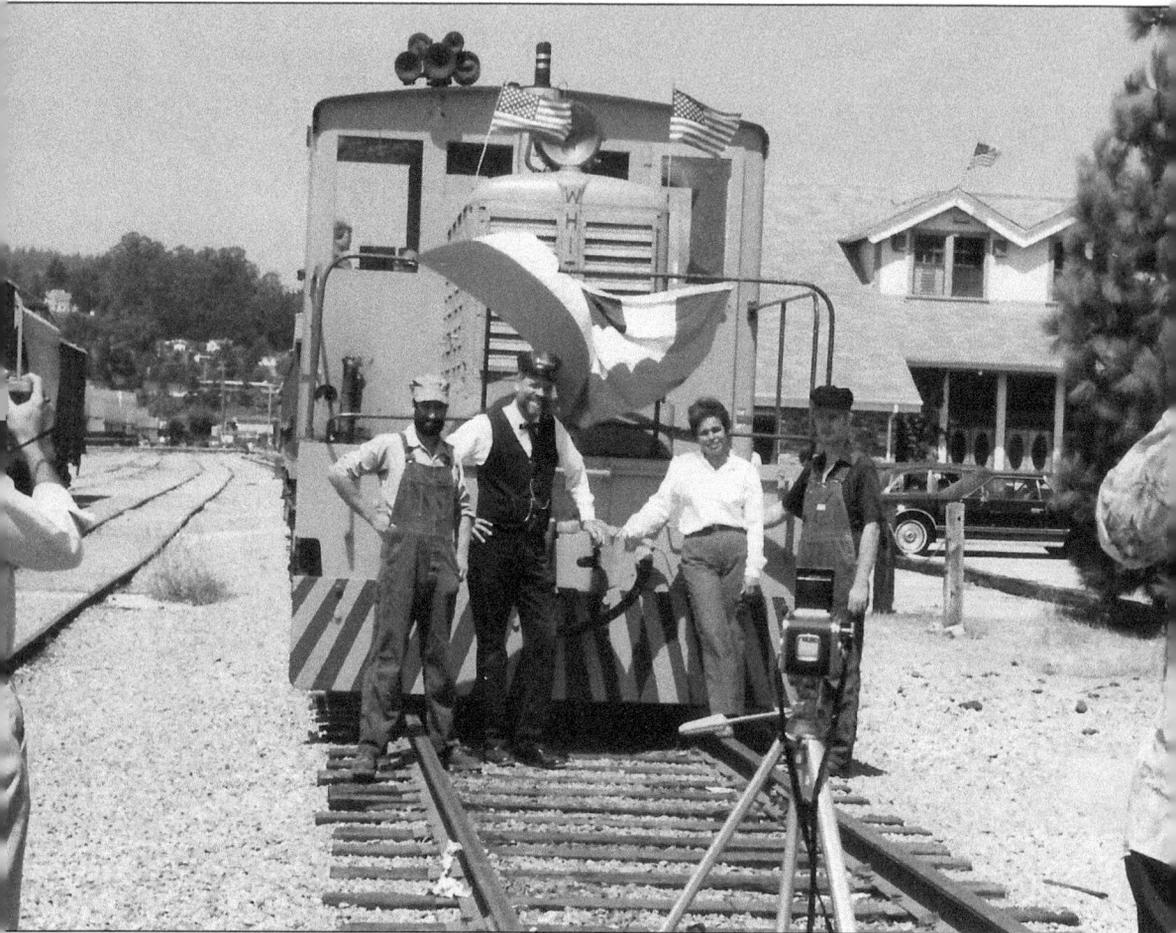

Roaring Camp CEO Georgiana Clark poses with the crew of the first Santa Cruz, Big Trees & Pacific train to arrive in Santa Cruz, on September 6, 1986, which started a tradition of bringing passengers "from trees to shining seas."

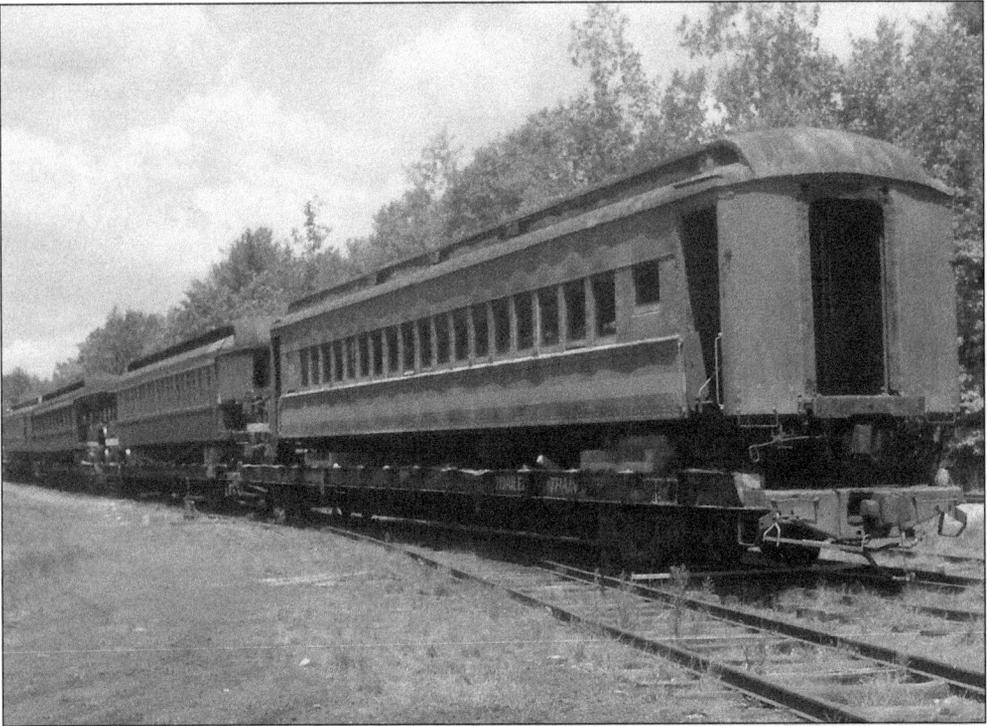

With their trucks removed and car bodies tied down securely to flatcars, five coaches are ready to be shipped from the Wolfeboro Railroad in New Hampshire out to California.

The crewmen of the Wolfeboro Railroad pose for the last time with their rolling stock before its dismantlement and shipment to the other side of the country.

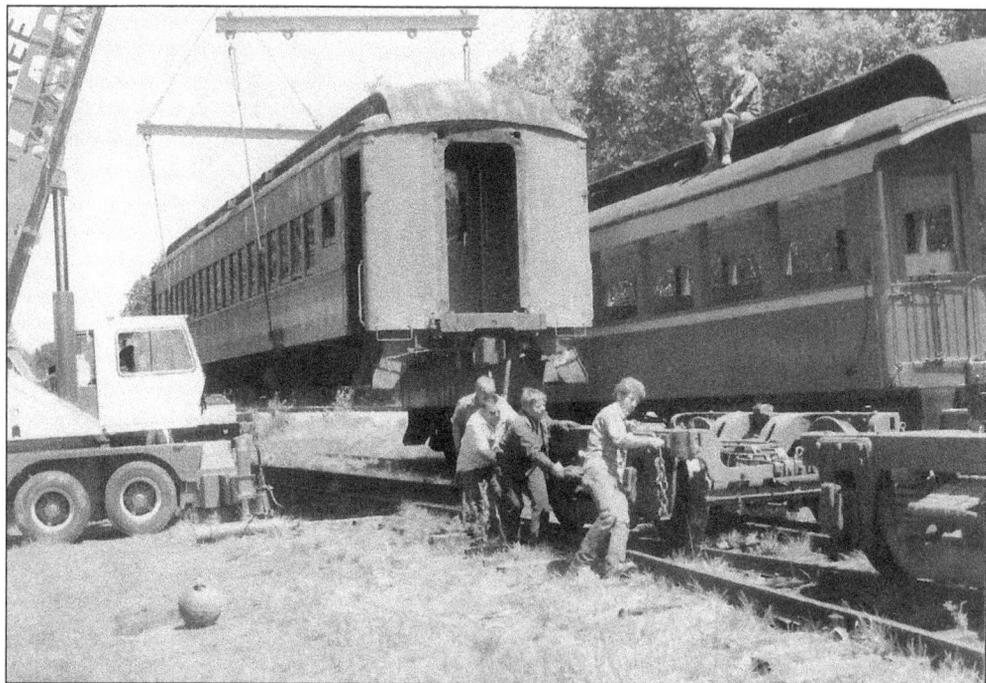

One of the steel ex–Jersey Central Lines coaches is having its trucks removed as part of its preparation for shipment via rail to the Santa Cruz, Big Trees & Pacific.

Jack Hanson (left) and Tim Landre pose in front of the short "bobber" caboose that was used on the first few trains to Santa Cruz. The longtime conductors worked on both the standard gauge Big Trees line as well as on the narrow gauge Roaring Camp steam trains.

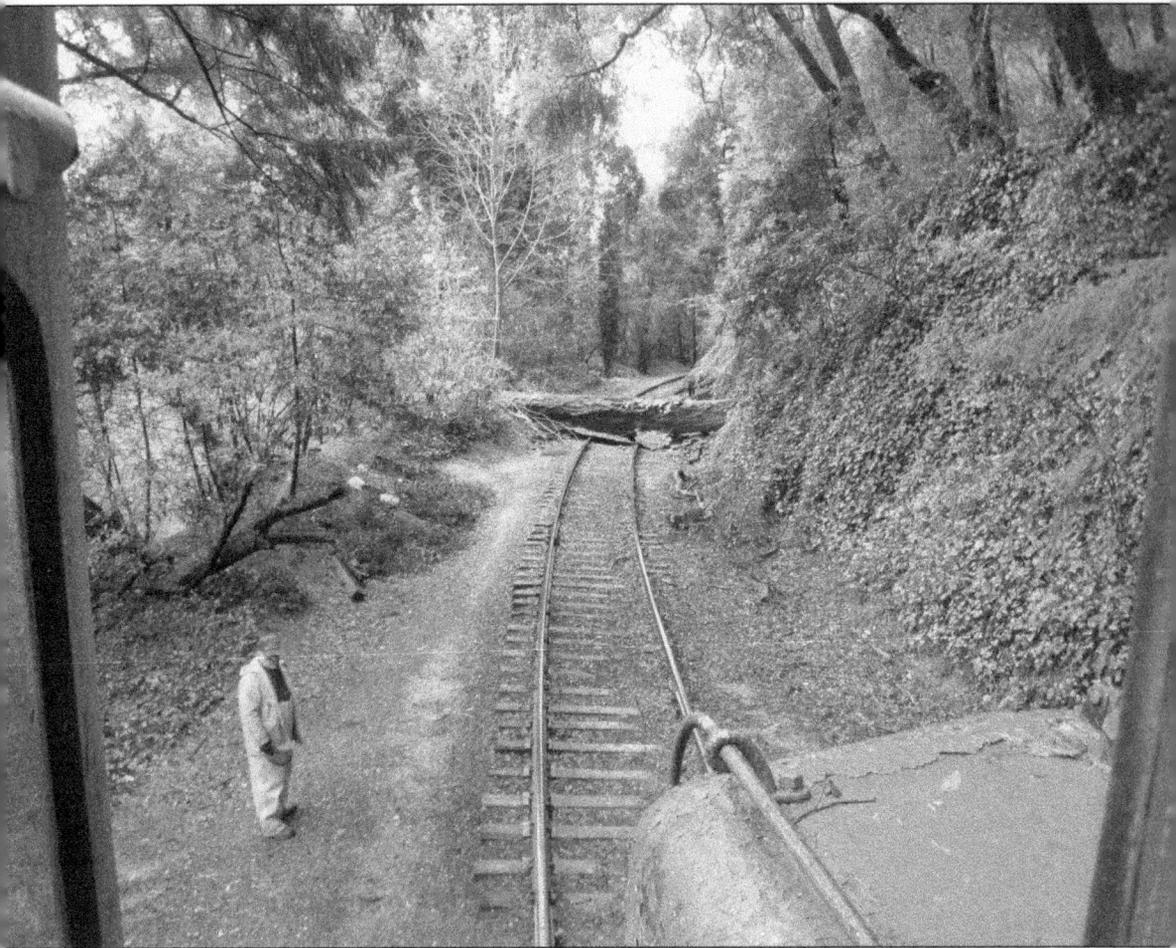

This view from the cab of Santa Cruz, Big Trees & Pacific No. 2600 in 2009 looks out at a giant, downed Douglas fir tree. Track foreman Juan Garcia looks on. Garcia retired from working as a maintenance-of-way foreman for the Southern Pacific Railroad in Watsonville. He now oversees track maintenance for both the standard gauge and narrow gauge railroads. (Courtesy of Nathan Goodman.)

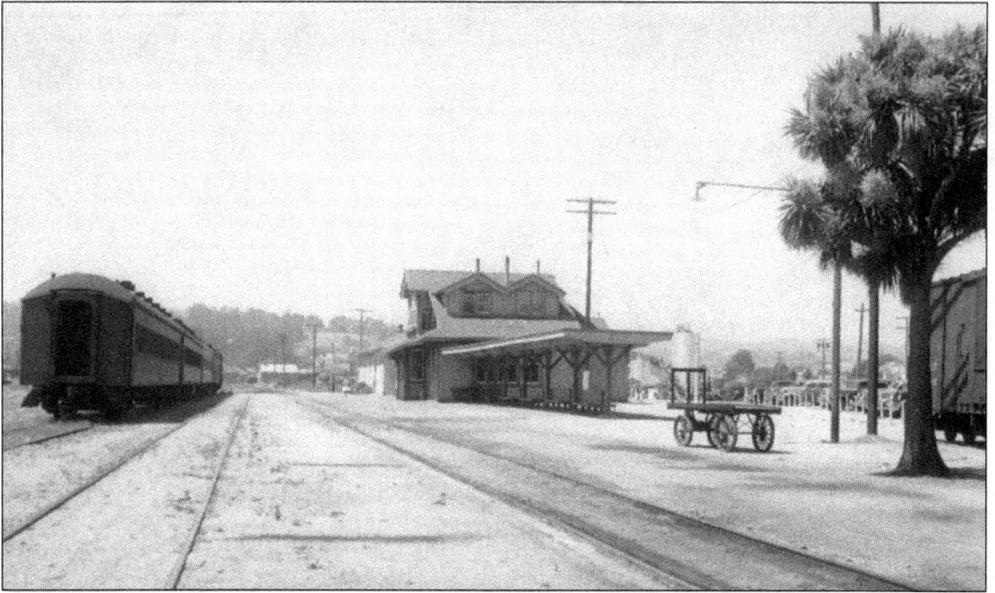

The Union passenger depot in Santa Cruz (above) was built in 1897 after Southern Pacific purchased the South Pacific Coast Railroad. At one time, as many as 20 passenger trains per day arrived and departed from the historic structure. Below, the depot greets the first Santa Cruz, Big Trees & Pacific train to Santa Cruz, on September 6, 1986, exactly 37 years after Santa Cruz saw the last passenger train in town. Unfortunately, the station burned down in 1996. (Above, courtesy of Will Whittaker.)

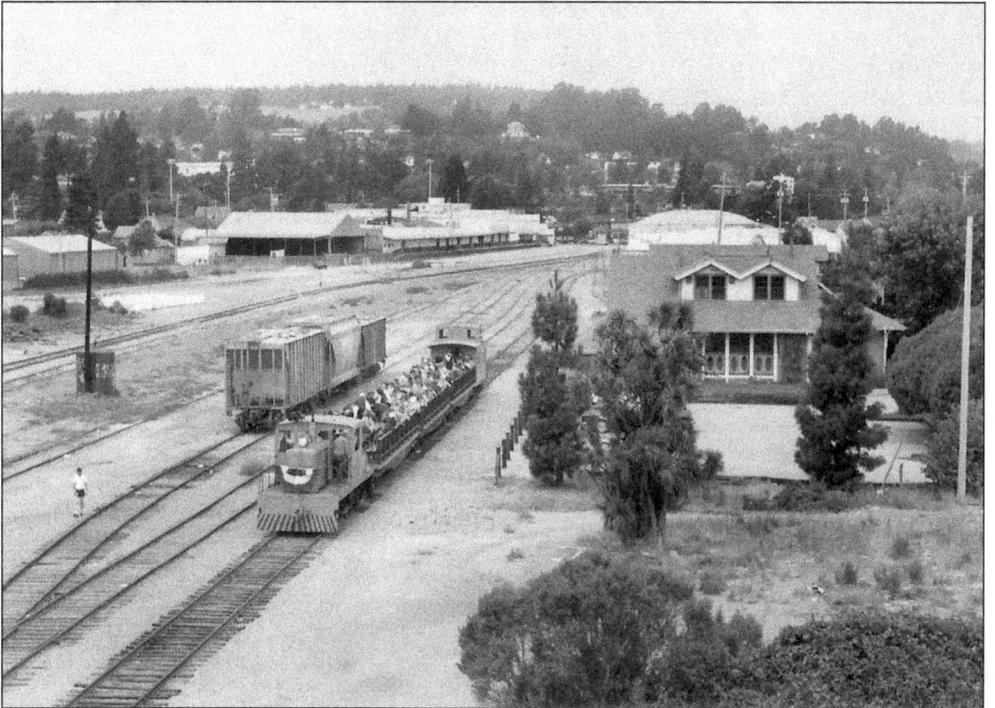

Atchison, Topeka & Santa Fe No. 2641 is seen here joining newly purchased coaches from the Wolfeboro Railroad, and the train is ready to leave the yard for the first trip on its new home turf. The coaches are a mix of steel-rolling stock originally built for the Central Railroad of New Jersey in the 1920s and wooden equipment built by the Boston & Maine Railroad in the early 1900s.

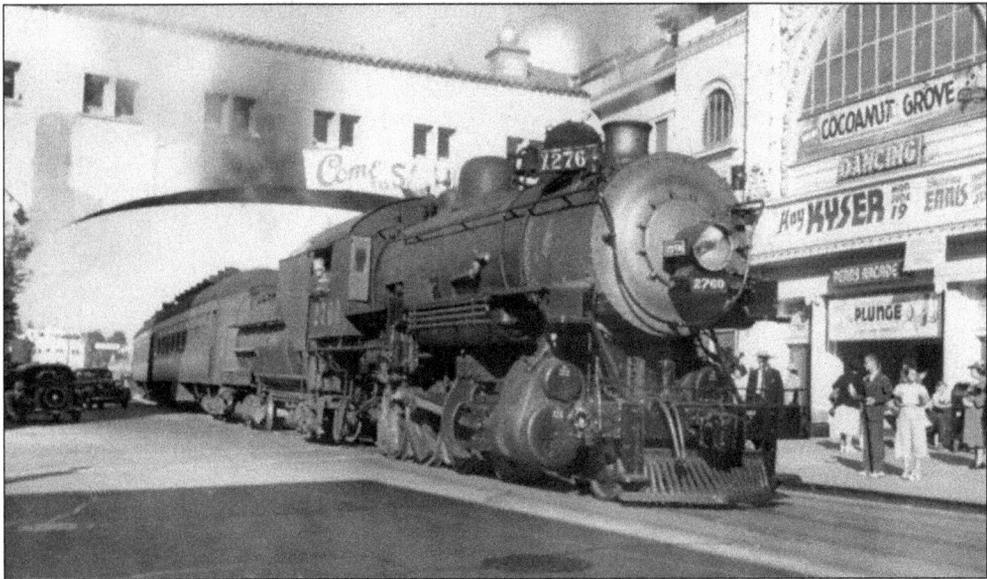

Southern Pacific No. 2760 is seen here at the Santa Cruz boardwalk casino stop. The covered walkway leading to the Casa Del Ray Hotel from the boardwalk was removed soon after this photograph was taken. (Courtesy of Will Whittaker.)

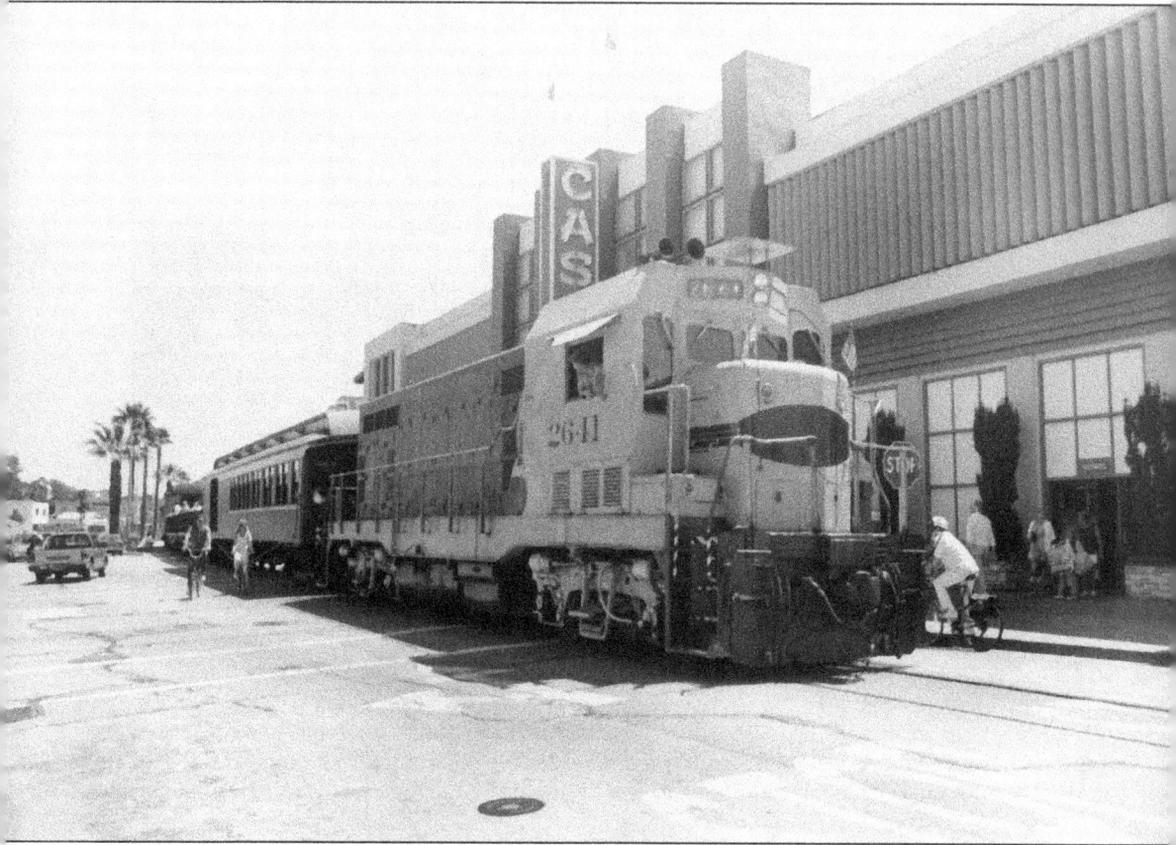

Santa Cruz, Big Trees & Pacific No. 2641 is about 50 feet farther down the track than the train on the previous page, about 50 years later, continuing the long tradition of bringing passengers by train to the Santa Cruz Beach boardwalk.

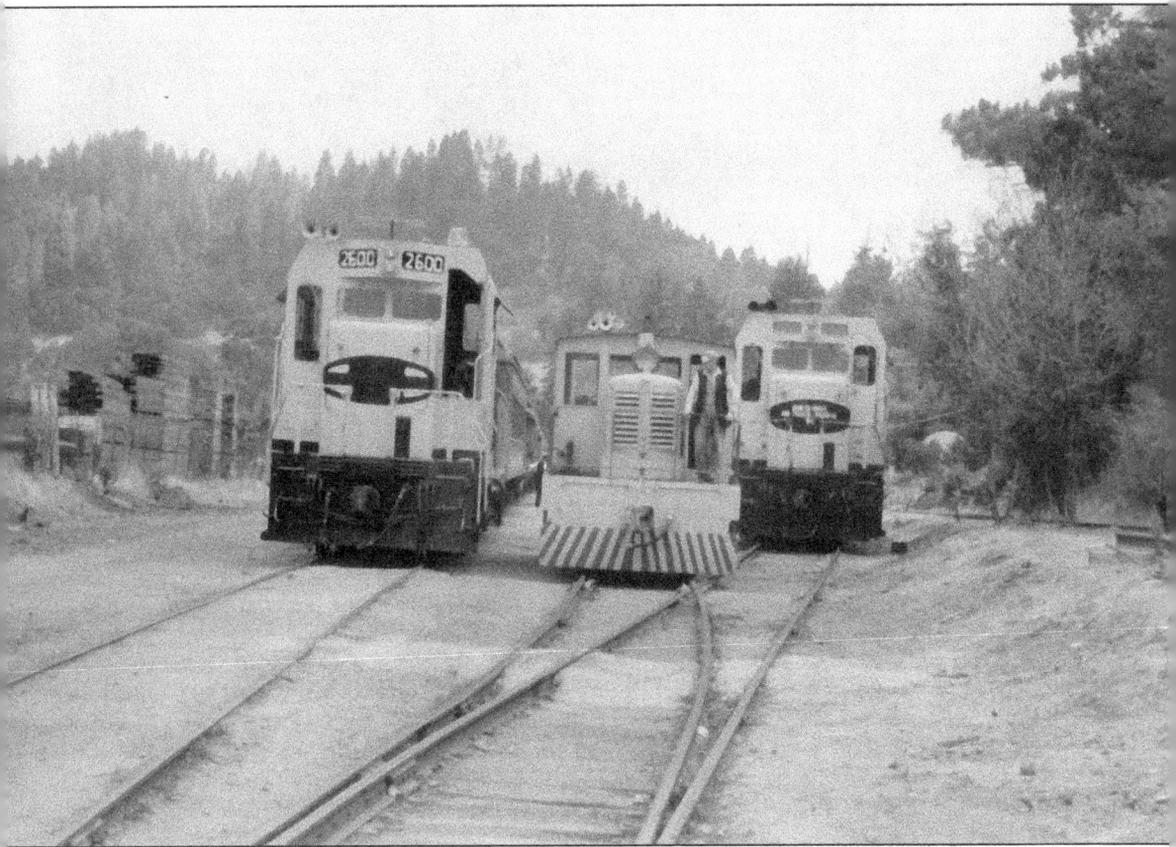

The SCBT&P fleet of motive power is seen here in the early 1990s. Both CF7 locomotives retain their original numbers from the Atchison, Topeka & Santa Fe.

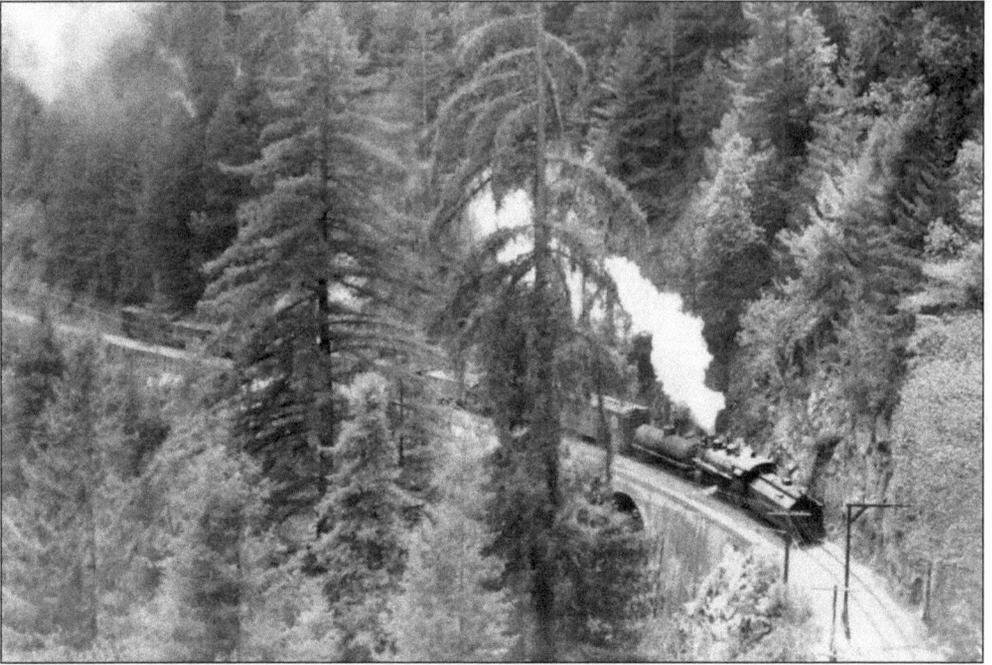

Above, Southern Pacific mixed freight rounds the curve above the cement arch built in 1909 as part of the Southern Pacific's standard-gauging of the former South Pacific Coast Railroad. Below, Big Trees CF7 No. 2641 passes through the same location with a train full of beachgoers. No. 2641 and its sibling No. 2600 were products of the Atchison, Topeka & Santa Fe's rebuild program in the early 1970s, which took a handful of aged EMD F7 locomotives and replaced their streamlined car bodies with a modern "hood unit" design, which greatly improved visibility for crews in yard-switching service. (Above, courtesy of Fred Stoes.)

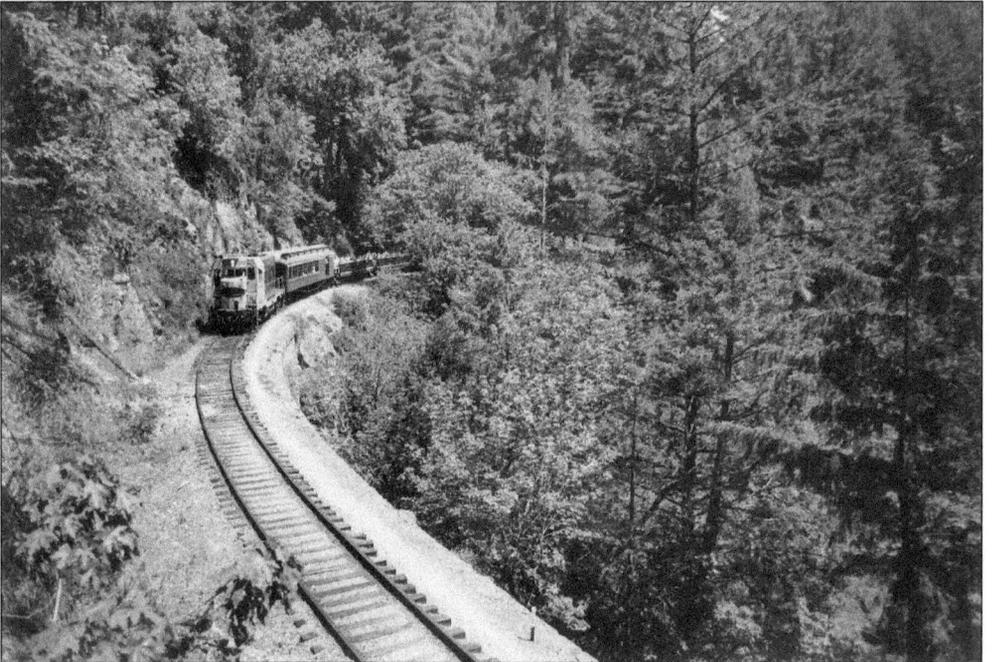

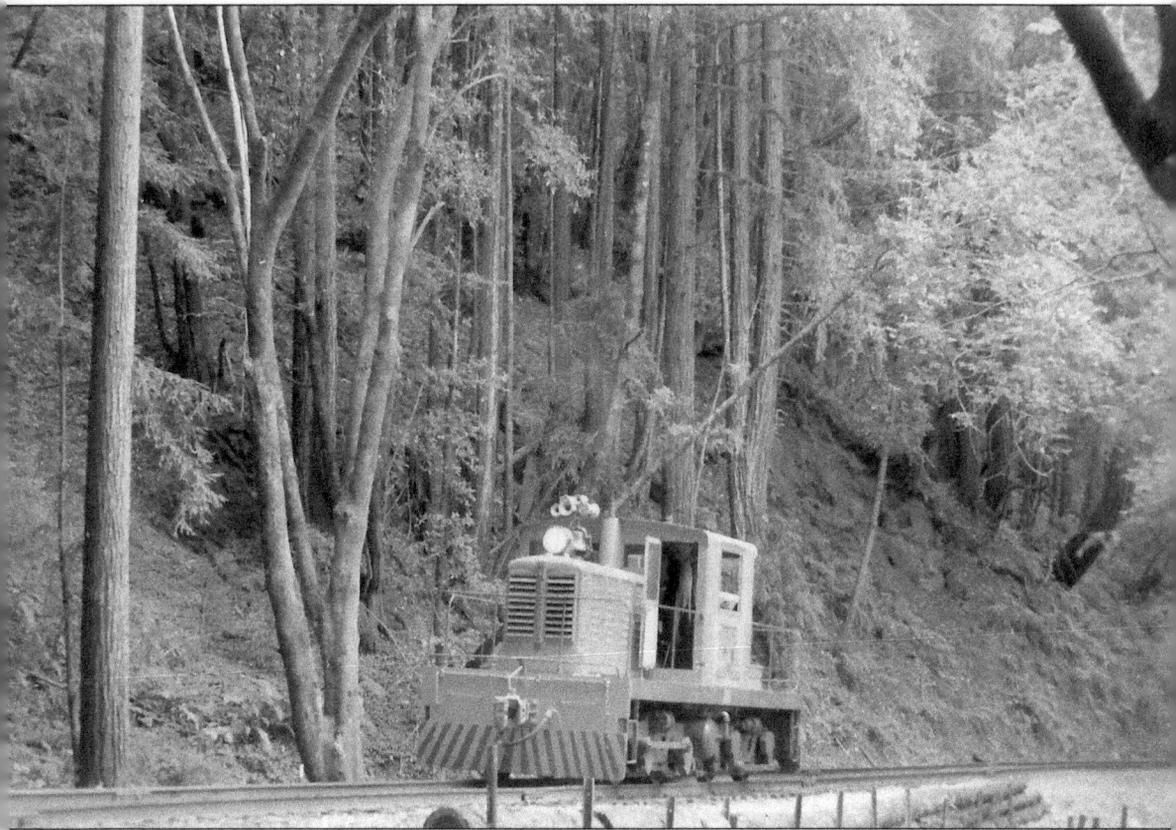

Whitcomb locomotive No. 20 is in the middle of the second-growth redwood forest south of Big Trees. In this section of the forest, the trees are only about 100 to 110 years old. The majority of the acreage in the Santa Cruz Mountains was clear-cut by the early 1900s, with the exception of Big Trees Grove and the property that Roaring Camp occupies, which are home to virgin redwoods, some of which have been standing for more than 2,000 years.

A special trip to Olympia was made for this group of railfans in the early days of the Big Trees Railway. Currently, the line between Mount Hermon and Olympia is out of service, due to the

condition of the right-of-way.

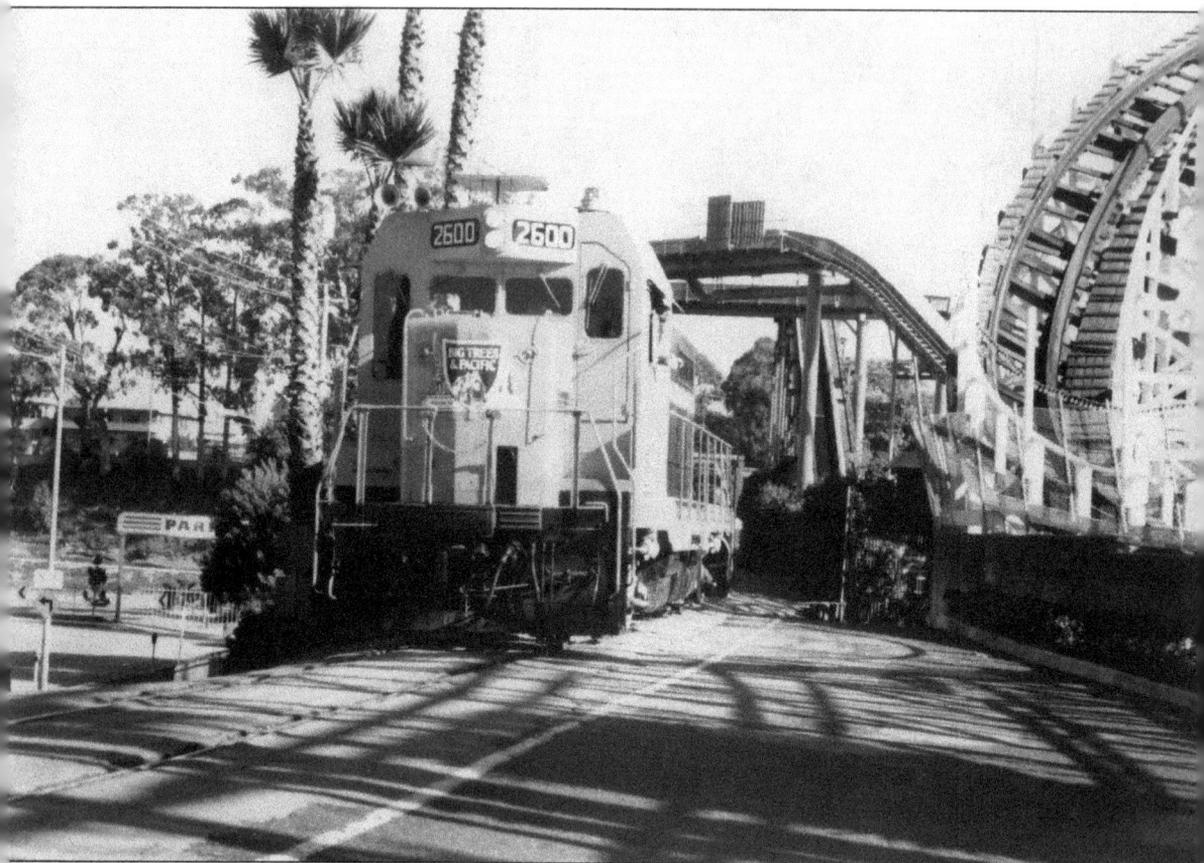

Arriving at the famed Santa Cruz Beach boardwalk, the Santa Cruz, Big Trees & Pacific Railway's early-day, diesel-powered passenger train parks next to the fifth-oldest wooden roller coaster in the world. Here, engine No. 2600 has received the brand-new Big Trees "shield" on its nose. Shortly after, it was completely repainted into a new paint scheme.

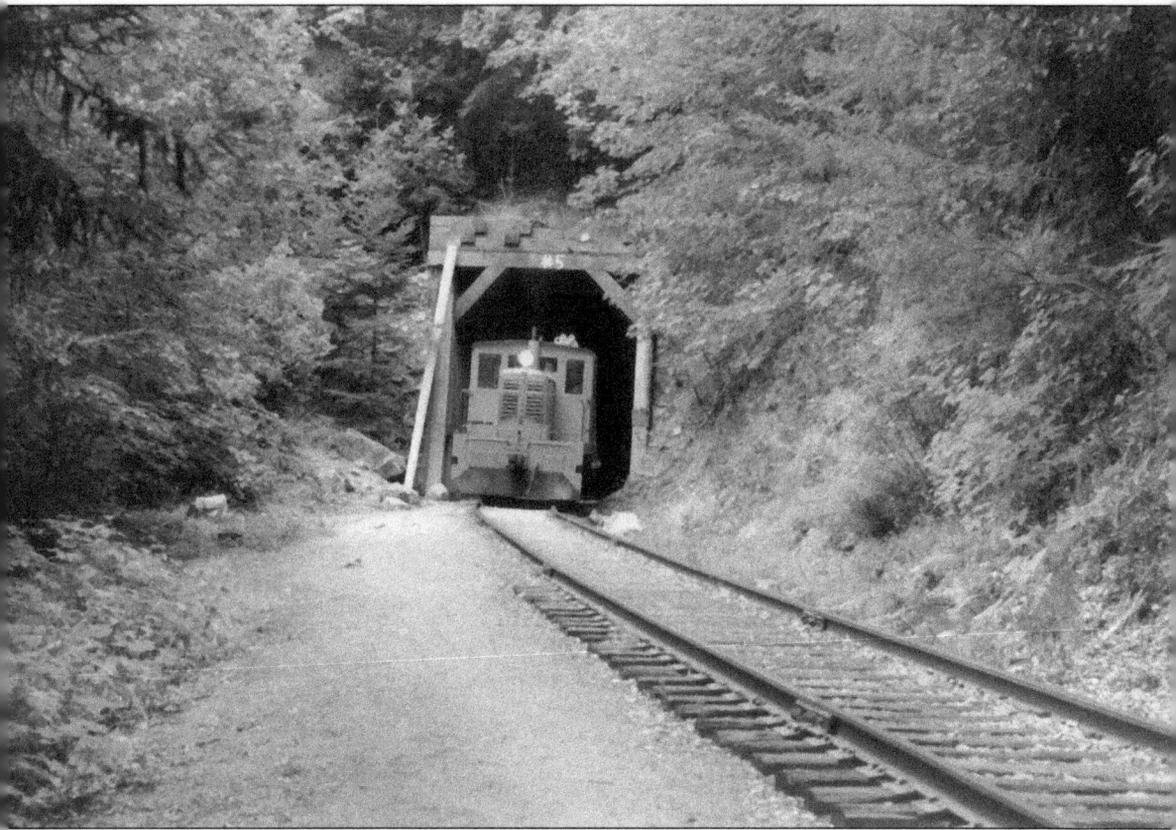

Engine No. 20 rolls northward out of Tunnel No. 5 and past the Garden of Eden, a popular swimming hole in the San Lorenzo River. The area's name comes from the tendency of its visitors to shed their clothes before going for a swim. This tunnel was constructed to ease a tight curve from the narrow gauge days of the Santa Cruz & Felton, allowing for higher train speeds.

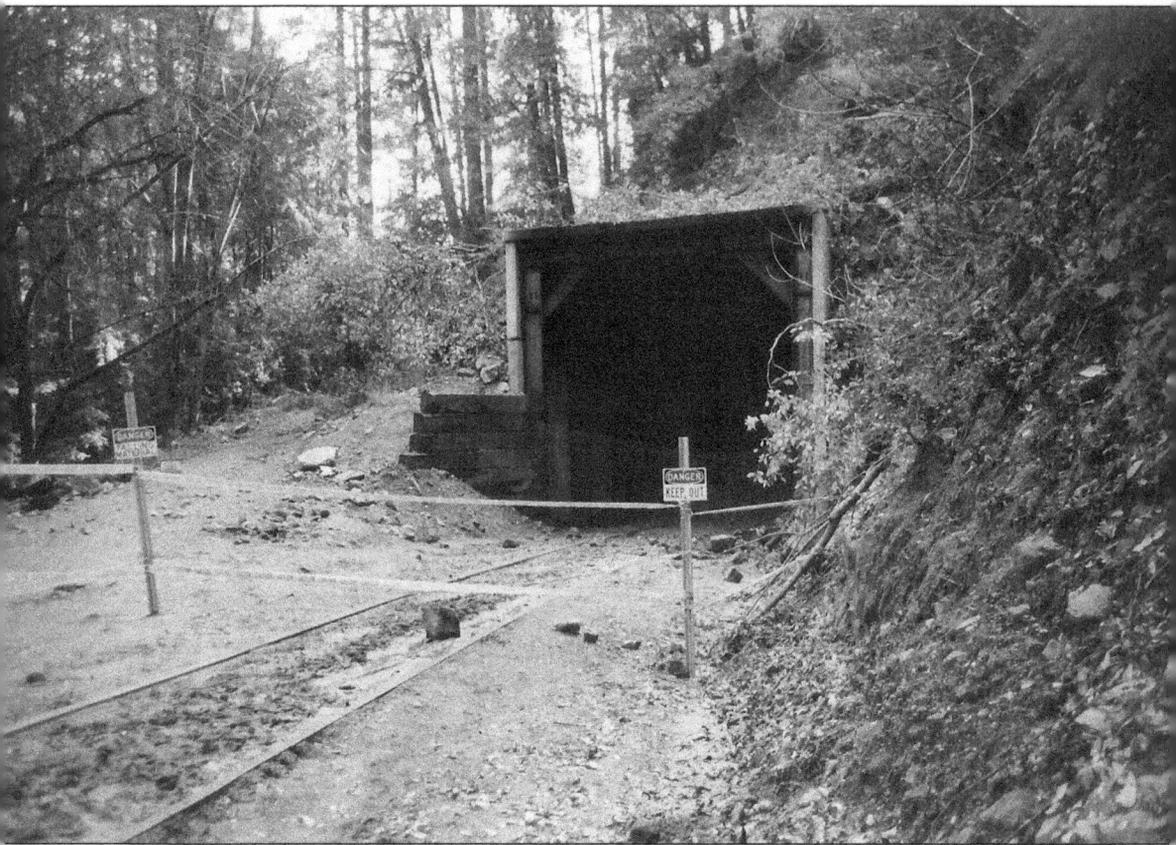

The north portal of Tunnel No. 5 is seen here shortly after its closure due to fire in 1995. The tunnel was later condemned, and the original route of the Santa Cruz & Felton narrow gauge railroad was restored to the left of the tunnel, around the side of the hill.

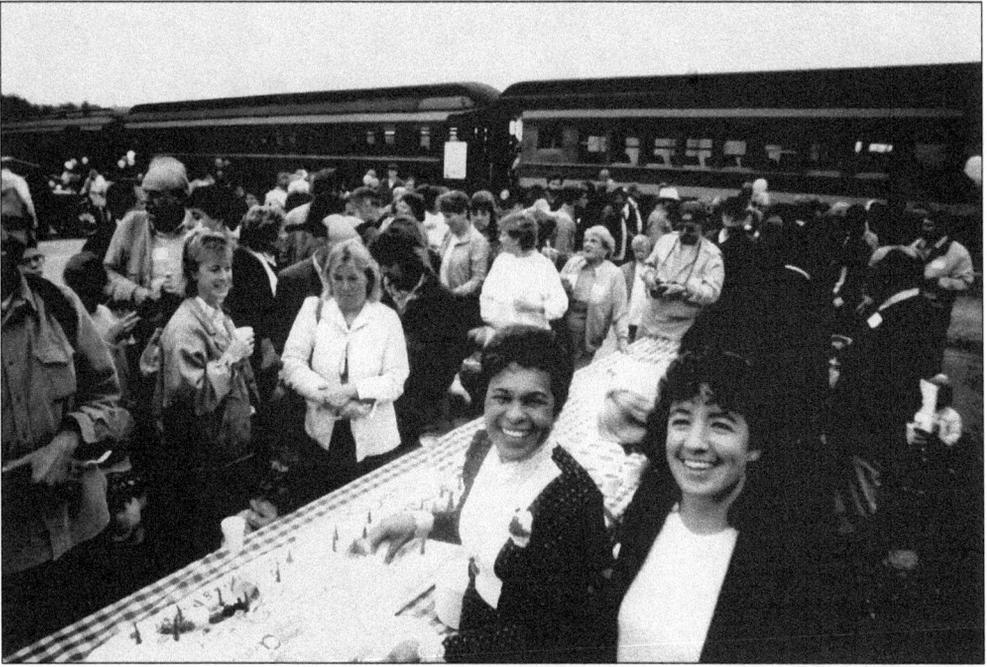

Roaring Camp CEO Georgiana Clark (left, foreground) and a few hundred of her closest friends celebrate the one-year anniversary of the Santa Cruz, Big Trees & Pacific at the Santa Cruz passenger depot on September 6, 1987.

The crew of engine No. 20 waves to the camera on a sunny afternoon at the Roaring Camp station. Henry Cowell State Park is along the right side of the tracks.

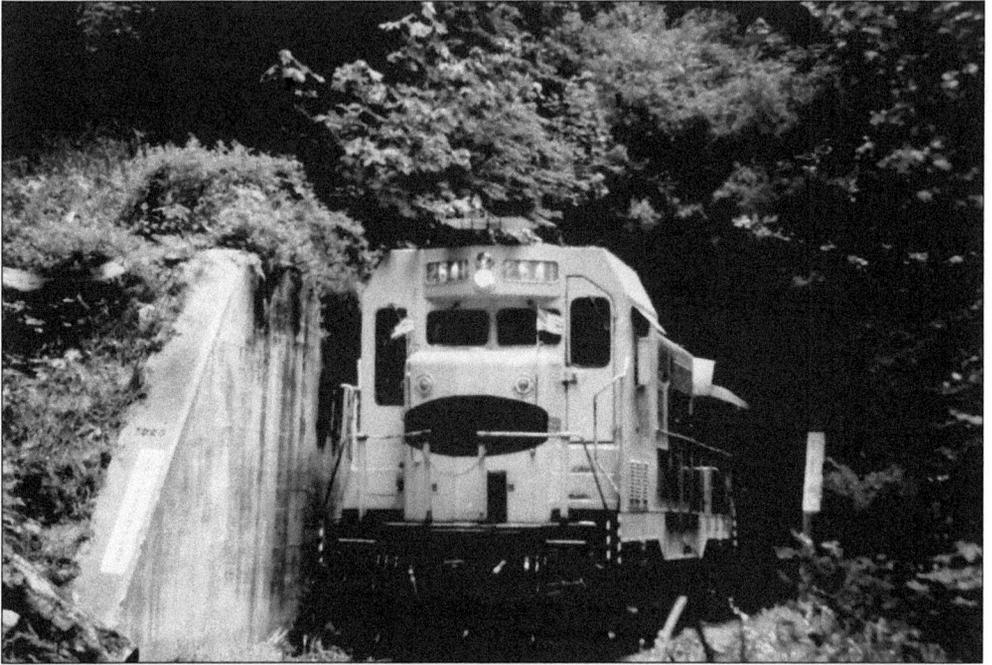

Big Trees No. 2641 emerges from the south end of Tunnel No. 5 on its way to Santa Cruz. The locomotive is in its transition phase, as the Atchison, Topeka & Santa Fe markings on its nose and long hood are blanked out. At this point, the new maroon-and-white paint scheme was not far off.

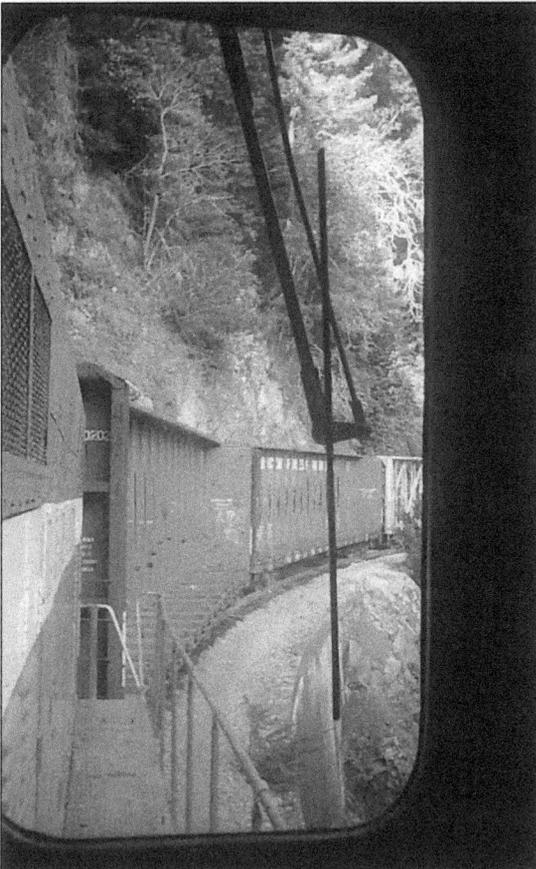

This view out of the back of Big Trees No. 2600 was taken as it pulled a string of empty center-beam lumber cars over the arch at Inspiration Point on its way down the hill to Santa Cruz. In 1990, the railroad resumed providing deliveries to San Lorenzo Lumber Company (later Probuild) in Felton. (Courtesy of Beniam Kifle.)

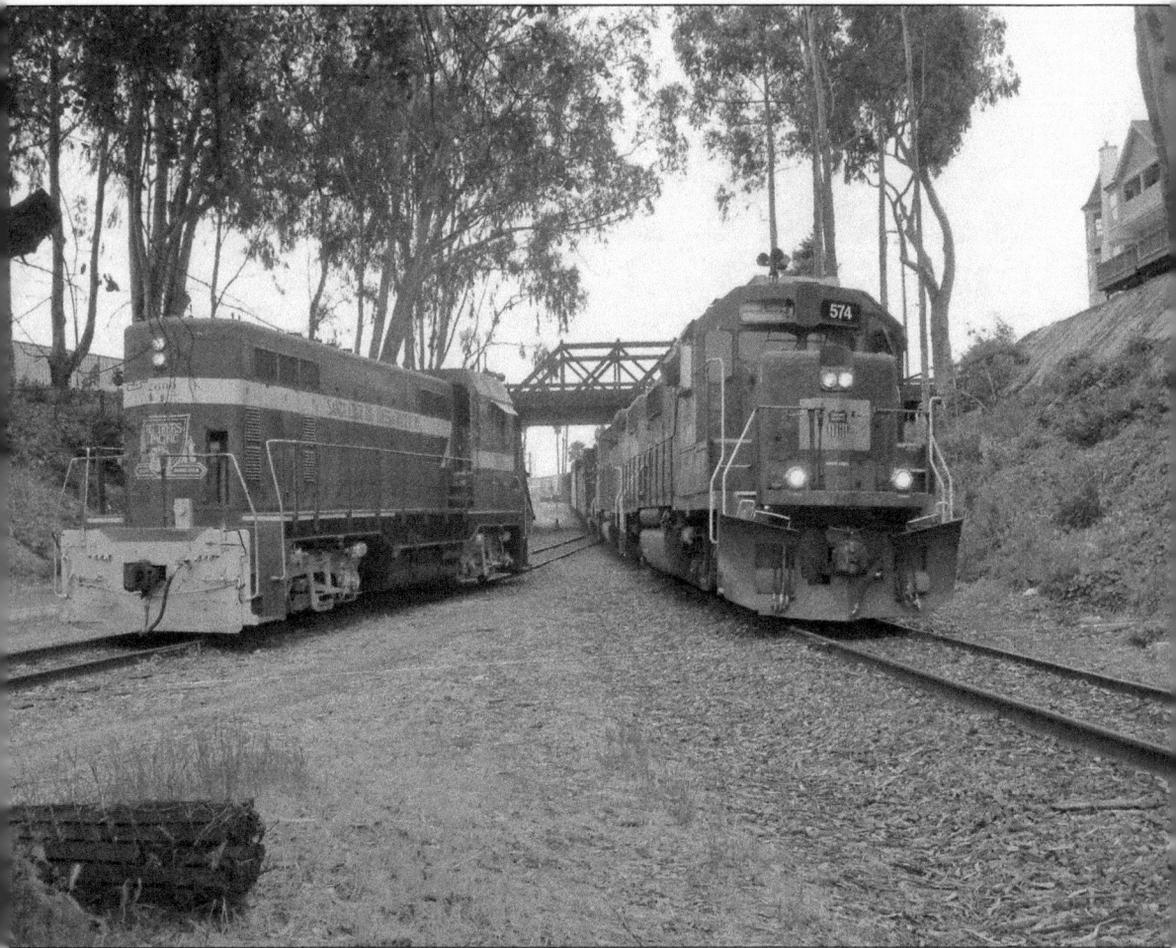

This scene has become a vestige of the past, as the Union Pacific Santa Cruz local passes by Big Trees No. 2600 at the wye in Santa Cruz in 2007. After years of negotiations, the Union Pacific finally sold the Santa Cruz branch line to Santa Cruz County in 2012, effectively ending the era of Class I railroading in the area. (Courtesy of TSG Multimedia.)

In the early 1990s, three modern, steel cabooses, one of which is shown above, were purchased from the Atchison, Topeka & Santa Fe to join their older brethren in serving as offices for the company.

Seven

INTO THE FUTURE

In 1988, Karl Koenig and Rick Hamman, both Roaring Camp employees, incorporated the Eccles & Eastern Railroad, with the aim of reopening the line "over the hill" from Olympia into Los Gatos. By 1992, their studies concluded that it would have been possible to relay rail on the abandoned right-of-way all the way to Lexington Reservoir. The last four miles to Los Gatos would need to be realigned to pass around the reservoir through a tunnel and then connect with the end of track at Vasona Junction. Some of the curves through the mountains were to be straightened to allow for train speeds of 40 miles per hour.

Unfortunately, the realization of Norman Clark's original dream fell apart time and again, due mostly to the volatile politics of the area and because of a public who was generally not yet interested in alternative modes of transportation. Hopefully, as more time passes and population density increases, the unsustainable nature of private automobiles will become more obvious, and this idea will be taken up again.

In 2011, Georgiana Clark announced that she would be passing the helm of the company to her daughter, vice president of operations Melani Clark. The younger Clark brings new energy to the company, and, as the 50th anniversary of Norman Clark's first train rolls around, the company's leadership and vision has passed from father to daughter.

In 2012, many years of work towards developing a nonprofit organization began to coalesce. This organization will work towards the restoration of Roaring Camp & Big Trees locomotive No. 5, a Climax-geared engine built in 1928 and acquired in 1975. With the restoration of this locomotive, Roaring Camp will have an operational example of each of the three types of geared steam locomotives.

The past is alive and well at Roaring Camp, and the future looks very bright. On any given day, visitors can see young people learning the tricks of the trade from people who have been at it their whole lives. The torch is being passed to the next generation, who will see to it that the railroad's future is informed by its history and that the artifacts of that history are preserved for generations to come.

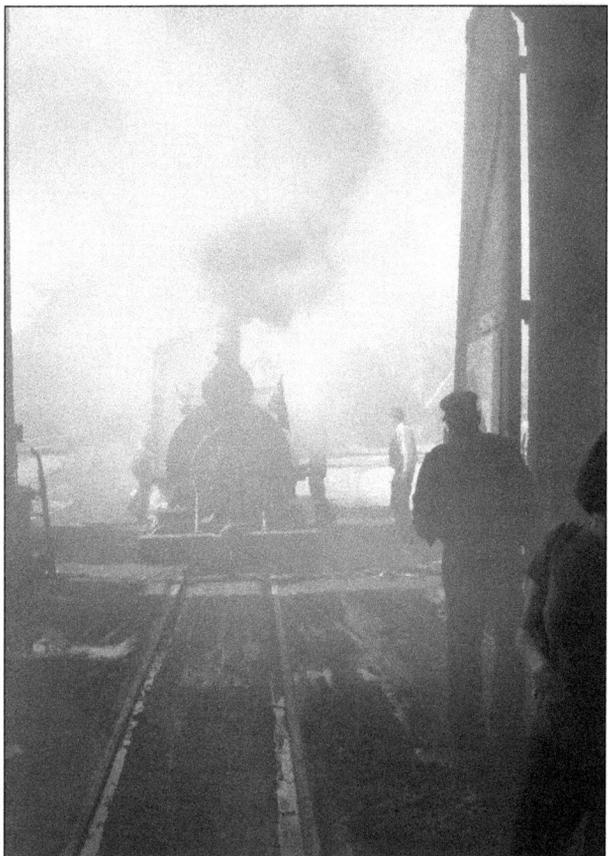

Here, bright and early in the morning in 2009, locomotive No. 3, *Kahuku*, is brought out of the engine house, fired up and ready for its day of service. (Courtesy of Nathan Goodman.)

Melani Clark, the daughter of Norman Clark, learned the art of firing a steam locomotive at a young age and was a regular crew member for many years. She is seen here as a teenager, waving to the camera from the fireman's seat of No. 1. In 2011, after many years serving as vice president of operations, Georgiana Clark named her the company's new CEO. Behind her, the second expansion of the Roaring Camp depot can be seen, as framing goes up for the new passenger waiting platform.

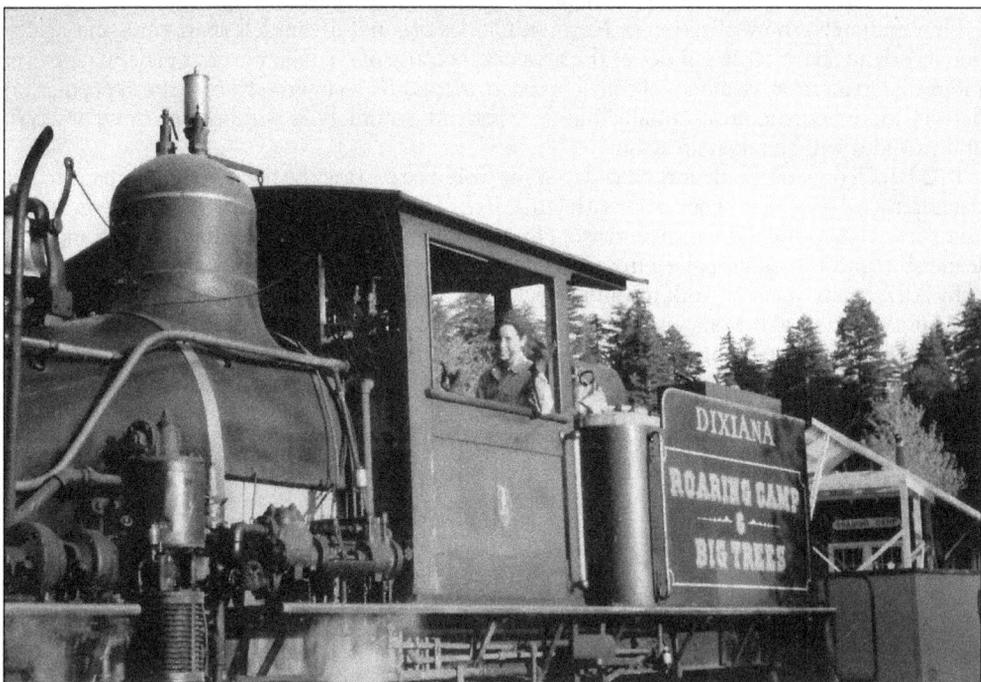

Engineer Nathan Goodman (left) and fireman Christopher Butler pose in front of the *Dixiana* after clearing several trees from the line with the locomotive in 2007. (Courtesy of Nathan Goodman.)

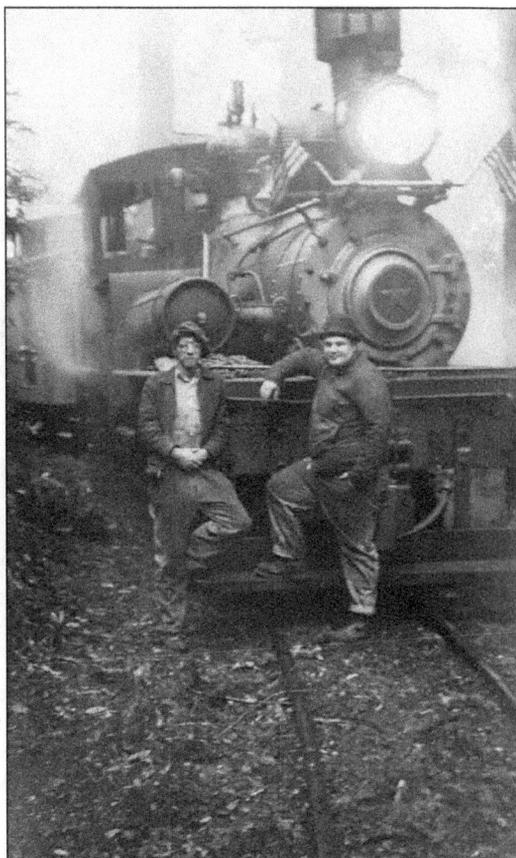

Over the years, a few retired cabooses from the Southern Pacific were purchased by Roaring Camp to find new life serving other uses. Some are now used as hamburger stands, while others are used as offices and storage cars. Southern Pacific No. 592 sits here on three-rail, dual-gauge track near the Felton depot in 1965, next to Roaring Camp & Big Trees No. 103. (Courtesy of Gene O'Lague.)

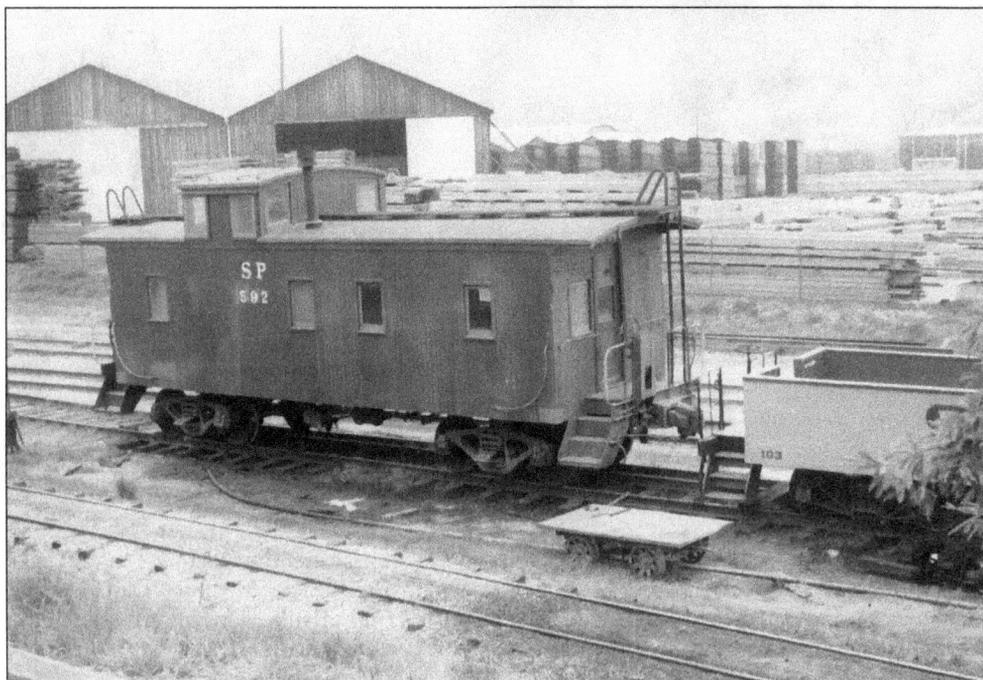

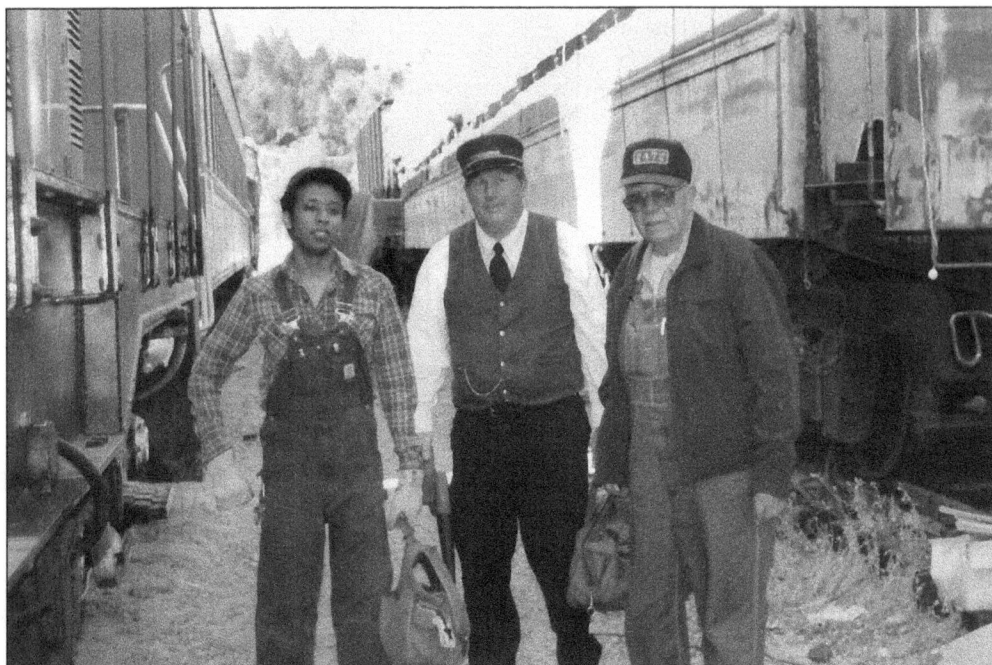

The crew of the beach train is about to "tie up" and call it a day at the yard in Felton in 2006. From left to right, fireman Beniam "Benny" Kifle, conductor John Park, and engineer Gene O'Lague worked on the summertime job for many years. After O'Lague's retirement in 2010, Kifle was promoted to engineer and still works on the train with Park. (Courtesy of Marvin Del Chiaro.)

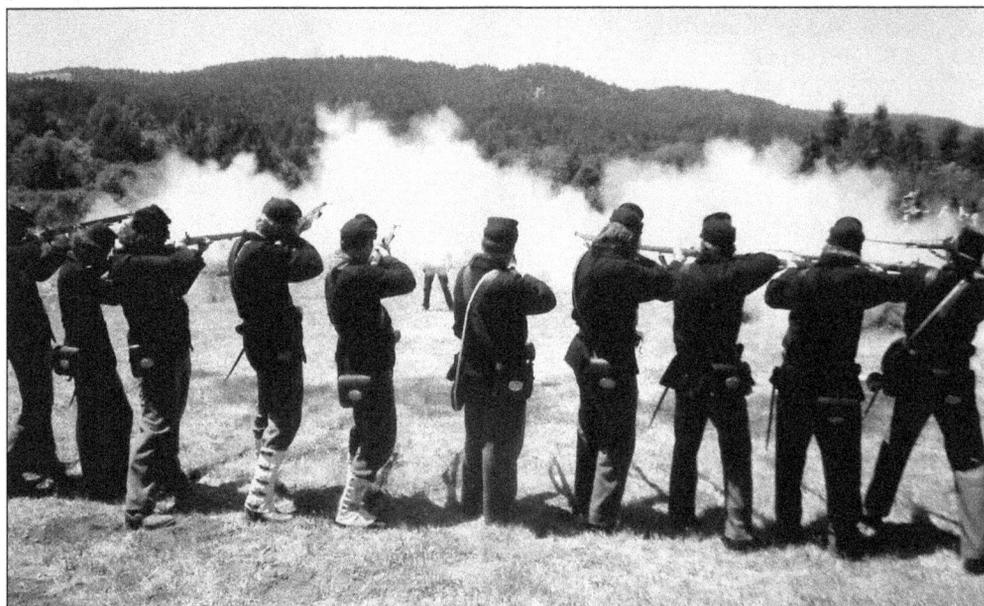

Civil War reenactments have been a Memorial Day tradition at Roaring Camp for many years. This photograph shows a participant's view of a midday battle. Every Memorial Day weekend, hundreds of living history reenactors camp out on the property for the weekend in canvas tents and cook over campfires. Passengers on the narrow gauge are treated to a skirmish at Bear Mountain before coming down the hill.

122

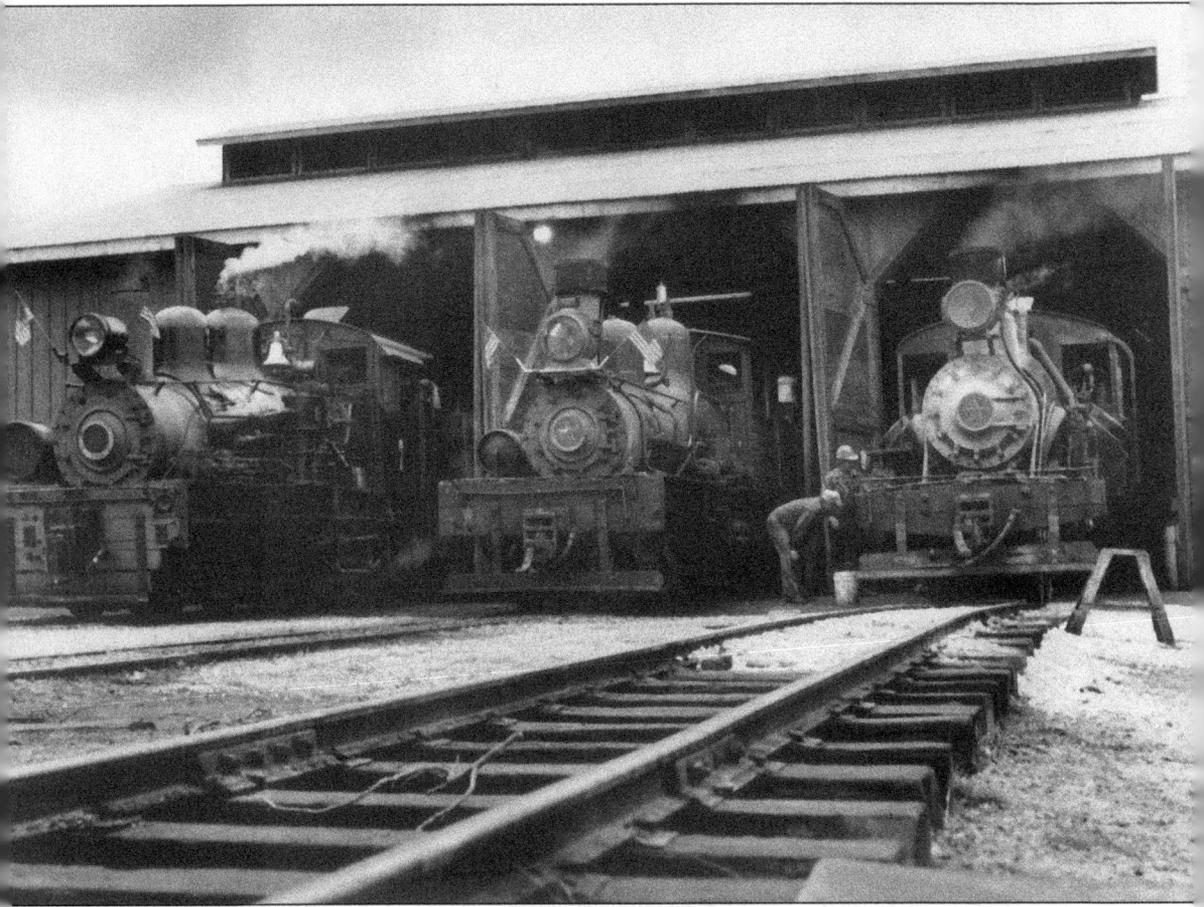

This photograph shows the engine house, with all three of the big locomotives steamed up. On any given day in the summer, visitors can take a ride through the redwood forest behind one of these historic engines. The No. 3 has become the "shop queen" and is typically only out on the railroad for two weekends at the end of July and beginning of August, running a parking lot shuttle train.

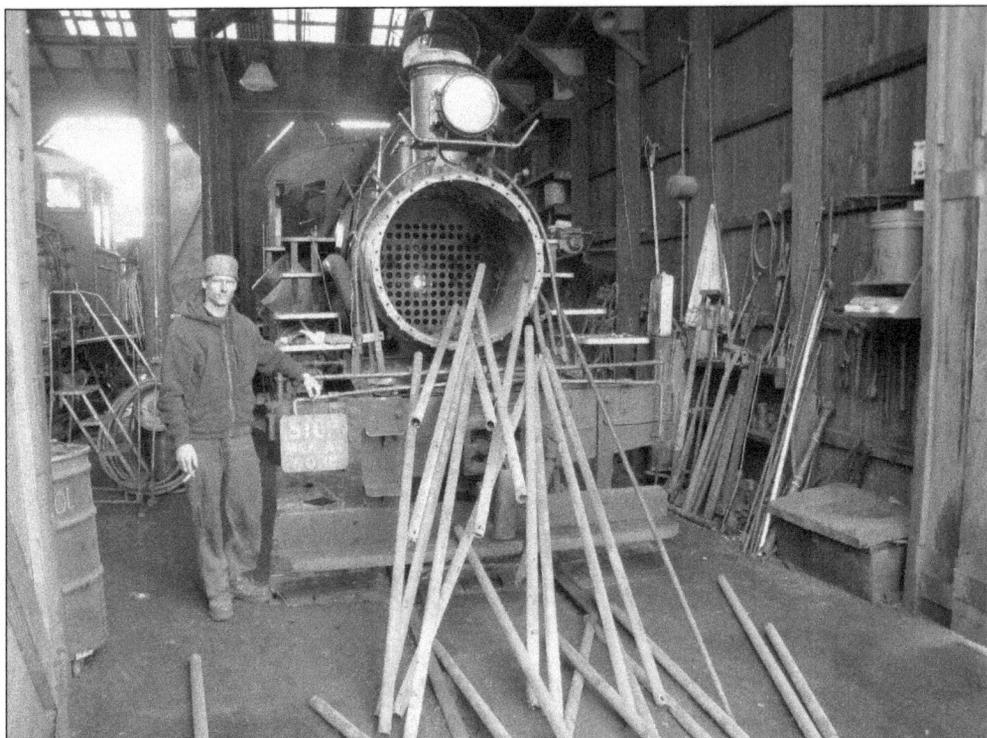

Stephen Mello wears many hats at Roaring Camp, as an engineer, fireman, and welder. Here, in January 2010, he is deep into changing the boiler flues in Heisler locomotive No. 2. (Courtesy of Nathan Goodman.)

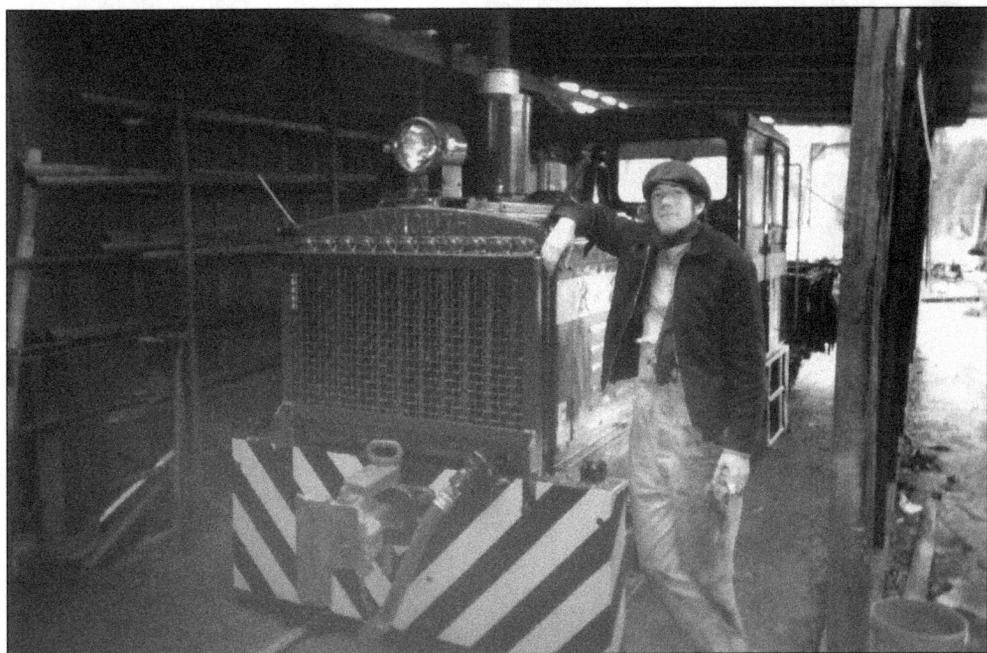

Nathan Goodman is seen here in the midst of a new paint job on engine No. 40, shortly after it received a new engine and rebuild in 2007.

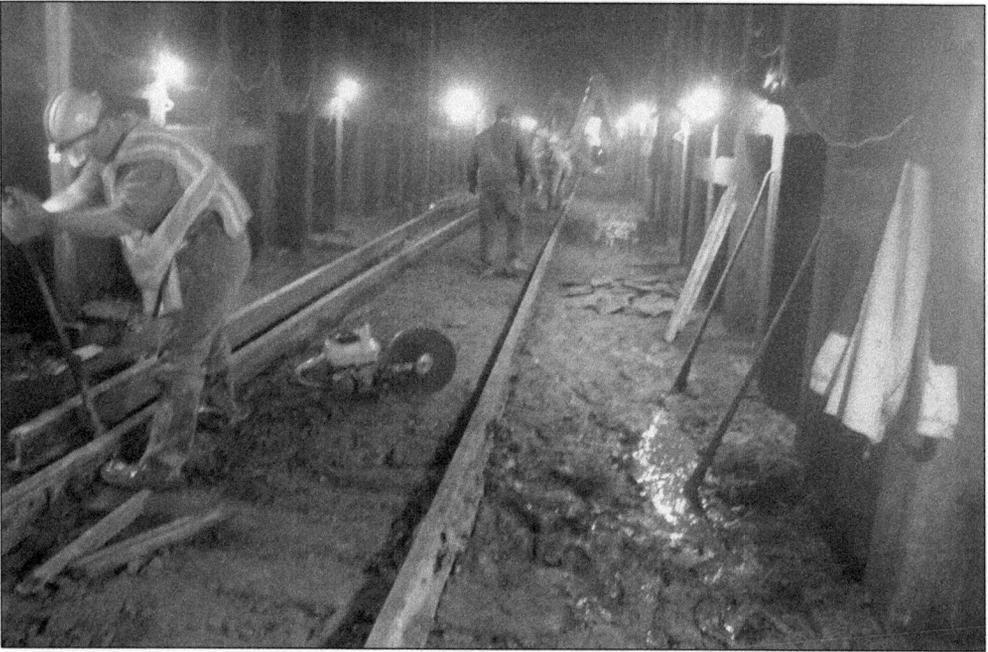

In 2012, the Mission Hill Tunnel in Santa Cruz had all of its rails completely replaced, a feat that took almost four months. The tunnel is approximately one-fifth of a mile long, and it took 56 sticks of 110-pound rail, all hand-spiked, to finish the job. Seen here working in the tunnel are, from front to back, Jason Bunter, foreman Juan Garcia, and Kyle Olson. (Courtesy of Nathan Goodman.)

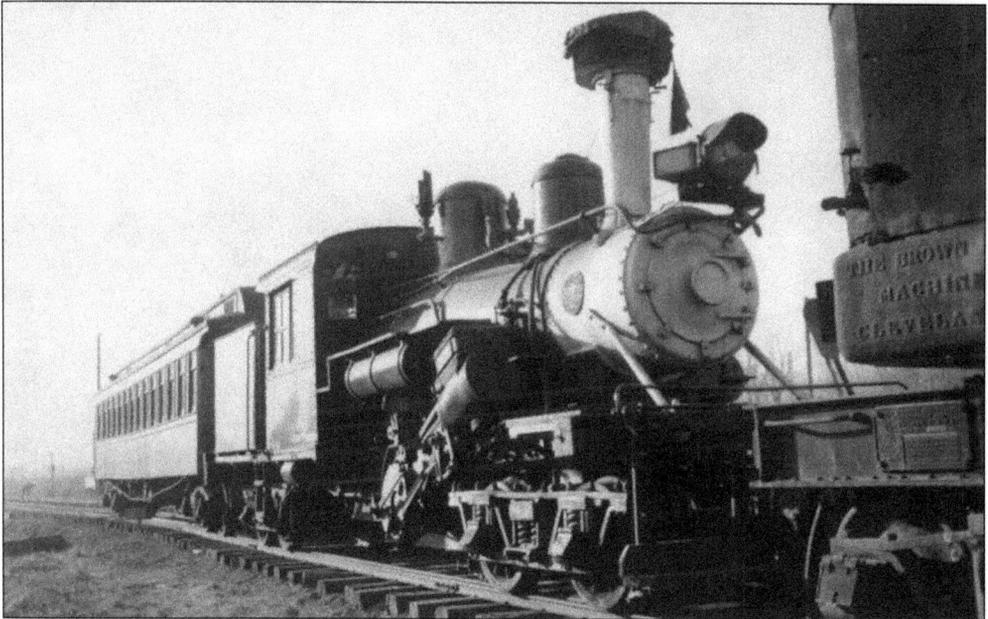

The Bloomsberg Climax was originally numbered No. 5 and ordered by the Elk River Coal and Lumber Company in Swandale, West Virginia. It was then purchased by the W.M. Ritter Lumber Company, which sold it to the Georgia Pacific Railway. It lived out the rest of its working days at the Carroll Park & Western Railroad in Bloomsberg, Pennsylvania, before coming out West. (Courtesy of Rick Hamman.)

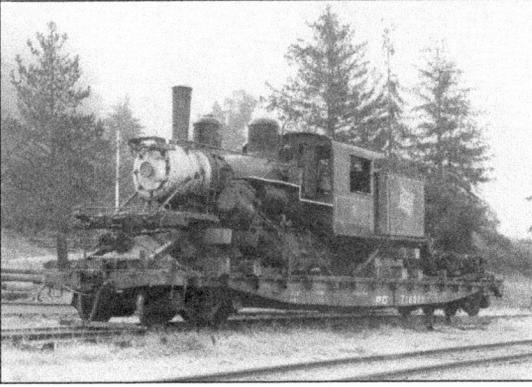

Climax No. 5 was purchased by Roaring Camp in 1975 and is seen here on the section of dual-gauge track at the Felton yard. It is the last locomotive of its type manufactured by Climax to run on logging operations in the West. Plans are currently underway to begin the restoration of the Bloomsberg to operating condition. It is currently 48-inch gauge and will need extensive rebuilding; however, a newly formed nonprofit organization may be taking up the challenge. (Courtesy of Jeff Badger.)

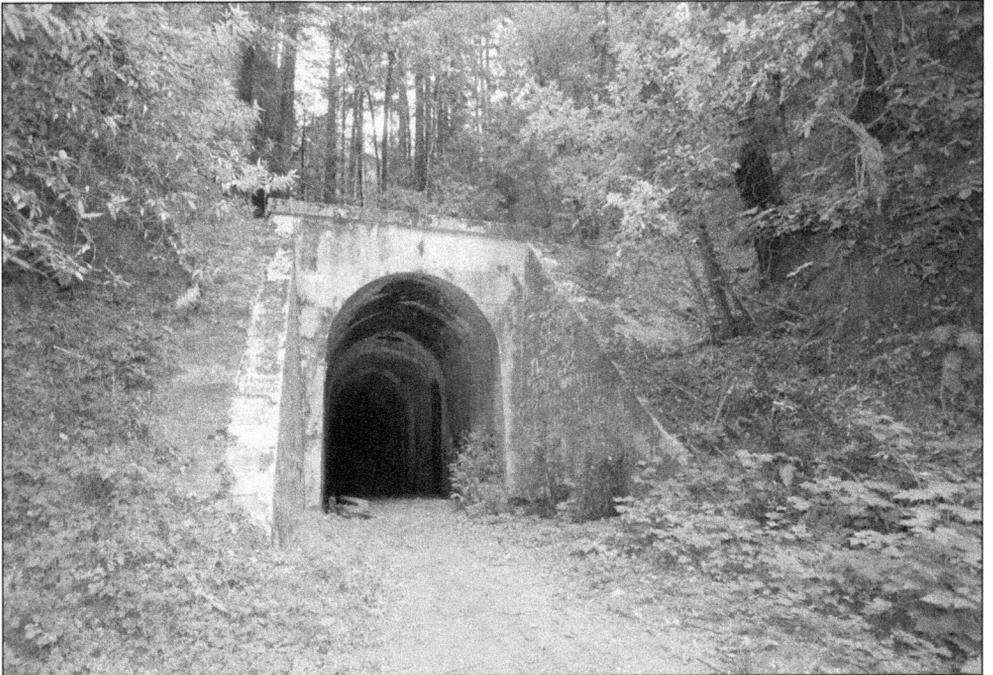

This abandoned portal of the Summit Tunnel in the Santa Cruz Mountains remains today as a reminder of the area's railroading past, history, and, perhaps, its future. Several times since the 1970s, plans have been formed around the reopening of the mountain route to alleviate congestion and pollution stemming from automobile and truck traffic on Highway 17. But as of yet, Norman Clark's original dream has yet to come to fruition. (Courtesy of Brian Liddicoat.)

BIBLIOGRAPHY

Beal, Richard A. *Highway 17: The Road to Santa Cruz*. Aptos, CA: Pacific Group, 1991.
Hamman, Rick. *California Central Coast Railways*. Santa Cruz, CA: Otter B Books, 2002.
MacGregor, Bruce. *The Birth of California Narrow Gauge*. Stanford, CA: Stanford University Press, 2003.
———. *South Pacific Coast*. Berkeley, CA: Howell-North Books, 1968.

Visit us at
arcadiapublishing.com

www.ingramcontent.com/pod-product-compliance
Lightning Source LLC
Chambersburg PA
CBHW050545110426
42813CB00008B/2263